BIG BUCKS

SELLING YOUR PHOTOGRAPHY

CLIFF HOLLENBECK

AMHERST MEDIA, INC. ■ BUFFALO, NY

Published by:

Amherst Media, Inc.

P.O. Box 586

Buffalo, N.Y. 14226

Fax: 716-874-4508

www.AmherstMedia.com

Publisher: Craig Alesse

Senior Editor/Production Manager: Michelle Perkins

Assistant Editor: Barbara Lynch-Johnt

ISBN: 1-58428-127-8

Library of Congress Control Number: 2003112483

Printed in the United States of America.

10 9 8 7 6 5 4 3 2 1

CONTENTS

PREFACE

Thank you for reading my book!

Several years ago the people at *Photo District News* (PDN) invited me to speak about travel photography at their annual conference in New York. During the question period someone in the audience stood up and asked: "All of these travel photos are beautiful, but what I really want to know is how to make the big bucks in photography!" My brief answer to his question spawned several additional seminars with PDN and became the basis for the first edition of this book.

Amherst Media publisher, Craig Alesse, has asked me to review and update *Big Bucks* three times. Each time, I have attacked the text with well-meaning intentions to completely revise every single word since the previous edition was published. And each time, including this one, I've found that the more technology changes in the business of photography, the more the administration and marketing stay the same. Obviously, the constantly changing equipment and sales technology have also been modifying the way we do business; they are the reasons for revising this book. However, creativity, good sales, and business practices are basically the same as ever; and they will always be the most important ingredients in the formula to make Big Bucks in photography.

Once again, I thank the many people who have contacted me to exchange ideas and give seminars and workshops about *Big Bucks* and the other books I've written. The fact that you find what I have to say useful is an inspiration to my writing and photography. I appreciate your questions and suggestions. For those new photographers reading this book, hoping to learn the secrets of success in this crazy business, I hope you find them within these pages. I wish you good shooting and good business.

I leave you with a little advice from the great Gandhi: "Live as if you were to die tomorrow. Learn as if you were to live forever." I also offer a recommendation of my own: Always get cash up front.

—Cliff Hollenbeck

INTRODUCTION

It's one thing to make great photography, something else again to sell it and administer those sales into profit.

Photography, in its multitude of forms, is the most creative means of communication and art known to humankind. Best of all, it's within the reach and use of almost anyone who can see. It's so easy, in fact, that *National Geographic* magazine once ran a cover photo that had been taken by a gorilla (Oct. 1978). We all know photographers who are related to this gorilla.

There is little doubt that the ease with which photography is made today is also the reason many people hang out their shingles as professionals prematurely. These pros often do not have the skills to be in any business, let alone those necessary to fulfill the far-ranging, roller-coaster demands of commercial photography.

This book can help you with ideas and suggestions about the business and marketing of photography, which can make you a more successful photographer. There are no pretty pictures or claims about how great Cliff Hollenbeck can shoot. What you will read comes from over twenty years of photography business experience—plus a firsthand observation of the leading photographers in the industry.

I've tried just about everything in this crazy business; I've made a few mistakes and have had some pleasant success along the way. What I suggest may or may not be ideal for your own business. It should be considered as a starting place for a never-ending education in photography. This is my candid opinion, not gospel. If you follow these guidelines and have great success, thank me. If your photo business is a total bust, blame the processing—everyone else does!

■ KEEP THINGS SIMPLE

Success in any profit-oriented business requires a few simple talents, most of which can be learned or imitated well enough to pass. Don't fool yourself or let others talk you into making things more complicated than necessary. The basic facts are that you need quality products, good business sense, strong marketing, and the right attitude to make the Big Bucks.

Simply put, your process for making Big Bucks selling photography depends on how well you provide those basics. Because we photographers are marketing tools of huge consumer-oriented organizations, things often seem anything but simple or profitable. Try to keep your business and marketing focus on the job and client at hand. I know it's difficult to remember that the job is to drain a swamp when you're up to your Nikons in alligators. Don't try to solve all of the copyright, work-for-hire, electronic imaging, photo CDs, clip art CDs, mega stock agencies, and other questions of our time. Leave those provocative subjects for the hotshots, who are much better equipped and experienced to do that worrying. You will be better able to deal with these things, and the day-to-day photography business, by joining a professional association. Otherwise, selling and administering your work will be a big enough job.

■ THE TRUTH ABOUT PHOTOGRAPHY

Two photographers were on Kodiak Island, in Alaska, making pictures of a huge grizzly bear. Suddenly, the bear rose up and charged. One of

the photographers dropped everything and started wildly running away. The other shouted, "Hey, you can't outrun a grizzly!" Still running, he yelled over his shoulder, "I only have to outrun you."

Think of the marketing world, publications, stock and advertising agencies, and clients as a huge grizzly. As this giant charges along in business, it eats up creative people—especially photographers. Those who manage to stay ahead of the competition will be around when the bear takes a break. At this point, we have the opportunity to do a little business. And opportunity is all we need.

▣ SELLING YOUR PHOTOGRAPHY FOR BIG BUCKS
Staying ahead of the grizzly and making Big Bucks in photography requires the following ingredients:

✓Commitment
✓Competence
✓Quality Product
✓Service
✓Persistence
✓Goals
✓Organization
✓Humor
✓Family Wealth

Family wealth aside, this book expresses my thoughts on how to meet these basics of good business.

1. THE INSANITY OF FREELANCING

You don't have to be crazy to succeed as a photographer, but it sure helps. It's okay to be crazy, but not stupid.

A guy driving along a country road had a flat. While changing the tire, he placed the wheel's lug nuts in the hubcap and set it alongside the road. As he was about to replace the flat, another car drove past and hit the hubcap, sending his lug nuts to the bottom of a nearby creek. Banging his head against the car, the man wondered, aloud, how he would get back to town to buy new lug nuts.

"Why not take one nut from each of the other wheels?" a voice asked. The man with the flat looked up to see a man leaning over a fence. A sign on the fence read Sunnydale Asylum for Mentally Ill Photographers.

"That was a pretty good idea," he said to the man. "How come you're in an asylum?"

"I'm crazy," he replied, "not stupid."

This story isn't true, of course, because all the really crazy photographers are still on the streets and in business for themselves. The stupid photographers are the artists who think business and marketing will take care of themselves. They continue to lose their assets and finally go into more meaningful careers.

■ HOW TO MAKE BIG BUCKS
Big Bucks photographers are made or unmade by themselves.

Every day you're in business there is opportunity to grow and prosper, and the chance to stagnate and fail. Your attitude, persistence, and goals determine which happens—to a far greater degree than your photographic talents.

Take a close look at the successful people in and around your own life. Read the books written by successful business and social leaders. What are the main reasons for their success? I'll bet each of them knows who they are and where they're going. In other words, they have a positive attitude and sensible goals.

To be successful in life and photography, be positive and planned in every action.

Rarely will you find a successful person who credits or relies on luck. Funny thing about luck, the better prepared and more determined I am, the better my luck seems to be. The harder I work, the more sales calls that are made, the better my luck. Plan to succeed. Be positive. Prepare and get to work. Your luck will improve as a result.

■ SUCCESS FORMULA
My formula for success requires:

✓Quality products and service
✓Good business sense
✓Persistent sales efforts
✓A positive attitude

In order to make Big Bucks you must score above average in each of these requirements and have a strong commitment and determination to succeed in the field.

Right about now, you're thinking this formula isn't any new secret way to Big Bucks and success. I know it sounds like pretty basic stuff, and that's

because it is pretty basic stuff. As with any formula, the better your ingredients, the better your results. Any baker soon learns that if you cut corners, the cake will be a disaster.

If you produce sound creative work, provide excellent client services, and back these up with good business practices, a solid marketing program, and a positive attitude, success will be yours. It's just that simple. Notice I didn't say it was going to be easy.

A good attitude is the single most important ingredient in any successful business.

Freelance photography, in its variety of forms and specialties, can present many challenges on the road to success. Along this road you can be your own best friend or your own worst enemy. The choice is yours and it's made daily in every thought and action.

Over the years I've developed a simple philosophy to check and keep my attitude positive. It has evolved into a simple list of do's and don'ts. I suggest that you read it every Monday morning in planning the week's business activities:

✓Think, act, and speak positively.
✓Keep your sense of humor.
✓Profit from mistakes.
✓Enjoy your successes.
✓See the best in yourself and others.
✓Never quit.
✓Don't take a failure or rejection personally.
✓Don't criticize yourself, competition, or clients.
✓Don't make excuses or complain.
✓Don't worry about what you can't change.
✓Don't dwell on setbacks.
✓Dream lofty dreams.
✓Live life to its fullest every moment.

■ PHOTOGRAPHY VS.
THE BUSINESS OF PHOTOGRAPHY
Photography is a wonderful art. Just make sure you don't become a starving artist.

If you're going to succeed in photography, act and think in terms of running a business. If you dwell on the artistic merits of photography, of which I agree there are many, do not let these thoughts interfere with taking care of business.

Ever notice what happens when a good business idea takes off? Everybody and their brothers jump on the bandwagon. Take, for example, the video rental

business. It was a great idea. For a few b[...] rent, and view in the privacy of your hom[...] of movies. The idea was so good that [...] places are now renting videos. So mar [...] sprung up that banks now refuse to i[...] loans to most new video rental entrepreneurs.

And so it is with photography. The basics of the art and science of making images are easy. Its attraction as a business is compelling. As a result, many people jump into the business of photography with little plan or thought about the realities of business.

Business is business. Whether you plan to make and sell widgets or photographs, the business principles are the same. Prepare yourself every day—mentally, physically, financially, and creatively—to take care of that business. If you don't, photography is so easy there will be someone there to immediately take over when you fail.

While I was growing up, my parents, teachers, bosses, and just about everyone else harped, "Learn from your mistakes." I do. I hope you will, too.

Profit from Your Mistakes. As a freelancer for some twenty plus years, I've tried many avenues that pointed toward success and made some mistakes along the way. I found out early in business that it's okay to make a mistake once. Recovering and learning from any mistake is a valuable experience.

Sometimes, however, a mistake or rejection can lead toward hard feelings, accusations, and even lawsuits. If there's one thing I've learned in the cruel business world, it's never to hold a grudge or waste valuable time worrying or seeking revenge. Believe me, the best revenge is your success and happiness.

So you made a mistake. 'Fess up right now, admit it to those concerned, and take immediate corrective action. Don't hope that no one will notice, that the client will miss the error, or that you can lay the blame on others. Don't get drunk or there will be additional mistakes.

I once worked for an airline public relations executive who was always saying "We don't make mistakes or have problems, we just have opportunities." He was right, because everyone makes mistakes. It's how you react and what's learned that will determine what kind of businessperson you are.

Once you've corrected a mistake and the cause, put it in the memory bank and get on with business. Don't spend the rest of your day, or life, trying to figure out the mistake, or why there are mistakes in general.

leave this sort of thing to the people who have the time and money for analysis.

Profit from Your Success. Spend a little time thinking about the roots of any success in your business. Why does a certain approach work better with one client than another? What's the reason a client came back or recommended you to someone else?

Believe it or not, many people think success just fell into their laps. If you can determine the reason for a certain positive result, the action can be repeated again and again for even greater profits.

Ask clients how they came to do business with you. Was it the portfolio, a sales call, a referral, a flyer, an advertisement, or what? It's a normal question in business. The answer may surprise you.

■ FREELANCE PHOTOGRAPHY
The real world demands hard work to become a success. Photography also demands smart work.

The Perspiration Factor. Success and all that it brings isn't the result of sweat. You can work yourself to the bone every day, and it will probably cause a bad back, tired feet, and an empty bank account. You can also sit on your butt and get fat. Neither is the road to great success.

Work smart. Use your mind before breaking your back. Make good business decisions. Take a few risks in new markets. Try something new in selling and shooting.

All the talent, education, and hard work in the world will not replace persistence.

The Persistence Factor. The more determined and dedicated you are, the more success there will be. Establish a good business plan, set sales goals, and start right now. Stick to the job at hand, get it done, and move on to the next one.

Lots of businesses fail only inches short of success, because their owners give up. Perhaps they don't recognize that success is just beyond the horizon.

In the music business, disc jockeys say that most songs are noticed by the public, becoming hits, at about the time everyone around the radio station is sick of hearing them on the air.

In his great baseball career, Babe Ruth struck out more times than he hit home runs. At one point, he held the world's record for both strikeouts and home runs at the same time.

I'm not crazy about comparing life with sporting events. Having the ability or guts to push for another yard on the football field does not translate into success in the real world of business. Only a noted small fraction of professional athletes also win in business. Having said this, I should point out that beyond a natural talent, most athletes are successful because they are persistent. The harder, and more often, they try, the better they get and farther they go. These factors do translate to the real business world.

■ PLANNING TO WIN
All the world's great achievements began as dreams, and people turned them into goals, then reality. It's okay to dream, but it's not okay to be a dreamer.

Plan to win by setting business goals and establishing priorities. Write down your ideal business situation for one year and five years from now. Make the listings in the present tense, as though they already exist. Update your goals yearly, taking a look at the previous year's desires for a little motivation. Some examples of this type of goal-setting include:

✓Sell $100,000 in stock images yearly.
✓Shoot two national client jobs each month.
✓Add one major new client each month.
✓Employ three full-time people.
✓Occupy a five-thousand-square-foot modern studio.
✓Shoot with super model Tyra Banks
✓Shoot four *Time* magazine features per year.

After setting goals, prioritize them in order of which are most important to you and your business. Be honest with yourself about your capabilities. Assign the letter *A* to the most important and desirable items on all your lists of goals, projects, and desires. Assign the letter *B* to things that would be nice to accomplish immediately after the *A* section but that you can live without for now. Assign the letter *C* to all other items. Now put every *A* item on a special list and get going. *B* and *C* will fall into place.

Action Planning. What you do determines whether or not goals and priorities become a reality.

Start right now. Take charge of your life and make decisions about business that are aimed at improvement and growth. If you wait around for the phone to ring, it won't. If you start making calls to all the potential clients out there, the phone will soon be ringing off the hook.

Let others know you're busy and successful, because that's the kind of professional they want on their team.

Always keep an active list of project ideas. These might be potential editorial or stock shoots, or they might be dream assignments or fantasies. Plan one of these shooting projects as though it were a paid assignment. Make a few calls to clients who share your interests and invite them to come along for the fun of participating. Call in a few favors from other potential participants. Shoot the project. Use it for a marketing effort, stock, or an assignment teaser. Call this personal shooting, practice, testing, or whatever, but do it at least once a year. It will sharpen your idea skills and keep you working toward shooting goals.

Freelance photography is a demanding mistress who rarely takes second place.

Associates. The satisfaction and highs created by a successful photography business are wonderful. The most stable shooters keep these times constantly in their minds as a sort of bait, to keep them plugging away when business isn't so good. As in any profession, there will be times that are slow or seasonal. Planning and saving for these rainy days will preserve your sanity and keep you around until business picks up again. And it will if you keep working.

As a group, photographers are a little like cowboys. Few people really understand them or their motives. Their fierce independence often makes them fair-weather friends and difficult to know well. They have a selfish, constant desire to create and compete (mostly with themselves). However, when a photographer's life and business are moving along at a successful pace, they are enjoyable characters.

Even the most successful creative life is, at times, a rocky road to travel. More often than not, you must be your own best friend and your own counsel. Some of us are fortunate enough to form associations with positive and successful people of like minds. These people generally have the same holding and staying power we require for survival. I'm fortunate to share the photography business with my wife. She is dedicated to our success.

Self-confidence is the strongest asset you can possess.

Who Are You? You must be happy with who you are and what you stand for as a photographer. You must feel good about yourself, look the part, and communicate this to the photo buyers of the business world. Smile and show a little humor as you approach life's challenges.

While you can't always choose the business circumstances, you can control your attitude and thoughts. Be positive, think great thoughts, aim high, and be happy with yourself. In the end, the business circumstances will improve, and eventually you will be able to control the choices.

■ PLAYING TO WIN
Photography, business, and life in general are all a big crapshoot. Play to win self-satisfaction with every throw of the dice.

You alone must determine what satisfaction, success, and financial rewards are desired from photography. In my case, I love to travel, explore, meet new challenges, shoot beautiful images, and make money. Pretty much in that order. I also planned to share it with someone special.

Most people are children of a material world, who keep track of their success in terms of cold, hard cash. It's been my experience that most photographers have a drive to create images that is stronger than their drive to make money. Once this creative drive is being satisfied on a regular basis, the need for a little material comfort pulls into a strong second place.

If you want to make Big Bucks selling your photography, you must dedicate your life to the business of photography. Now!

I believe in karma, which, in simple terms, means you generally get what you have given and what you deserve. No one will be handing you assignments on a silver platter. What you get, you will earn and deserve. What you don't get may come around again if you give it another try.

Get out and let the people who control those Big Bucks know who you are, what you do, and what it will cost, and then deliver the most creative goods you can produce. Do it right now, tomorrow, and every day in every action.

Love what you do, and do what you love.

After reading this entire book, please come back and reread this chapter once again.

2. PHOTOGRAPHIC ABILITY AND CREATIVITY

"Nothing is more important than creative development. The best way to market yourself is to produce work that other people talk about. If you've got a great creative product, sooner or later you're going to be able to market it. No matter how badly you go about it."

So says New York photographer Jay Maisel. And he should know; because he is one of the leading photographers of our time. Maisel produces rich, creative images that meet both the high standards he sets for himself and the equally demanding commercial needs of major business organizations. This in itself is an art. Anyone who meets Jay Maisel finds him to be every bit the creative artist.

If you expect to be successful in selling photography, you must first have the technical and creative ability to produce that photography.

But there is another Jay Maisel many photographers sometimes fail to see. This is the shrewd businessperson. Despite being an artist with a camera, Jay doesn't rely on his art to sell itself. The fact is, his success also comes from good solid business practices. The combination of art and business makes Jay Maisel someone you should watch from both perspectives.

■ CREATIVE ABILITY
Your creative ability to produce images will be the foundation of a successful and profitable photography business.

Simply put, adequate images will provide adequate income, while great images have the potential to produce great income. There's a lot of ground to be covered in the process.

Your Creativity. While some photographers were born with natural creativity, it is a capability that, to a great extent, can be learned and constantly improved upon. Several factors can be brought into play to learn creativity, but the primary method is to follow the work of successful shooters.

I constantly review the best photography being made in the world. It's a simple matter of reading a few select publications each month. *National Geographic, Communication Arts, Islands,* and *Nikon World* are magazines that specialize in publishing a wide range of creative photo images. *The Stock Workbook, ImageState Stock Catalog, Photo Media,* and *Fuji's Professional Profiles* are publications that showcase the work of today's best commercial photographers.

I clip the best images and ideas in several national and international publications, keeping them in a working ideas file. These clipped images are selected for interesting subjects, unusual lighting, new thoughts in composition, hot color and contrast, and any other outstanding use of photography. By reviewing this file from time to time, I am able to improve my own approach to creative thinking. I also frequently ask myself why this image was selected for my file in the first place.

Start your own clip file by selecting images that reflect the type of images you wish to produce. Use this file to develop your own self-generated assignments. This means creating something new, something beyond the present range of your work. It doesn't mean shooting an exact copy of the subject or situation in the clipping, which may have

legal consequences. It hinges on developing something that challenges your imagination, using the clipping as a reference or starting point only.

Since this isn't a book on shooting, experimentation will be left to your own imagination.

■ WHAT IS A CREATIVE PHOTOGRAPH?
Viewer impact is what makes a photograph creative to potential buyers.

I know there are a hundred other things that may come into play in the consideration of creativity and buying of images. It is, however, the image impact, or viewer stopping power, that will generally determine the difference between big bucks and small bucks.

I always view a selection of images as a whole: first for their overall impact and second to see if any single image stands out. This is often how clients make their initial selection from slide sheets of similar images. One of my best-selling stock shots, a young Hawaiian hula dancer, always seems to draw the viewer's eye. The image's initial impact keeps making sales.

Impact can mean subjects of unusual interest, exotic beauty, or simply the shock of tragedy. Impact is also composition, color, contrast, or a combination of these and other graphic elements. Some photographers confuse images of sensational events, spectacular locations, or bizarre subjects with creativity. Jimmy Bedford, the late University of Alaska journalism professor, said it best: "A creative photographer has the ability to make uncommonly good images of common subjects."

Being in the right place at the right time with the ability to use a camera only allows you the opportunity to use your skill and training. Hotshots like David Burnett and Eddie Adams have made it their business to be creative no matter who, what, when, or where they photograph a subject. Both have been shouted at, shot at, and totally ignored by every subject imaginable and they always come home with quality photography. They make these images happen, rather than simply recording the event.

There is another growing problem with image creativity. We photographers, not to mention the public, live in a visual society and are inundated with thousands upon thousands of images by the mass media. For the most part, these are limited to the recording of events, or snapshots. We are blasted with this visual garbage until nothing seems to have much real value. Sadly, the emphasis seems to be on quantity rather than quality. As viewers, we eventually learn to ignore all but the most significant or creative of these photographs—the ones with impact.

Warning! If you spend too much time trying to digest the bulk of today's mass media, it will dilute your ability to see properly in your own image-making.

■ MAKING QUALITY PHOTOGRAPHY
The difference between a creative image and a very bad one is immediately apparent. After evaluating why a certain image has failed, destroy it forever. If you save a poor shot, sooner or later a client will see it, usually at the wrong time, and make the wrong assumption about your work.

How does an art buyer decide between two good, perhaps equal, images? The answer is usually in the form of a sale. In fact, the decision may be reached for two reasons: your style and your ability to make a sale.

Developing your own style, one that results in photography with impact and quality, is something that requires thought. I call it thinking in images. Study, experimentation, self-generated work, and constant shooting will eventually lead toward an individual look or style.

Great photographic images are made when everything comes together in one perfect moment. Believe me, you'll know when this happens. For me it's being in the right place at the right time, with a plan in mind, seeing images develop, and having creative freedom.

I did a photo shoot in Cancun, Mexico, for Hyatt International some time ago. Their Cancun Caribe Resort is an outstanding property on the white beaches of the beautiful Caribbean Sea. Hyatt provided a smart corporate location manager, a very cooperative and understanding resort manager, the best models in the business and, most important, the freedom to be creative. The results were great images, which satisfied both my standards and the client's commercial needs. It's wonderful to enjoy this type of client support and confidence.

Make the best possible images you can in every situation and of every subject. Ask yourself, "Is this picture going to be worth my effort?" If the answer is yes, shoot a few extra frames of film (referred to as *similars*, not *duplicates*) for the file. Now the question becomes, "Is this subject worth shooting several frames of film?" A seasoned and successful professional will rarely shoot a single frame of anything. If it's worth their creative time, it's valuable enough to want additional similars.

Edit Your Work for Quality. Good image editing demands the ability to separate yourself from the

shooting. Consequently, the best photographers are not always the best editors. The ability to separate yourself from the shooting comes with lots of editing practice. It means spending hours over the light table.

Sometimes there is a great image sitting on the light table, but you can't see it for all the slides.

You should be able to view a 35mm slide with little or no magnification and immediately determine if it has any impact. This is exactly what the photo buyers will be doing, so use this as your own editing guide. Always provide your best images to the clients for their consideration. Never take a buyer's critical comments personally. Their job, which is similar to yours, is selecting the best images to market a product, not stroking your ego. Pay close attention to a buyer's comments about photo needs, ideas, and things that can improve your ability to make, sell, and edit images.

■ TECHNICAL ABILITY
Your images must be of the highest technical quality to sell for serious money.

This means properly exposed, sharp, and in focus. You must be able to operate the equipment properly in order to create.

Some photographers confuse their ability to use equipment successfully with the ability to make great photography. These people spend most of their time playing with equipment, shopping at camera stores, buying the latest gadgets, and talking to other photographers. This time should instead be put to work shooting and experimenting with equipment, learning to use it as an extension of yourself under any conditions. Fumbling with equipment will eventually result in lost images and missed opportunities.

You must have the right equipment to do the job at hand and the ability to use that equipment creatively.

The Right Stuff. Never say something like, "I could make a great picture with a different lens, a different camera or another piece of equipment." It is not smart, let alone professional, to let a client know that you don't have the ability to operate something or that you don't have the right equipment.

Capability. Pretend that your livelihood, which includes those little extras like food and rent, depends on extensive ability and knowledge to operate all of your equipment correctly. You can gain this capability

through lots of practice and, when everything else fails, by reading the manual. Another idea is to take a shooting seminar provided by an equipment manufacturer or top pro. They will share the latest tricks and modifications available, which can improve your shooting edge in making and selling images.

It's easy, and fun, to bluff amateurs, lovers, and people on the beach with a Nikon and long lens hanging around your neck. You can't, however, bluff photo buyers about technical ignorance. Your images must be sharp, correctly exposed, and technically proper, or they won't sell. Photo buyers can spot a poor technician quickly, which is why such photographers will leave the buyer's office without a sale.

Specialization. If you have a burning desire to create great pictures of bananas, then you've got to be the best possible banana photographer and find a market that needs banana photos. This is called *specialization*.

If you have a burning desire to make pictures of just about anything, think about being a generalist. Later, you may find a more specific type of work that is both appealing and profitable.

Don't waste your time and energy making pictures of things that you don't approve of or downright hate. If you dislike alcohol, tobacco, corporate America, cars, or whatever, then don't include them in your work. Please give me a call if you plan on turning down an assignment to photograph the next *Sports Illustrated* swimsuit issue.

I specialize in travel-related subjects. This means resorts, location fashion, destinations, countries, and items that relate to travel. My stock images reflect the fact that I have a burning desire to see the world. I also appreciate beautiful suites in the world's greatest resorts and traveling first class. Making images that reflect this passion, at a profit of course, is my product.

While you must have the technical ability to make good images, few clients really give a rip how or where that knowledge was acquired.

Education vs. Experience. Which is more important technically? Education or experience? The business answer is: Your clients don't care. They just want to see the images.

I have worked with assistants who were graduates of serious photography schools. Technically, they were very good. Better than I am, for that matter. What they didn't have was experience dealing with the conglomeration of people, modified equipment, crazy logistics, even crazier hours, and general screw-ups

photographers face on many jobs. Such skills come to these people fairly quickly on the job. It's called learning through experience.

I have also worked with assistants who had learned everything by trial and error. That is, by doing the job on the job. All around they were very good. The one thing these people didn't always have was that finely-honed ability to make the technically perfect image. Most of us professionals, it should be pointed out, are constantly striving to meet this goal, too.

A little education mixed with a little experience always wins out as the best way to become a successful photographer.

Where to Learn. Learn professional commercial photography by attending classes, seminars, and workshops, and by assisting—not by seeking and accepting a job that you may not be ready to handle. If you attempt to learn any profession solely on the job, the profession as a whole suffers a loss of credibility. Learning only by experience can also become so complicated and costly that you lose your career in the process.

Schools and Programs. Photography schools and programs that are part of higher-education systems are good places to learn and practice the technical aspects of photography. This is the most direct, and probably the most expensive, way to learn photography. Knowing and working with a number of these graduates led me to believe that there are some very good instructors on the scene.

Workshops and Seminars. Attending workshops and seminars conducted by working professionals is the way to improve an already basic knowledge and photographic ability. The best place to listen to experiences, see work done, and ask direct questions of the best professionals is a *Photo District News* photo conference. Presented in major cities throughout the year, these conferences draw top equipment and material manufacturers, who show and offer instruction on their wares. The conferences present two-hour seminars that are worth a thousand times their minimal fees. You can read about many of these things monthly by subscribing to *Photo District News.*

Providing Assistance. Assisting a working professional, it seems to me, is the best way to expand your knowledge of the business of photography. This is the place to see what it really takes to make saleable photos. If you get the opportunity to participate in both planning and shooting, you and the pro will benefit. If

you watch and listen to what is happening around the shooting (general administration, client participation, marketing, logistics, and general attitude), you may learn what it takes to become successful.

Many of today's leading professionals once assisted leading professionals themselves. Stephen Wilkes, who assisted with Jay Maisel, is an excellent example. This is an ideal way to get acquainted with commercial photography without the risks associated with starting any new business.

I started my photographic career in Alaska, which is an experience in itself, during a time when few professionals resided in that great state. This means I learned the hard way. *Life* magazine's man on the scene, Joe Rychetnick, University of Alaska Professor Jimmy Bedford, and *Alaska* magazine editor Dick Montague all helped me in much the way a professional would help an assistant. They candidly shared their knowledge and experience. They took the time to examine my work and push me in the right direction.

Such relationships are more difficult today. For starters, people in these positions are under the gun to produce materials for their employers. Not many have the time to cultivate a young photographer's goals and desires. However, all is not lost. Many of these people, including me, participate in seminars and workshops. We don't get rich off these programs. Rather, it is a way to share some of the experiences that have helped shape our careers.

There are three types of assistant: full-time, freelance, and professional.

The full-time assistant is a house employee, much the same as a corporate executive's assistant. By the way, the IRS is firm on this employee relationship. Getting one of these rare jobs means selling yourself. Start looking among photographers you admire. Check with ASMP (American Society of Media Photographers) and PPA (Professional Photographers of America) for their addresses. Write a simple letter, make a call, and try to visit and show your work. It might be easier to catch them at seminars or conferences, which can give you an idea of his/her personality and interest in assistants. While an assistant hopes to someday have their own business, the professional for whom they work hopes for a long-term employee.

The freelance assistant is hired on a job-by-job basis as an independent contractor. They operate as an established business, much the same as the photographers for whom they work. In addition to the business licenses, tax registrations, stationery, and other business trappings, freelance assistants must market them-

selves to photographers. This requires the same marketing and business skills that a full-time photographer must possess.

Working with a variety of photographers, as a freelance assistant, is both demanding and rewarding. First, you must have a wide range of experience and knowledge just to get hired. Second, it's a great way to see how several different photographers approach business and shooting. This is an excellent way to eventually become a successful commercial photographer. These people are my choice as assistants.

The professional assistant is in business to be an assistant. They are not seeking to become commercial photographers, although that may happen occasionally. It's been my experience that these independent businesspeople are very good at assisting and are in high demand. Of course, they must also meet all of the requirements of being in business.

Overall, assisting is the ideal way to learn on the job, assuming you are able to work with quality professionals. Since assisting is a relatively new phenomenon, many working photographers, including myself, didn't have this opportunity.

If you are seeking work as an assistant, or to work as a commercial photographer for that matter, it makes sense to look in the area where you hope to eventually be established. Don't look for work in Los Angeles if New York is where you hope to make the Big Bucks. However, you can assist anywhere possible as an educational, temporary, endeavor.

If you are interested in becoming a banana photographer, there isn't much sense in assisting in fashion. In all of your interviews, remember that you ultimately want to be a photographer, whereas the professional wants someone to be an employee. You'll be showing a portfolio, while the photographer is looking at you. Approach them with organization, intelligence, and a willingness to work. As an assistant, you will get to do everything in the office or studio. That means everything the boss doesn't want to do. You won't be the photographer.

As an assistant, you may work for photographers who aren't as skilled as you are, and there are times when you could have made a better shot. How you handle these situations determines your future role in photography, certainly as an assistant. Be too pushy or cocky, and you might be looking for another job with a very poor performance report following you around.

Personally, I want assistants to participate in my shoots. This means working with me to make good shots. It means thinking about the shot and offering ideas that may improve what's being done. It also means making a shot, on occasion, with me assisting. However, it doesn't include making me look bad! This approach allows me to utilize another set of creative eyes on the job. It also means someone could take over if I am unable to work for any reason. I still call the shots and control the overall production. I also have the client contact, the contract, and the responsibility to deliver.

When seeking work as an assistant, or working as one, you're asking a professional to open up and share a lifetime of work, not to mention client confidences, with someone who ultimately wants to be a competitor. Some professionals can deal with this thought, and many can't.

■ PROPER EQUIPMENT
Think of your work as a parachute jump. The last thing you want to worry about is the equipment.

Use the best equipment you can afford for the job at hand. What is the best equipment? It's not always the latest high-tech Nikon, although that's exactly what I use. The best equipment is dependable, easy to use, made for the job on which you use it, and within your budget. There's no sense in spending the entire family inheritance on equipment, unless you've got plenty of shooting jobs scheduled.

In considering an equipment purchase, the best gauge is your experience. Few retail camera store salespeople have any serious professional experience, with the obvious exception of the professional stores. You can tell the difference in these stores by the prices. Professional stores do not discount Nikon and Hasselblad equipment. You pay for their knowledge and the opportunity to compare the best in professional equipment.

Never test equipment, or use an untested piece of equipment, on the job. So what's the answer? Test equipment on a simulated job by first visiting the rental department of those professional camera stores. You'll have to secure rentals with serious credit cards or firstborn children, but it will allow you to shoot with the equipment. Rental equipment gets well used, so if it holds up it will probably work for you, too. Ask the rental people for their opinion on the new cameras. Test the rentals and test your new cameras.

I replace camera bodies and lenses about every two or three years. This means I have new equipment and the latest technology at all times. When something goes wrong with any piece of equipment, which is rare

considering my turnover rate, I have it fixed and trade it in for a new item. I do not want anything going wrong with my equipment in the middle of nowhere.

■ MATERIALS AND PROCESSING

The best possible film and processing should go hand-in-hand with the best equipment. Few image buyers will ask what type of film and processing you select. They expect you to be the professional and use the best materials for the job. No matter what amateur-oriented advertisements and endorsements say about their products, professional films and custom processing will make your images look the best they possibly can.

Why on earth would someone use drugstore film and processing with a $2,500 Nikon?

In selecting film and processing, do as you would with equipment: test and compare everything. Try shooting a still life, scenic, or people shot with two or three types of film. Have them processed at a professional lab. Compare the results, and retest your first choice on a more difficult situation. Look at the overall image, color, and contrast for impact and sales potential. Does the image look good? Don't get caught looking for minute differences in film quality as the primary test.

Buy film from sources that store and ship sensitive materials properly. For me, this eliminates most mail-order purchases. I like to see the materials available in large emulsion lots and stored in a cooler until the purchase is made. I am willing to pay the small markup that stores charge for this service.

In the big picture, film and processing are cheap. Shoot lots of film. Test every type of film that comes on the market. Try several processing labs. Make up a shooting guide of your results. Someday you'll need a certain result or a special process and these tests will pay off.

Mail Order vs. Local Purchase. You can purchase film, and most photo equipment, from mail-order houses and on the Internet at some attractive discounts. To be honest, I've bought equipment from a few of these places over the years. This has ranged from great buys and great service to less-than-great buys and no service. As with any supplier, the relationship must be established and respected on both sides. This generally means a few test runs.

Buying equipment by mail order and online means knowing exactly what you need: make, model, and retail price range. I purchase from these places with a credit card and request overnight shipment. If the product doesn't arrive immediately, the credit card people can cancel payment.

I buy the majority of film and equipment from professional photo stores in my area or, in some rare cases, the areas of my assignments. The personal attention, negotiations, immediate availability, and community support are all things I consider important to being in business.

■ PROFESSIONAL ABILITY
Creative and technical ability must go hand-in-hand with professional ability.

You are in business to provide a service, create a product, and administrate an ongoing business. The better you are at all of these things, the more clients and more income will result. That's what this book is all about.

Your professional ability means acting like a professional and taking care of business as the client wants. You can be an artist, perhaps a creative genius, but just make sure to show up on time and deliver what was promised. Businesspeople will consider you a professional when you show them you are, indeed, a professional. It's like being a great lover—a lot of talk will never replace a superlative performance.

■ THE DIGITAL REVOLUTION

Shooting and working in digital formats has become the rage in recent years. Being able to receive still and live images via telephone, cable, or satellite moments after an important news-making event occurs has been a windfall in modern communications. And because many art directors and photo buyers are media junkies, this need for immediacy often works its way into the photography procurement arms of magazine, advertising, and marketing organizations.

To create and deliver salable photography for a specific market, you must learn and keep up with the technology that your clients utilize. If your clients are part of a fast moving organization or market that wants images created by digital cameras and sent to them online, then you must have that knowledge and capability. In the case of digital photography, this means having the right camera, computer equipment, and software programs, as well.

To be a successful photographer in today's marketing climate, at the minimum you need to know how digital photography is created and delivered. In order

to keep up with your competition, you need to understand and take advantage of the World Wide Web or Internet as a sales and delivery tool.

For the past two decades most professional photographers have relied on custom processing labs to take over after an image was created. They simply dropped off the film for processing, followed that with a quick sort and catalog of the results, and made a delivery to their client. This allowed them more time to sell, shoot, and administer a business. Photographers who convert to digital shooting and delivery are finding out that they must now spend a lot of additional time in their electronic darkroom. Few raw digital images are acceptable to the client without some color correction and manipulation. This is a consideration that needs to be taken into account—both time and cost wise—when bidding on or proposing a job.

The bottom line in the digital revolution still remains the same as it always has in photography. You must do two things: First, and foremost, you must create the images your clients and potential clients need and are willing to purchase. If you don't have that image-making ability, you won't make enough sales to stay in business. Second, and equally important, you must deliver images to clients in the format they need and are willing to purchase. For some clients, this will be original photographic images on film, so long as that technology continues to meet their needs. For other clients, this will be a digital format of one sort or another. Again, if you can't deliver in a format the client wants, you won't get many opportunities to shoot, and your clients won't buy much.

3. PHOTOGRAPHY IS YOUR BUSINESS

Act like an artist around creative people, amateurs, and potential lovers. Take care of business with clients, bankers and auditors.

Being a professional photographer is a way of life. The hotshots of our business, such as Jay Maisel, David Burnett, and Eddie Adams, aren't thought of as just photographers. When someone mentions one of these names, we can't separate the person from their images and their reputation.

A professional photographer isn't so much what you are, but who you are.

That's your goal: to have people immediately associate the type of photography you make with your name. It's a difficult but attainable goal, one that requires *living* photography, not just being a photographer.

■ PROFESSIONAL PHOTOGRAPHY

A photographer friend once told me about a potential client asking why the rates for shooting simple subjects are so high. More specifically, he wanted to know why his company should pay so much for a photo shoot. He showed the prospective shooter some prints shot by a niece, who had taken photography in college. They were nice scenics, flower close-ups, and shots of couples gazing at each other and the camera. He suggested a lot of time and money could be saved by hiring his niece. This photographer, having done his research, pulled out copies of the last catalog and annual report the company had produced. The publications contained complicated photo and lighting situations. Does your niece have the expe-

rience and equipment to deliver similar images? he asked. The answer, of course, was no.

The real difference between a professional and amateur, or even a beginning professional, is their ability to take care of business. Among other things, this means understanding the client's needs, budget, time frame, and creative opportunities. Seasoned professionals become seasoned because they always bring home the bacon. This means producing images that make the client happy. Top-selling professionals dedicate themselves to completing assignments that satisfy both their clients and themselves.

Making Big Bucks in photography means living the business.

If you are a professional photographer, act like one. Dress and behave in the businesslike manner that the client expects from his fellow employees. Act like an artist when someone wants to talk about creative photographs and dramatic lighting. Try to determine the client's immediate goal and take care of the business at hand. If you are successful—and expensive—clients may still show their relatives' photos, but they will be asking for a few pointers.

■ LOOK LIKE YOU BELONG

One of my best clients, a major hotel chain, used my work the first time for one primary reason—the way I dressed. I received a call from their marketing director one morning, asking if I could immediately shoot an office situation with their corporate chairman. By the way, she said, would I wear a jacket and tie? After I had made the shots,

the client took me aside and said that a popular local photographer had been hired to do the shoot. Seems he showed up in a T-shirt, jeans, and tennis shoes. They asked him to leave.

Remember that you make photography for a living and must to some extent conform to the desires of those paying for your work. Being creative should complement shooting what they want and dressing in a manner that will be met with approval. New York photographer Greg Heisler is known for his interesting suits, ties, and hats. He dresses creatively, one client pointed out, not like a slob who just thinks he's creative. A fine line, perhaps, but you must know where the line is drawn. Heisler, by the way, has a reputation for delivering creative images that fill his clients' needs.

The Great Hawaiian Aloha Shirt Screw-up. Early in my career, during a location shoot in Hawaii, I managed to get portfolio interviews with both Aloha Airlines and Hawaiian Airlines. Putting on my best three-piece suit, I ventured into the Aloha Airlines executive offices for the meeting. Sitting around the conference table were the vice presidents of marketing, advertising, and public relations—all in bright aloha shirts. The meeting went fine, but everyone kept asking if this was my first visit to Hawaii.

Afterward, I went out and bought the brightest Thomas Magnum aloha shirt in Waikiki, and headed for Hawaiian Airlines. The executives sitting around their conference table were all dressed in dark three-piece suits. Fortunately, no one asked if this was my first visit to Hawaii. The moral is obvious: Check out your potential clients before venturing onto their turf. You might also want to know that today, I'm known for wearing flammable aloha shirts. Go figure.

The Client Image. Your clients maintain a certain image of themselves and their business. They have goals that can usually be seen in visiting their offices or reading their consumer materials. Your job is to know about their image, in advance, and to help perpetuate it at all times.

If you want to do corporate annual report work, be prepared to fit in with Madison Avenue advertising people and Wall Street business types. These people take themselves very seriously, probably because they are dealing with very serious amounts of money. If you want a share in this money, look as if you don't need it. Look like your client. These people don't much care for artists or street people, unless or until you turn out to be an important and profitable part of their business. Their emphasis will be on profit.

If you're dealing with computer programmers, editors, art directors, and designers, then go ahead and be creative. These people appreciate individuality and imagination. They don't like fitting into other people's molds any more than you do. Just make sure your creativity is clean.

Your image must be adjustable to every situation.

If the client's receptionist calls the police when you arrive, take a look at yourself in the mirror. Potential clients will evaluate you during the first minute of contact. Watch what you say and anticipate what they see. Do this by putting yourself in the client's shoes and looking across the desk at yourself. Would you do business with yourself?

Positioning. Those who are seeking the big jobs—and the Big Bucks—position themselves with potential clients long before making any face-to-face contact. This is done by third-party introductions, letters from happy clients, or by sending a letter of introduction yourself.

Go to a meeting armed with knowledge about the products, corporate affairs, people, and business goals of the company with which you wish to do business. Check out their public relations department: ask for annual reports, company history, and executive bios. These people love to give out this information, as does the local library, newspaper, and Better Business Bureau.

Prospective clients should be on your regular mailing list. They should get your informational flyers, copies of news articles on your services, and tear sheets that relate to work they might desire. Make them think you are somebody before making an appointment. Also have a specific proposal in mind before you reach their office.

Arrive five minutes early for every appointment. This is being a professional and will improve your image.

In your clients' eyes, your standing in the photographic community is generally determined by such things as trade publications, advertisements, flyers, mailings, and non-photographic accomplishments. In other words, the most popular photographers aren't necessarily the best shooters. However, they are the best promoters. Simply put, they have positioned themselves in the best possible light within their respective markets.

■ THE BUSINESS PLAN

A good way to keep on the professional track is to establish and follow basic business goals. The real world calls these goals a business plan and you should have one, as well. For the most part, this means writing down and evaluating your assets, capabilities, clients, and realistic hopes for their use, growth, and profit.

This is something that you do at the start of a new business, again in a yearly review, and at five-year intervals in an established business. Start by asking yourself how things are going and how you would like to see them in the next yearly review.

I've provided some suggested business plan outlines for photographers in chapter 6.

■ THE BUSINESS PROCESS

The photography business is comprised of a number of unchanging processes. The good news is, because these basic elements seldom change, you have the opportunity to practice and perfect each step. This will allow you to isolate areas that require the most attention and deliver the most profit and satisfaction.

A list of these requirements and a close-up look at each follows.

✓Selling	✓Bidding	✓Invoicing
✓Showing	✓Negotiating	✓Collecting
✓Proposing	✓Producing	✓Following up
✓Estimating	✓Delivering	

Selling. Selling is the showing of your work and making proposals or bids; it opens the door for negotiation. Selling is everything in the business of photography. It is the factor that allows you to shoot and eat. Selling is the foundation of making Big Bucks in any business.

Showing. Showing your work to potential buyers is one of the most basic and important steps in the selling process. These potential clients will determine your capabilities and desirability as a photographer. Don't waste a lot of time showing portfolios to other photographers (who won't ever buy your services). Show to your group of business advisors, who may know potential buyers themselves.

Proposing. Proposing is generally done in answer to requests from clients. It differs from bidding in that you can include shooting and marketing ideas. Unsolicited proposals require some knowledge of the client's needs and markets, in addition to presenting an unusual approach to a project. Few clients will respond to unsolicited proposals.

Estimating. Estimating is your educated opinion of the general range of what the basics should cost for a given project. The client is asking for your professional generalization of potential costs, which they know may change in practice. Estimates should include several options and variables. Give them a variety of things to consider, and a range of acceptable prices for each stage. There's no reason to be exact in these estimates, unless the client wishes to have you make a hard price quote. An estimate is usually requested by a regular client who is happy with your past work and intends to award this job to you.

There is a vast difference between estimates and quotes. Make sure you know exactly which one you are being asked to provide.

Having the opportunity to estimate or bid on a photo project means you're in the right place at the right time. It doesn't mean you're in the running.

The marketing business has focused its attention on the bottom line in the past few years. For creative suppliers, this has meant a lot less emphasis on talent, ideas, and creativity. What it means is the lowest bid. This is especially true of industrial and government-related organizations, who aren't known much for creativity. Governmental related organizations generally make sure artistic suppliers are anything but artistic. In dealing with these places, have an attorney read the fine print before you sign anything. Forget about getting paid in thirty days; this just isn't in the cards.

Bidding. Your bid is your quote, or guarantee, to complete a project at a certain rate, usually following a client's specific requirements. I'm sure you know how many photographers it takes to complete the average job. Fifty. I know it only takes one to do the job, but forty-nine are there to tell your client that they could have done it cheaper and better. This is the mentality of bidding against unknown factors.

The biggest potential problem with bidding is the insider. This is a photographer who knows the real budget and may already be the buyer's choice. Often, this person will have the chance to see the other bids before submitting their own. In these cases, all the other bids are to satisfy management or regulations. This is called wasting your time, unless you're the insider. Insiders are not uncommon in the larger commercial and government jobs. Being the insider is, on the other hand, a very nice position to occupy.

The best creative managers aren't looking for the lowest bid. They know from experience you get what

you pay for. However, creative professionals request bids, rather than estimates, for several other reasons. They want to see if their stable of photographers have been taking care of business, treating each project fairly, and are in line with photo buyers' expectations. The bid process also allows these people to take a look at previously unknown photographers. This is your chance to shine.

Most photographers fear talking about money almost as much as they fear making sales calls. Buyers have the ability to smell this fear and may use the bidding process to weed out the chickens, cut bud-gets, and keep themselves in the driver's seat. Settle financial matters early in your project discussions.

Your Bid Package. Keep a generic bid, proposal, and estimate package available in your computer. Only a few specifics—including the client, shooting requirements, and budget—need to be added to the basic draft for each new project.

Your proposal should be short and to the point. It must contain a brief description of the project, the client's use rights, a shooting schedule, estimated expenses, and your fee. You should preface bids with a cover letter that approximates the following letter.

Dear Potential Client:

I am pleased to enclose my proposal [never say bid] *to produce photography for so-and-so company. Thank you for giving me the opportunity to present this information. Should there be any areas that need clarification or revisions you deem necessary to make the proposal acceptable, please feel free to call. I look forward to working with your company.*

Sincerely Yours,
Photographer So-and-So

Your basic proposal outline should contain information on the project, its scope, the client application, and copyright and usage allowances, as well as outlining project activities, budget, fees, and expenses (with markups). Use the opportunity to discuss your work and include carefully chosen samples as well.

The Project. Briefly outline your interpretation of the project. For example: *Research, plan, and produce photography for a product catalog suitable for all existing Widget Company markets.* This is the place to be creative. You are proposing top quality photography

that will reflect the reputation for excellence and service that has been established by the company.

Scope. This is the place to outline your technical response to the shoot list and related requirements presented by the photo buyer. Your list might contain specific requirements in studio setups, location portraits, and generic workforce images.

Application. Spell out the exact purpose for the photography. At a later date you may refer to this application in selling additional uses and photo sessions.

Copyright and Use. Outline the exact rights your client is purchasing from your photography. Do it in writing and list it shot by shot if necessary. Don't use legal terms. For example, you might say that the Widget Company will receive unlimited national print advertising copyrights to the photography produced on this project for one year, described as follows. Always say that additional rights, including electronic reproduction of the same materials and layered multiple image creations, are available and negotiable. It's also a good idea, with the proliferation of photo manipulation programs, to prohibit any alteration or major change in your original image without specific written permission. Be prepared to answer with rates, rights, and reasons when they ask about these additional requirements. There is additional information on the subject of rights in chapter 7.

Never Say Never. Some clients will ask for everything, which means all rights to all photography and their use of it in any manner they see fit. See if they really mean *everything*. They may want to make sure the images aren't used against them in competitive markets. They may need unlimited use. They may pay handsomely for all these rights. If you interrupt and say never, they may decide then and there never to work with you. Be careful of making generic statements in the area of rights and uses. While this may be popular with many photographers, each job negotiation is different. Again, keep an open mind to all of their proposals.

Project Outline. This is the place to mention and suggest your approach to the photography. Talk about shooting opportunities, production planning, and allowing time for making spontaneous images. Let them know there are several ways to shoot a widget, and that you'll be giving them something new and exciting to see.

The Budget (Your Quote). This is your offer, estimate, or quote (say which it represents), and it will be examined with great care. The projected budget should cover specifics such as photo fees, materials,

processing, models, assistants, transportation, and so on. (Use the estimate guide provided in the forms section of this book. Some clients will let you know how specific costing must be, others will leave it open. Use your best judgment. Err on the generic side; you can always get more specific in the negotiation stage. No matter what your bid includes, there will always be some additional questions and negotiations.)

Include a paragraph that covers variables such as weather, model no-shows, acts of nature, fires, and whatever else could spoil a shoot, as well as who and how much must be covered. Be conservative and be reasonable with these variables, as clients will zero in on them as negotiation points. Remember, you have to live with, and profit from, the figures in this budget. Go over everything several times with a calculator.

Payment of Fees and Expenses. Let the client know up front how and when you expect payment. Specify that "Payment to Jane Photographer is expected for all estimated expenses and one-half the photo fees thirty days prior to shooting date. The balance will be paid upon delivery of the images, at which time an exact accounting of costs will be provided. Any adjustments of costs will also be settled at that time."

Mark Up of Expenses. Most businesses mark up materials and other items directly related to a project. Photographers, for some reason, don't always do this. Mark up anything you must spend your own money to purchase and any unusual items that take your production time to procure. I add a small markup to film and processing, which covers the cost of captioning, sleeving, and time spent with processing managers. It's a simple matter for prospective clients to find out that a roll of film doesn't cost $50, so don't try to slip in outrageous markups. That tactic may be the reason you are eliminated from the bidding process. Be reasonable in the submission and recovery of your expenses. This will be appreciated by all clients.

Your Photography. This is the place to tell clients about yourself, your work, and your other clients. Don't make the presentation look like a college résumé. A short paragraph on your photography and recent clients will suffice. State that references are available.

Always advise prospective clients of other places your work can be viewed. This might be an exhibition, website, or a well-known client's annual report.

Samples. Show a few samples, dupe slides, or tear sheets that will encourage the client to select you for the job. Send only your very best images and limit the number of samples to five or six.

Winning Bids and Proposals. Bidding should be considered a positive opportunity in business. Once you've discussed or read the client's basic needs, the first step is to decide whether or not you can handle the job. Don't bid unless you're capable, interested, and willing to complete the project and can do so at a profit. Always let a bid requester know if you are unable to participate.

In every bidding process there is usually one golden opportunity to talk with the person who makes the final decision. Use this chance to cover both the project and your personal involvement. For example, you might point out that this is an assignment you are particularly interested in completing, and will therefore offer a better than normal bid. Make the whole process into a sales call. Let the client know that, whoever receives the bid, you're going to be on hand for future bids, and that you appreciate the opportunity and prospect of working for them.

I suggest providing a complete proposal as your bid. This means covering all the client's requirements in an organized and businesslike approach. Your competition may only respond with a simple letter and a basic budget. Make your business approach look just as professional as the client's.

Negotiating. Negotiating directly determines how much you charge for your product and services. When you get down to the stage of negotiation, don't flinch or even blink. Otherwise, you'll be working for little bucks and big headaches. Try something most salespeople and photographers don't do. Listen to everything the client is saying, not just an element in the proposal that excites you.

Talk about and settle financial matters as early in this process as possible. Keep in mind that your potential clients talk about money in just about every facet of their business. They will want to know the basic costs just as quickly as you'll want their okay to do an assignment. Don't let finances be the only area of a project open to negotiation. While money is important, your use rights, stock opportunities, future work, job satisfaction, and profit margin should also factor into possible negotiations.

Successful people (which, you must assume, includes your clients) consider the art of negotiation to be one of the basic aspects of business. An experienced businessperson can determine the cost of an average project based on the cost of past projects and will also know how much room there is for leeway. Make sure you do this, too, and are ready with an intelligent rundown on costs, image market values, and proposals.

In the negotiating process, always give the other person a chance to talk numbers and commit themselves first. The figure they have in mind might be very interesting. It might be substantially higher than the one you were about to suggest. If this isn't the case, simply state your estimate of expenses, time, and a range of fees to complete the assignment and meet the client's needs.

If you are talking numbers, rather than making a written presentation, start with a high estimate. It's much easier for a price to be negotiated down by a client than up by you. Few photographers are sure enough of their position that they can look a client in the eye and talk serious money. Most buyers know they are in the driver's seat and are more than willing to let you talk yourself down a bit. Don't do it just to get a job. At this point, the buyer will be watching, listening, and waiting to see how low you are willing to go. Look them in the eye the entire time and ask for the world, then let them negotiate you down a bit.

If a potential client seems happy with the general direction of negotiations, use the classic salesperson's approach and *ask for the job*. This means saying, "It sounds as though we can make this project work together. Are you ready to set a shooting date?" If the potential client says "Yes," they are no longer a potential client. Set the date. Say you'll drop a simple confirmation letter in the mail, along with any other particulars needed to secure the assignment.

Your client's needs are generally to increase business, show a profit, and look good to customers. And not always in that order. Your sales goal is to get the job, of course, and meet all of the client's needs. Their objective in a photo project isn't always predicated on bottom-line costs, so much as meeting a certain marketing goal. Listen to their expectations before jumping into the discussion, or to a conclusion.

Your clients are businesspeople. They will respect your ability to understand the basic business process. They will enjoy your ability to negotiate a good deal for both sides. They will not appreciate getting screwed. They will, however, appreciate screwing you. And that is the way of the business world.

The Confirmation. Once you've been awarded a job, get something down on paper to confirm things. Verbal job okays are fine, as long as you've been doing business with the client for a while and have established a mutual trust and understanding. Currently, the business world is litigation crazy, and that means the prospect of lawsuits in every project. Both you and the client should know exactly what is expected of each other. Letters of confirmation and letters of agreement are the best way to approach an assignment, because they spell things out specifically.

Ask for a company purchase order. This will tell you what the client expects to receive and pay for the project. Purchase orders tend to be like photographers' delivery memos. There is so much fine print that the original intent can be lost. If there are any problems with purchase order fine print, especially something that is contrary to your understanding of the agreement, scratch it out and make a notation. The client will get back to you immediately if this isn't acceptable. More likely, the client's accountant will be calling to say, "This is the way we do business with all photographers. We can't issue a check if you make changes in the purchase order." The best reply is that you have an agreement with the client that is contrary to the PO's fine print. If that isn't acceptable to the accountant, suggest that they contact the person who signed your agreement. Otherwise, you may have to initiate a new agreement through another negotiation with your client. Remember that you already have an agreement in principal, and that a signed contract will generally carry a greater weight should it ever come to a legal dispute.

Your general organization and planning will determine future opportunities.

Many of the things you do and the people you meet during the negotiation stage of a photo project will never involve images. Their entire impression of you will be the business process and the initial impression you make. Make sure it's a good and business-like impression.

Pre-Shoot. Immediately define the client's goals and uses of your images. No matter what the original project outline, there will be changes before shooting begins. If the client has potential future uses, additional products, changes in marketing, changes in people, and the like, you need to know.

Define responsibilities for creative and financial approvals and how to handle any changes of time and production costs. Follow up all changes in the project in your progress reports. This is your pass-the-buck protection against any finger pointing as to who did what to whom.

Present a schedule of proposed shooting dates and times, if they don't have one already. Include an information sheet that lists every person involved in the shoot, their phone and fax numbers, e-mail addresses,

social security numbers, and notation showing who they work for and who pays each one. This pre-shoot memo should cover and include copies of things such as model releases, insurance coverage, deadlines, props, and location requirements. It should also list your telephone and fax number as well as an e-mail address where you can be reached at all times.

Proposed shooting layouts should be distributed to all participants early. Your production people, models, transportation and office schedules—not to mention other shooting schedules—must be considered in pre-shoot plans.

Administrative checklists are the easiest method of keeping track of shooting schedules, props, people, and locations. This is your responsibility.

I use job envelopes—one for each project—to keep receipts, client documents, and related paperwork in one place. A simple ledger sheet is attached to the outside. Each expense is entered on it, along with the date and description, before the receipt is enclosed. A unique job number is given to each project and is written on everything associated with the shoot. In the confusing business of doing several projects at one time, this system has proved to be a real time-saver in finding important paperwork.

Successful photographers have two things in common: They are flexible and they get things done.

Variables. Model no-shows, bad weather, product failure, union objections, earthquakes, floods, bankruptcy, even deaths and births, all have the potential of happening during your shooting project. The preplanning and on-site reaction will determine your client confidence and future work.

One of Mexico's most famous resorts called me for an over-the-phone shooting estimate. As a result, they hired me to do a four-day shoot that included two top models. Interestingly, they had been using a famous shooter for several years and there was no negotiation on my rates. After a wonderful shoot, I pointedly asked the resort manager why he selected me. Weather, was his answer. Seems his last project had been beset with several days of bad weather. As a result, the famous shooter sat around and did nothing for ten days, left without shooting a single shot, and invoiced them for ten days at his full rate. The client said my proposal required an extra day for potential weather at no charge. If the weather was good, we took off or shot a little stock and the resort covered basic expenses. In our phone conversation, he had

asked what would happen if the weather stoppage went on for more than an extra day. I suggested that our photo team would attempt to set up a few interior shots. If that wasn't possible, we'd give the bad weather two days at most. "How much would all this cost?" the client asked. "How about a day's pay and expenses?" This reasonable response has resulted in additional shoots with other resorts in the company's chain. And there hasn't been a bad day of weather, either.

Good planning, memos, and proposals should cover the unlikely possibility of shooting interruptions. Include extra days and basic expenses for variables that relate to your client and the project. Be conservative, businesslike and, above all, reasonable. Keep in mind that you already have the job. The client is happy with everything else. Don't be so demanding that it might cost you future work.

Producing. Producing exciting images is the basis of, and the supposed reason for, your being in this crazy business in the first place.

This book isn't about the production of exciting images, however; it's about producing exciting profits. Tell that potential lover, off-the-wall art director, or amateur photo buff that you're in it for the creativity. "I'm making photographs as an artistic statement." We know this won't count for much with the landlord, processing lab's accountant, or that fine restaurant in Little Italy. These people want cash, which leads to the next step in the process of photography.

Never Kick Inanimate Objects. Never, never get mad at your client, the client's employees, your photo team, your equipment, or kick a cement wall in sneakers. Let the client blow up at employees. Let the models grumble about the hours. Let your assistant kick the wall. Pound a grape with a hammer and see what your finger could look like if you got mad enough to hit it. You can always get another grape.

Client confidence is gained by taking care of every situation. Anyone can get nasty, get mad, and get even. The photographer who gets the job done, while keeping everyone happy, gets the next assignment.

I have had the pleasure of watching several of the world's best shooters in action, thanks to being part of a few of the Day in a Life book projects. These shooters can get anyone to do anything. No matter how bad a situation, they can make frosting out of cow chips and feed it to the most difficult editor or client. This is undoubtedly one of the reasons these shooters have such good reputations. That should be your goal in every project.

Delivering. Delivering your photography should be done as professionally as the rest of the job. Package your work as though it's something valuable and important to both you and your client—which it is. Every image should have complete captions, release information, your name, and a copyright symbol. Images should be sleeved in new view sheets with an attached delivery memo. The entire package should be backed with cardboard and enclosed in a strong, secure, well-sealed mailing container. I always ship by registered mail or an air express service, which requires the recipient's signature. This gives me a name should something go astray. Your clients will appreciate the efforts you take to protect a valuable sales tool (your photography).

During the planning day on a major international resort shoot, the project manager offered to show me the previous photographer's efforts. Opening a file cabinet, he said it would take a little time to sort through. In the cabinet were about seventy-five lab boxes of slides. Not a single box or slide had any information—not even the photographer's name. The shoot was done, processed, and sent directly to the client from the processing lab. The manager said the shoot was pretty bad, because he saw everything. That means bracketed exposures, test shots, and bad shots never meant for the client's eyes. He simply gave up trying to edit the shoot and called me to start all over again. Thank you very much. In looking through the images I saw some nice work, all done by a noted New York shooter. The manager was impressed with my return package and, needless to say, recommends me to other resorts.

$ Photographers are known for what they show, not what they shoot. Show only your very best work.

Bad Photos. There is a variable most of us do not even want to think about—and that's bad photos. What do you tell the client if, for any reason, every shot is a bummer? Ruined for one reason or another. Immediately let the client know that there won't be any images. Don't sleep on it or get blasted on airplane glue. Just make the call. The client won't be happy, but may be able to reschedule another shoot, which you offer to do free. Or, in some cases, the shots may be saved by computer manipulation, and you can offer to pay the costs. Remember that you provide a service that will be remembered beyond quality and price. How you handle the rare mishap will determine the degree of client loyalty.

Obviously, the good photographer will be using more than one camera to back up shootings. But once you say that something will never happen in this business, get ready for that exact thing to occur on your next shoot. The smart shooter will make sure a client doesn't see any bracketing or other low-quality images from a shoot. Never give anyone the opportunity to see images that put you in a position of explaining.

Invoicing. Invoicing the project as quickly as possible is simply taking care of business and meeting deadlines. The sooner your invoice is received, the sooner it will be in the client's accounting and payment process. Your invoice should state the rights that are being purchased and that they transfer only upon payment.

Collecting. Collecting the final payment for a job may include some additional negotiation with the client's accountant. If you've asked the client to cover basic estimated expenses up front and a portion of the photo fee, collection will not be a desperate effort. Up-front money is a must if it's your first job together. Any client who refuses up-front money will likely be a collection problem. Try not to play the bank by loaning a client money, at no interest, to do their job.

Collecting from slow, bad, and nonpaying organizations is a financial art. Your CPA and business advisors may provide some hints in this area. Keep in mind that you may wish to do future business with this client, which they know, so don't send Bruno the Enforcer to their offices to make collections.

In attempting collections, simply make a reasonable call to their accountant and try to work things out. If this doesn't pay off, try a reasonable letter with a second-notice invoice that has a service charge added. My invoice fine print says there will be a monthly re-billing charge after thirty days. After about forty-five days, and a call to the client's accountant, I send a second invoice with the re-billing charge added.

The big agencies generally work on their suppliers' money, some taking three months to pay an invoice. You can bet they have already invoiced and collected from the client, putting the money in a thirty-day money market fund. They may feel that your service charge is quite a bit less than the interest they can make with a certificate of deposit. These people are interested in making money, too, and this is a pretty interesting way. What photographer wants to quit the big agency, Big Bucks scene? This is a good reason to request cash up front for expenses and partial fees.

If all of your reasonable attempts to collect on invoices fail, it's time to take more serious legal action.

One of the best methods of taking action, which really is no action at all, is to write your lawyer and instruct that legal action be taken in ten days. Sending a copy of this letter to the client tells them that you're getting serious and they still have a few days to pay the invoice. Most of the time this letter is all the action that's required. Of course, the nonpaying client may call your bluff, at which time you should read chapter 7.

Following Up. Following up the job with a simple thank-you letter may be the only reason you get another opportunity to repeat the whole business process. Following up is certainly less expensive, in both time and money, than starting all over again with a whole new selling and proposal process. Saying thanks for the opportunity to work with the client is the least you should be doing.

Following up also means checking to see that your client's mailing list entry is correct, for future marketing. The last thing you should do is clean up the shooting file and combine it with your regular client file. This means organizing model releases and other documents that may be needed later.

Profit and Taxes. Are you making a profit on every job? Can you financially break out each part of the job? Profit is measured by: money; satisfaction; reputation gained through the extension of credit lines; portfolio tear sheets; and client introductions. Try to cover all of these in your profit search.

What is your tax situation at the completion of each job? Have you made too much money, but not enough profit? Can you run a quick profit-and-loss statement? How is the cash flow, compared with the estimated taxes? Both profit and taxes are discussed, in greater detail, in chapter 8.

Your Retirement. Someday you may wish to retire. I love my work so much that retirement isn't even a consideration. But if that's your eventual goal, start planning today. Stick 10 percent of every check into a safe place for that retirement. Put it in stocks, bonds, money funds, certificates of deposit, savings, insurance, silver bars, old Chevys, stock images, or a sock under the mattress. Also believe that no matter how tight things are, saving for retirement is easier at age twenty-five than sixty—or so I've been told by the experts.

4. ADMINISTRATION SHOULD BE AN ART

It ain't over until the paperwork is done.

No matter how good you are at photography and marketing, if you overlook basic business practices, failure will rear its ugly head. A few years back, an international photo-oriented magazine assigned an Alaskan photographer to shoot an editorial feature. The prospective article was important enough for the magazine to send an editor and writer to Anchorage for the project. It was a dream-come-true assignment for the photographer, who had been sending images and ideas to the magazine's photo editor for nearly two years. On the day shooting was to begin, everything was in place, including a float plane, a remote cabin, a guide, and enough food for two weeks on location. Everything was there but the photographer. He never showed.

There is more to photography than the ability to make and sell great images. You must administer those images into a profit. In other words, take care of business.

In less than two hours, another photographer was hired, and the group took off for Alaska's wilderness. The original photographer said he had forgotten about the assignment. The magazine, however, hasn't forgotten him. They will forget him when the time comes for future assignments.

Was this photographer just a flake? No. He was, and still is, a very talented shooter. So what went wrong? How could he forget such an important assignment? Obviously, he didn't take care of business and probably doesn't even know the elements of good business. He certainly hasn't much chance

of making Big Bucks as a photographer unless some drastic changes are made in his professional attitude. Okay, so I happen to think such an incident qualifies that photographer to be called a flake. Don't let the same thing happen to you.

While most photographers will never forget assignments, it's not uncommon for them to show up late, dressed poorly and unprofessionally and, believe it or not, many forget to invoice the client for all the expenses of a job.

■ THE BASICS OF GOOD BUSINESS

Good business administration has been the subject of countless books and seminars, not to mention discussions with bankers and IRS auditors. Yet there seems to be a consensus that to be a good photographer means being poor at business. We've even heard photographers themselves claim to know little about the business side of things. What a crock! What a waste of talent!

Good business practice is simply using common sense in making the journey.

Without a doubt, the single most important ingredient of good business is organization. That means regular planning sessions, schedules, files, paperwork, bookkeeping, and taxes—all managed as carefully as you maintain photo equipment. It means making a list of things to do, knowing what needs to be on it, and going down that list item by item. Business success, we all eventually must learn, comes from taking care of the details.

If you want to make Big Bucks in any business, especially photography, it's going to require lots of common sense. Having a masters degree in busi-

ness from Harvard isn't worth much in the real world of freelance photography, where we must combine the skills of an artist, salesperson, business manager, collection agency, and janitor. If, in fact, you do have an MBA, don't waste any more time as a photographer. Start up a stock photo agency. That's where you can shine as an administrator. Then you can sell it to one of the mega agencies and retire.

■ BUSINESS ADVISORS

Hire experienced business advisors for one-on-one counseling. A successful photographer, lawyer, CPA, banker, and insurance agent should be considered as possibilities. Expect to pay them hourly, based on their established rates, for a minimum of one hour per session. If you're short on money for this, the Small Business Administration provides some free help and information. I also highly suggest talking with a professional photography counselor, such as Maria Piscopo (see chapter 13), once a year for the first few years of business.

The best place to begin the search for experienced advisors is at one of the *Photo District News* photo conferences. Attend seminars covering the areas in which you need help. Talk with or drop a note to the people you want as advisors. Some of these people offer regular seminars throughout the country and provide some individual counseling. All of this counseling should be considered before making any seriously expensive business moves.

You should try to meet with advisors that have active business experience of their own, who have learned by taking risks and making mistakes. Don't be put off if these people are reluctant to share such experiences. Think about the time, money, and emotion it cost them to gain that experience. Professional teachers, with no business experience, have only theory or other people's experiences from which to draw.

I happen to think that Maria Piscopo is among the very best business advisors in the photography business. A few hours with her will change the potential success of your business efforts.

■ YOUR BUSINESS IMAGE

Look at any successful business, especially professionals such as CPAs, lawyers, or bookkeepers. They have the look of being in business. So should you. Start with your telephone, stationery, and business address.

Telephone. Our clients expect to find a business phone number listed in all of the proper directories and to have that phone answered in a businesslike manner. Call around to a few professionals, especially your advisors and other photographers, and see how they answer the phone. "Hi," "yeah," "yo," and a simple hello aren't all that unusual for photographers. These greetings are often accompanied by the jarring sound of screaming kids, barking dogs, a blasting stereo, or daytime television soundtracks. Is this any way to run your business? When was the last time your doctor's phone was answered in this way? I wouldn't let a surgeon whose dog helps answer the phone cut me open.

The telephone is often your first point of contact for public relations and sales efforts. Have a business phone number and answer it in a businesslike manner. Never use a personal or home phone as your primary business number. Never let the kids answer the business phone.

Have an answering service or recorder on the telephone if you, or an employee, can't answer promptly. Your message should be short, say ten seconds, and also businesslike. For those who hate these recorders, keep in mind that they are much better than leaving a call unanswered. Please don't say "Leave a message after the beep." Everyone already knows that answering machines beep.

If you're on the phone constantly, making all those sales calls and taking assignments, get a second line. A busy line may not be called back soon, if ever. Today, the phone company offers a host of additional line possibilities such as paying for time used rather than an unlimited line. Call your phone company business representative and get some free advice. Start with AT&T. They invented almost everything.

Stationery and Forms. Correspondence should always be typed or printed on letterhead, which, along with your business cards, should have the correct information, without scribbled notes. It's okay to send a handwritten personal note to a regular client, especially when following up conversations or meetings.

Stationery means: letterhead, business cards, envelopes, and mailing labels that all match and seem to come from a photographer. You may design a logo for these items. Our clients have come to expect this professional business look from their suppliers. In other words, they expect our paperwork and letterhead to resemble something that would come from a real business.

You can get simple logos and stationery design done by most quality print shops. However, it makes more sense to contact an art director or designer you've worked with, or one that's recommended by an

associate, to have something classier produced. Your stationery and forms are an opportunity to show clients that you are both creative and business-oriented.

My own letterhead, checks, notepads, business cards, and related forms have a palm tree logo. In addition to saying exactly who the materials are from, the graphic look portrays the area of photography in which I specialize. Yours should, too.

The Address. New York, Los Angeles, or even Beverly Hills may be good addresses for photographers. Others may disagree. That's not the point. While the location may not matter so much, you need a proper business address for correspondence, invoices, and proposals. Many photographers have a post office box, which allows them to keep the same address while moving about an area. It's possible, although not too practical, to have a Beverly Hills post office box and live in East Los Angeles. The fast pace of photography will necessitate a street address for overnight deliveries and pickups.

Office and Studio Space. You should have a place to administer your photography business—whether it's a studio, small office, warehouse, or spare bedroom in the home. No matter where you've established business, when you're in that place it's for taking care of business, and it should reflect that fact to anyone who enters or calls.

Obviously, the better your office or studio, the better you are going to look to clients. However, less than 25 percent of the average non–studio photographer's clients visit that place of business.

It should be immediately obvious to visitors, when they enter your space, that you are both a photographer and businessperson. It's okay to be funky. It's even expected by art directors. But it's not okay to be dirty or messy. Display samples of your best work and make sure the place looks businesslike. Keep it safe, secure, and clean. Sounds like common sense again.

Office Equipment and Furniture. Keep office machines that can handle twice as much business as you expect for the next three years. This is your planned growth. The right office equipment, used properly, can save time, money, and people power.

A typewriter may have been a necessity for clean and businesslike forms and other paperwork in the past (I still use one for those odd sized and single sheet forms that are required by most bureaucracies), but computers are used to create such forms today.

A calculator with paper tape is another necessity. It's really a simple adding machine that does other functions. You need the paper tape to double-check figures

on bids, taxes, and invoices; otherwise this function could be performed by a computer. An incorrect figure can often make or break the assignment, profit, and tax audit. The IRS especially likes to see well-organized tapes attached to receipts.

The more time you spend on the little things that a calculator and computer or typewriter can provide, the less your clients, bankers, bookkeepers, and tax auditors must spend.

Computers are no longer a luxury. They have replaced the typewriter, file cabinet, telephone, calculator, and fax for many business applications. Computers have become our bookkeepers, secretaries, caption machines, fax machines, salespeople, and post offices. Some photographers also use computers to create images they are otherwise unable to produce. Making Big Bucks and competing with hotshots requires the ability to utilize computers. In fact, computers are so important to our business that I've included a separate chapter on them in this book.

The fax machine is also part of today's daily business routine. The fax provides quick transfer of the written page or other graphics such as Polaroid prints and comps (drawings or sample layouts created for clients) over a telephone line. Photographers use them to bid on jobs, receive stock requests, correspond, make travel reservations, and instantly invoice clients. Our clients use them to confirm assignments, provide comps of prospective shoots, request stock, and send purchase orders. While the telephone must be answered, often to the distraction of meetings and sleep, the fax machine just leaves its message for reading at any convenient time. You can rent fax services from local mailing or office companies.

File cabinets, with room to grow, are inexpensive and are a requirement for every aspect of business. Have separate file drawers for each part of your business. Invoices, clients, expenses, information, suppliers, inventory, mailing lists, and related items should each have their own place and always be in that place. It's called organization.

Your photographic images should be organized and filed by job, subject, location, and related information. Expensive fireproof files for photos are generally a waste of money. While these files prevent paper from burning, they don't always prevent transparencies from baking. Invest in master image duplicates and keep them in a separate location. Protect these valuable items with insurance, too.

Obviously, desks, chairs, and similar office furniture are necessary to conduct business. If you're just start-

ing out, visit the used-furniture mart and save some money. Take a look at the office through your clients' eyes. Make sure things are comfortable, clean, and competitive. Shop around. Don't ignore office equipment needs to buy the latest high-tech Nikon. Make your office efficient and productive first, then buy the new Nikon.

With all this expensive high-tech equipment sitting around your office or studio, there may be those who wish to borrow it without your permission. Install the best monitored burglar and fire alarm that you can afford. This may reduce property insurance and will certainly improve your chances of owning the equipment long enough to pay off bank loans.

■ BUSINESS FORMAT

Talk with a lawyer, accountant, and an experienced independent businessperson before jumping into any business format with both feet and your bank account.

Business format means the legal description or makeup of your business. It can be a corporation, partnership, or sole proprietorship. Starting or changing the format of a business is a legal, and potentially expensive, proposition that shouldn't be entered into lightly.

Most freelance photographers are sole proprietors. This is a designation that usually includes a spouse. This is the easiest way to get started and operate a small independent business. Most of us begin this way.

Partnerships are little more than sole proprietorships with several proprietors. All partners share liability and are thus vulnerable to judgments and other potentially expensive situations, regardless of their percentage of ownership. Little is gained in a partnership that would preclude your consideration of a corporation or sole proprietorship.

A limited liability company is little more than a partnership that reduces the liability of some participants. It's a relatively new type of business format, often used to raise money, create, and sell a single product, such as a movie.

As photo businesses grow, make more money, gain assets, have greater liabilities, hire employees, and seek outside agents and investors, they often elect to become corporations of one type or another. In this format there is some protection against bankruptcy and personal liability, a few tax advantages, and a great deal of real business credibility to be gained. Estate planning, which should be considered as early as possible in your career, is much simpler with a corporation than a sole proprietorship. There are other advantages

of incorporation that are not immediately apparent—including a strong business stance.

Corporate status raises you above the mom-and-pop image. It requires certain records and official meetings, which means paying more attention to administration. Because of these requirements, a corporation is much more attractive to bankers and investors, while being somewhat less attractive to tax auditors. Ownership of a corporation is easier to transfer, through sales of stock, and easier to pass on in estate planning. Even if you are a mom-and-pop operation, both mom and pop can be corporate officers and paid employees. This may allow deductions when both travel on assignments, attend seminars or conventions, and have company-owned equipment.

Stockholders of an S, or sub-chapter S, corporation operate with all the advantages and protection of incorporation, while allowing stockholders, such as a couple, family, or limited number of partners, to claim profits and losses from the business in their own income tax returns. This type of incorporation was provided by Congress just for smaller independent businesses. While this may sound simple, I suggest talking with a CPA, experienced in forming new businesses, well in advance of filing any sub-chapter S paperwork.

There are incorporation packages available at office supply shops and bookstores. Reading and following the suggestions in these programs can be of great value. However, do not start or change the format of your business without sound advice from a lawyer, accountant, and experienced independent businessperson regarding these matters. They may point out that the easiest method is not necessarily the best for your specific situation.

Plan to be in business for a long time.

■ LICENSES

No matter how small, or which business format you have established, *get the proper licenses* before starting a single day's work. All cities and states, not to mention the federal government, have basic requirements for tax registration, licenses, permits, etc. Most of these bureaucracies will provide you with some sort of a "Getting Started in Business" booklet. Read it and discuss the requirements with the same people who help you plan a business format. Don't overlook these forms, permits, and registrations, as our local and national governments have plenty of time and opportunity to levy penalties for such oversights.

Of course, all of this paperwork can also bring the bureaucrats around for inspections, audits, and little hidden costs that keep them in business, too. These people have a job to do and are usually more than happy to help you help them do the job properly. When you have any questions, call and ask. Fear of forms and the people who send forms is a serious problem with independent businesspeople. Overcome this fear, and you will glide through the problems that cause administrative nightmares.

■ RECORDS

What are the first things tax auditors want to see? Receipts and canceled checks. What are the first things bank loan officers want to see? Profit-and-loss records, financial statements, and tax returns. Everyone you do business with will eventually ask you to provide some type of records. The better you are at establishing, filing, and providing records, the easier things are going to be for all aspects of your business.

Accurate and complete record keeping is the heart of successful business administration.

The Record Keeping System. Start a good system for information gathering and filing. Have a separate file folder for every type of expense you incur or expect. Keep an individual file for every client. Be sure to list pertinent phone numbers, addresses, names of personnel, the type of business, and related information in your active client file. File every estimate, assignment, submission, and invoice. File copies of tear sheets, annual reports, and news clippings. All of this information should be examined and updated as you progress with a client. Knowledge is power, and record keeping begets knowledge.

Stock photography has its own set of records and forms, which are covered in chapter 12.

Forms. Business is a battle of forms, and there is a form for everything. I've included several examples in the forms section of this book. The professional photography organizations have good generic forms available to their members and for sale. Just make sure you have all the necessary ones to conduct business. Keep them as simple and readable as possible. Ask your business advisors to examine all your forms and paperwork. If they have problems understanding anything, so will your clients.

Your basic form needs will probably include estimates, invoices, location expenses, cash expenses, model and property releases, checklists, and delivery receipts. File copies of completed forms in the appropriate expense, client, or information file.

Bookkeeping. Most record keeping is simply financial accounting for expenses and income. Our bankers and auditors want to see where the money comes from, where it went, and reasoning as to why it went there. *Accountability* is what they call all of this financial record keeping.

New and small businesses generally keep their own records. Few of these people have had any experience in bookkeeping, and this is no place to scrimp. Get educated about the basics of bookkeeping. City college night programs can help.

If you are unable to do the books, hire the services of an experienced bookkeeper or CPA firm from the very start. Let this person evaluate your needs, set up a basic accounting program, and make frequent visits to update it. This person can assist with budgets, loan applications, licenses, federal employee requirements, your social security and retirement, and train you to do some of this work. This isn't an expensive service. It's something you will need as your business grows.

CPAs and computers can play an important part in your record keeping and accounting. Because of their role in our business, chapter 5 has been devoted to computers, while chapter 8 covers CPAs and taxes.

Banking. Find a good bank and start a business account. A banker will help advise you on loans, lines of credit, and ways to structure financial transactions. Good bankers seem to be as rare as doctors who make house calls, so seek referrals from your advisors.

The bigger your jobs, the more immediate your needs. A line of credit is just a revolving loan that starts when you write a check. Set this up when you don't need the money. If you wait until a job starts, it will be much more difficult and time-consuming to establish. Because lines of credit are just like and as difficult as business loans, you might want to start your own with a simple savings account and low-interest credit card. A credit card is a good way to get your hands on a few thousand dollars quickly. While credit cards may be easy to get into, they can also be the source of financial problems. Pay off the total balance due every month, and they are great short-term free loans. Pay an interest fee each month and they can become the most expensive loans available.

Several airlines offer their own credit cards through sponsoring banks. With every purchase you make using their credit card, you also get mileage credited in frequent-flier programs. This is a good way to fly free in the future. Make sure you get in a program that

allows your mileage to grow forever. Some of them have miles that expire. Alaska Airlines offers one of the best frequent-flier programs around.

My accounting system revolves around a bank account. A check is written for every possible expense and all income is deposited. This provides a good solid account of transactions. Every check should be immediately noted under a budget deduction. See suggested listings in the budget section of this chapter. A business credit card (the annual fee is deductible) is the next best method of payment. It will provide a good financial record.

Paying expenses in cash is the poorest method of doing business. However, at times it may be the only method possible. Keep a written record of any cash expense, be it taxi, luggage porter, photo fee, etc. Basic expense accounting forms are provided in the section on forms, which starts on page 119.

Financial File/Check Systems. When you write a check for a deductible expense and make the entry in your accounting system, also write the check number and date on the receipt. Drop this receipt into the file that represents its deduction category. Do this with every returned check, as well. At the end of the year you will have every deduction category organized, and taxes will be a matter of using the calculator and filling in the forms. You can also immediately find a canceled check and the paid receipt should a question ever arise from the bank or suppliers.

Find, fill out, and file tax registrations before starting a single day of business; otherwise you'll spend Big Bucks.

Taxes. Business advisors can outline basic requirements and necessary forms, as can the local Better Business Bureau, Small Business Administration, and city, state, and federal revenue agencies. Ask for a listing of basic start-up requirements from everyone. Some of these organizations provide free basic business tax guides. All of these organizations provide liberal help with questions.

Start an individual file folder for every single registration and department with which you have contact. Put copies of all paperwork in their respective files. For example, your city business license file should contain everything between you and the city. This way, you can pull out the file for auditors and advisors who may have detailed questions, or who may have lost the originals. Never attempt to answer detailed questions without a quick review of the related file.

Keep copies of everything related to taxes—and everything else for that matter. This means deductible expenses, which include those you have billed to a client job. You can't be too fanatical about anything related to taxes. The better organized your business tax records, the less potential for problems. The IRS, bankers, and related record readers are usually willing to bend a little on gray areas as long as you have well-organized records. Keep everything in an old shoe box until tax season and you will pay the consequences. Record reading people have the time, patience, and person-power to closely examine every receipt in every shoe box.

Inventory and Insurance. Your inventory of business equipment and of stock images is very valuable and must be accounted for in records and administration. Such assets should be listed in a master inventory. Start with a complete description of the item, serial number, purchase price (include tax but not freight) or market value, and any special characteristic (such as being custom-fitted). Put a copy of the master list with insurance papers. An example of such a form follows.

EQUIPMENT INVENTORY	
Item—*Camera*	Description—*35mm*
Make—*Nikon*	Color—*Black*
Model—*F5*	Purchased—*08/03*
Serial #—*1234567*	Value—*$2,500*

Try to keep an inventory listing of your photographic images. This is easiest for current shooting, more difficult with files that were established last year or ten years ago. This inventory definitely requires computerization and constant attention. Some slide-captioning machines, such as those made by Trac Industries, have the ability to assign an individual file number to each slide during the captioning process. You will have a much easier time collecting for major image losses, be it by fire, theft, or mysterious loss while with a client if an inventory and individual number exist.

STOCK IMAGE INVENTORY	
File #—*L-7-101*	Format—*6x17*
Location—*Honolulu*	Released?—*Yes*
Subject—*Surfer*	Value—*$7,000*
Client—*Stock*	

Setting an image value can be tricky. If there is a major loss, you will undoubtedly be required to present some evidence on how the value was determined.

If you haven't been in business long, I suggest using the ASMP $1,500 lifetime image valuation standard. This has been recognized in several legal actions. If you're established, then a lifetime sales potential can be proved in legal contests. This will probably mean showing one-time sales invoices for images similar to those that have been lost.

Insurance. Your images may be of value when it comes to financial statements, loan applications, and insurance programs. Even the most jaded banker or insurance agent will have a heart attack when looking at the value of just ten thousand cataloged images in your file.

When it comes to insurance, try to cover everything possible—that is, everything you cannot afford to lose. Your record keeping here is just a matter of making copies of inventory sheets available to your insurance agent.

Make copies of important insurance documents and the inventories they cover. Carry copies of equipment policies on location shoots, along with your agent's local and national phone numbers. If there's a problem, immediately call your agent or the national hotline, and ask for instructions on your liability and for help to get quick replacement rentals.

There is a detailed section on insurance on page 36.

■ MANAGEMENT

Employees. Making money in this business requires working with and managing people. With all the files and record keeping we've been talking about, sooner or later you're going to need help. Hiring employees, such as assistants and bookkeepers, is an interesting proposition. Certain businesses pay employees just enough to keep them from quitting. On the other hand, certain employees do just enough work to keep from being fired. Therein lies the challenge of effective employee management.

First, you must find and attract quality people to help with your business. Your future employees don't necessarily need experience in the photography business. In fact, this could be a detriment. Don't hire the friend or lover of another photographer, or someone who hopes to become a photographer. They'll just rip off your best ideas and clients along the way.

Some people can manage an office full of people, while others can't manage their own schedules.

Look for someone who has been around a bit. Someone who has experienced several different jobs, perhaps in completely unrelated fields. Someone who has worked with people and someone who understands office work. I call this street smarts. You can easily teach the basics of a photography business to a person like this, and they can teach you a few tricks.

Hire employees on a part-time basis, if possible, at first. See if they can hack the crazy atmosphere of our business and the erratic personalities of photographers. Few spouses or lovers are secure enough in their own identities to survive the big time or the lean times with photographers. This may be due to the commitment we must make to photography.

Be sure to pay your help a reasonable salary. Offer an incentive—say a percentage of stock sales after six months' employment—something that makes them part of the business and not just hired help. Give them leads to contact about potential sales and share some of the goodies for making sales. Add them to your health insurance program.

Don't try to avoid employee paperwork and tax withholding by contracting professional services. While this is an attractive thought, the IRS takes a dim and penalizing view of the practice. If you have a full-time assistant or office manager, then cover both yourself and them with the proper paperwork. Some states require freelancers to be covered for various medical and unemployment benefits. Tax people should be consulted in this important area.

Have weekly planning sessions with everyone connected to your business. Use this time to establish short-term goals, schedules, and assignments. While employees may be dedicated and loyal, few will immediately share your vision. You must constantly sell employees, family, and suppliers, too, on this vision in order to get their complete support.

Outside Services. There are many areas and times when full-time employees aren't necessary or desirable. Good assistants often work for several different photographers.

Managing the area of outside services is easy. Simply hire the best person available, pay them well, and let them share in the project. I have learned a great deal from assistants who are working for my competition. Some photographers choose to boss assistants around, rarely seeking advice or, heaven forbid, letting them shoot something important. Assistants have eyes and brains, too, and these assets should be utilized.

Young and small businesses often find outside services to be more economical, of higher quality, and simply easier than hiring full-time people. You can operate this way for many years. Bookkeeping, accounting,

legal, graphics, computer, secretarial, and just about every other area of business has service organizations. Try these established organizations first, because they will take care of all the employee and tax paperwork that you pay for but don't have to complete.

If you contract any freelance services, there are a few things to keep in mind. Make sure that freelance people have a business license, tax registration, and the trappings of a business. These include a business card, letterhead, invoices and, most important, freelance work with other photographers. Keep copies of their paperwork in the file. The IRS will ask for this support material in an audit.

Managing outside services means having things ready for these people when they show up for work. Keep them busy and challenged. Let them handle some of the hard labor and some of the creative tasks. For example, I take my CPA on an occasional tropical beach shooting project as an extra assistant. He gets to hang around with hot-looking models and shoot a few photos, while I'm paying the basic costs. This has worked wonders for his understanding, not to mention appreciation, of my business.

Never work with anyone you don't like or can't get along with, no matter how good, how cheap, or how well recommended they come. Sooner or later, things will deteriorate into an unworkable and often explosive situation. In these cases, everyone loses.

It's okay to fall in love with someone you work with, someone who has an acute appreciation of your business. That's exactly what I did. My wife, Nancy, is an important part of our business. She is a positive survivor who shares all the highs and lows of this exciting lifestyle. However, not everyone can work with a spouse. In some cases, working together can cause divorce. Try it part-time and remember to set and aim toward the same goals.

Agents and Reps. If you grow and succeed in photography, there will be agents and representatives to manage along the way. In reality, they think they are managing the photographers.

When it comes to these outside associates, work together. Read all of their paperwork and complete the tasks they request. After all, they represent you in the field and in the market. Communicate on a regular basis, equal to the amount of work they do with you and the amount of income they provide. Don't become a bore, and don't become a missing person either. Keep a good file on each one.

Don't work around your outside people. If they are selling your work, let them sell it. Constantly calling to check out their progress is just a waste of time. Let your agent's or rep's track record speak for itself. If they do a good job, keep them doing that job. If they fail, look elsewhere.

A major advertising agency once called my office for stock images and then called my agency for the same photos. After some negotiation over an image, my agency seemed to want more than these people were willing to pay. The ad people told the agency that the photographer would certainly come down in price if they dealt direct. This could have put me on the spot with both the advertising agency and stock agency. Fortunately, my stock agency communicates well with me and did so immediately. I managed to get the stock agency working with the ad agency by making it plain that I wouldn't sell around my agency.

Time Management and Priorities. Seems there was this guy driving down California Highway One, just outside Malibu. He saw a beautiful sunset and stopped along the road to see the view. As he opened the door to get out, a huge eighteen-wheeler came along and took off the BMW's door. The guy was incensed, jumping around and yelling at the truck driver, "You ruined my Beemer! You ruined my Beemer!" The driver looked on for a while and then said, "Boy, your priorities are all mixed up. When my truck took off your door it also cut off your arm." The guy looked shocked and screamed, "My Rolex, you ruined my Rolex!"

Setting priorities is relative to the business and personal goals you establish. Over the years, I have found that the following rules help in the administration of my business tasks:

✓Make a daily list of things to do, organized in order of importance.
✓Do first things first.
✓Do one thing at a time until it's completed.
✓Assign deadlines to all tasks.
✓Delegate as much as possible.
✓Have a hot spot for important things.
✓Have a place for everything.
✓Work on projects in the mornings.
✓Schedule meetings and calls in the afternoons.
✓Plan ahead.
✓Don't worry about things you can't complete.
✓Learn from mistakes.
✓Set weekly, monthly, and ultimate goals.
✓Aim every action toward meeting your goals.
✓Take time for people and things you care about.

Your Schedules. Ideally, business will be so good that it will require a monthly event schedule. Start keeping a daily, weekly, and monthly schedule right now. I use a daily sheet, which is kept in my computer and has a phone log and schedule for each day. I use this to keep track of marketing calls, appointments, shooting expenses, and related items. I keep this information on a regular basis, in order not to forget important items. Both the IRS and courts have accepted my daily logs as accurate records.

■ INSURANCE PLANNING

Small businesses can't always afford to have the insurance coverage that is provided to minimum-wage employees at fast food outlets. Welcome to the real world of freelancing.

Insure everything you cannot afford to lose.

What you need is an experienced business insurance agent. The more this individual knows about your business, the better he or she can advise on insurance. Talk with your advisors and check with some of the major insurance brokers. Also check out the professional photography organizations, which may offer photography-tailored insurance programs to their members.

First consider a basic business insurance package, which includes the important types of coverage you will need. Packages can save you a lot of money and time in searching for specific coverage policies.

You must insure both your office equipment and photographic equipment. Lose this stuff and you may be out of business. Cover the most expensive items and live with the potential loss of smaller stuff.

Health and disability should get the same insurance consideration as equipment. If you're sick or disabled, you're out of business.

Consider some type of umbrella liability insurance. This should provide protection if you're found at fault for an injury to someone on or near a job, for damaging someone's property related to a job, or if someone walks by your property and somehow gets hurt. While you may be in the right, a legal defense could still be very costly. Read the proposed policy carefully and ask your agent if you are covered in every business situation and in every location you anticipate working. Liability insurance is also available for a photo misuse (i.e., use without a release or in an obscene manner) or film lost for any reason. This is more expensive, but it's necessary in some photography specialties.

Property insurance covers your home or office, often including the liability questions just mentioned, and equipment. It can insure important papers, computer software, and loss of income. In some cases it can cover image files, but requires some special attachments to your policy.

I have five hundred thousand stock photos insured under the important papers section of a business policy. They are covered for their material value only of $1 each, with a $2,000 deductible. This means I collect on major losses, such as a fire, for the value of the film, processing and filing but not for market value. The cost is less than $1,000 per year.

Insuring images for today's standard market values, $1,500 to $2,000 each, would be a gigantic expense and such coverage is nearly impossible to find outside of Lloyds of London. Photographers have had trouble proving image lifetime sales value in several courtroom cases. Those who keep good records of past sales, image inventory, delivery memos, material cost, and the like have had the best results in court.

Convincing an insurance investigator that ten thousand images are worth $15 million would undoubtedly mean expensive legal confrontation. Insuring my five hundred thousand images for $1,500 each would be $750 million in potential value. My agent says "Get real." The alternative is insurance for material value, which does not alter market value. It's the same as a painter insuring the value of paint and canvas but not the value of the painting.

Death insurance, which is called life insurance, is necessary if you have business partners or family who must be cared for in the event of your unplanned passing. In the early stages of business, get low-cost life insurance to keep a partner afloat in the event of your death. After five years of business or so, this should be converted to insurance that pays off, or can be borrowed against, if you live.

Make sure your auto insurance covers any business driving, drivers other than yourself who drive for your business, and any car you drive or rent for business purposes. Some auto insurance does not cover car rentals outside the United States. AAA, the American Automobile Association, has some excellent services along these lines.

Production insurance, which covers almost any part of shooting, expenses, materials, and processing, is available through specialty companies. For the record, people in the movie industry use this expensive type of insurance to protect their investment, which is usually in the millions.

■ COMMUNICATION

Good communication always accompanies success. If you don't communicate well with clients, employees, banks, auditors, and suppliers, you will become a lonely businessperson except for visits from the tax and loan collection people.

Most successful businesspeople, even those you purchase services and supplies from, don't always have the time to physically see or talk by telephone to everyone. However, these people will take the time to examine most written, faxed, and e-mailed materials.

Correspondence. As was just mentioned, nearly everyone will read first-class mail. Businesspeople love to get interesting letters and rarely let them sit unopened. However, many of these people hate to write those same letters.

Writing your thoughts and ideas is the easiest way to communicate. You can take all the time you want getting things just right. If it's well presented, your intended reader should have no problem understanding what you want, and answering positively.

Your correspondence is important to both administration and marketing. Business communications must be answered to meet various government regulations and requirements. Correspondence is also necessary to get, keep, and complete business. Don't let your active correspondence file become inactive. Answer important correspondence today.

Try to write your own correspondence, composing at the typewriter or, better yet, on the computer, where it's a snap to make corrections and check spelling. In the long run this will help you become a better writer for all purposes, and save a great deal of time and money. It will also make you appreciate the necessity of good communications and let you include personal touches.

Keep filed copies of all written, faxed, and e-mailed correspondence, coming and going. You will refer to and use these files often. Use your professional letterhead and envelope. Type or use the computer for everything except personal notes, which are nice when handwritten.

Proposals and Bids. As the world of photography slowly realizes that it's also part of the marketing world, we're required to compose extensive business proposals. If you have good ideas for proposals, get them down on paper and present them to the proper client. Turn proposals into promotional campaigns.

Administratively, proposals are easy. Develop a simple proposal format, covering your objectives, scope, markets, market value, logistics, budget, rights, rates,

references, and samples. This information can be bound into a small booklet, featuring your letterhead as the lead page with photos, news clips, and your promotional flyers included. Printers, office suppliers, business-service companies, and graphics houses can help develop effective proposal packages.

Ask your business counselors to read your initial proposals. They will have ideas regarding all aspects of proposals, including where to send them.

Keep proposals simple and to the point. Make up two or three extra presentation copies available for immediate shipment to potential clients.

Communicate your ideas to people who buy and use ideas. In our business this means art directors, creative directors, marketing managers, and small business owners and investors. Make lots of proposals. Learn what works and what doesn't. Keep copies. Get advice and ideas from others.

Every now and then, draw up a proposal for your dream job, project, and client. Use this as a working goal. Present it to your advisors. Present it to yourself. Present it to your dream client. This dream client may share your dreams.

Research your markets and the market in general.

Research. Know what business is doing generally and what it may do to you in particular. Don't rely on the boob tube. Read business and news publications. Learn everything you can about the markets in which you wish to sell. Research what's going on around the business and photography market, your client's market and business in general. This is basically a matter of reading the trade magazines, business publications, regional news magazines, and checking the client's website.

Research your clients and potential clients. Get their annual reports as well as copies of their current advertising materials and handouts. Find out who's who in their business. Keep an active file of this research. Refer to it when making proposals. Clients appreciate, and expect, knowledge of their business.

Research changes in your business and tax requirements. This entails not just knowing what you need to file but also learning about trends and changes that are taking place. Much of this information is logged by professional associations, such as ASMP, PPA, and others. Attend some of their meetings. Meet the people. Stay on top of things that may change the way you do business. Research, be ready, and be there ahead of the others.

Clip and print out the interesting and important information. File this information and refer to it when planning promotions, proposals, client letters, and other communications that rely on such data.

■ CAPITALIZATION

Pretend that you're in business to sell products, just like a hardware store. Jot down all the elements you think are necessary to start up your business. These might include a store, warehouse storage, plenty of products, display cases, salespeople, advertising, packaging, a service department, working capital, a bank account, and so on.

You need a plan. You need to know what's needed to be in business—and to stay in business long enough to start making enough money to stay in business for an *even longer* time. Sound like a never-ending story? You're getting the idea! Use the information provided in chapter 6 to start making an extensive business plan, no matter what the stage or age of your business.

Budgets. Everything in business revolves around your (proposed) budget. Your clients want a budget for the job. Your bank wants a budget so they will know how you plan to pay off bank loans. You need a budget so the money is spent according to plan.

Take a look at the IRS Form 1040 Schedule C, which sole proprietors must file. It will give you an idea of the basic items most independent businesses utilize. It follows that if the IRS has made provisions for deducting certain items in their tax forms, they must be related to the business process and generally acceptable as deductions (so long as they are normal and necessary to your own specific business).

The following elements should be included in most business budgets. I suggest you include each in a separate checkbook category, so they can be entered each time an expense is paid.

Advertising. This is the cost of advertising in creative books, websites, and other marketing media. Include the cost of color separations, artwork, mechanicals or production time, placement of your ad in the publication, and cost for the advertising space.

Bank Charge. The charges your bank imposes, on business accounts only, for services of any kind. Include the cost of checks provided by the bank. I suggest you establish an interest-paying checking account, where temporary extra money earns something.

Capital Expenses and Improvements. All office equipment, furniture, photo equipment, and major improvements made to business property. Budget the full amount you expect to spend in a given year.

Remember, however, that for tax purposes, the cost of these items must be depreciated over their useful life.

Car and Truck Expense. Gas, oil, car wash, parking, and simple repairs made during gas-up. Major repairs should be listed under repairs. Lease payments for business cars should be included under this heading.

Commissions. Sales commissions you pay to agents and others. Don't include your stock agent's commission unless you issue them a check. Employee wages fall into another category.

Employee Benefits. Health, vacation benefits, retirement, and other non-salary or commission items. While a swimming pool may be an employee benefit, you might not want to include it in this budget or as a tax deduction unless you're ready to provide some serious arguments to bankers and auditors. Being an underwater photographer might help.

Entertainment. Hosting a client, potential client, assistant, supplier, employee, or other related person to a business breakfast, lunch or dinner, falls into this area. Budget the full amounts you plan to pay, but remember, only a percentage can be deducted in filing taxes. Other entertainment can include the theater, concerts, movies, and similar events that you can prove are necessary to present and future business. Expensive wines, lavish catering, Caribbean trips, fancy yachting events, and similar items will be more difficult to get past the money-watchers and tax people.

Goods and Materials (to Be Sold). Films, processing, props, and items necessary to produce your products or services. Include any taxes you must pay under this budget. Make sure you or the client pays retail taxes in accordance with applicable local regulations. You will also have to keep an inventory and deduct what's sitting on the shelf at the end of the year.

Insurance. Budget any insurance you need for the business, employees, contractors, auto, and rentals. Do not deduct these items across the board without checking the latest tax rulings. Some insurance, such as medical, may be very necessary for a secure business operation but may not be completely tax-deductible.

Labor (Wages). Your employee salaries. Do not list your wages or those paid to contract employees.

Office Expenses. Postage, petty cash items, window washers, stationery, flyers, software, office supplies, sodas for visiting clients, paint for existing walls, temporary displays, small Christmas gifts (under $25 each), and the like.

Freight. Shipping of images to clients, freighting supplies to your location shoot or studio. You should include air and ground freight expenses.

Dues and Publications. Professional associations and publications, such as yearly directories. A reference book that is used for more than a single year is not a publication, but a business expense. Your professional library may be a capital asset that requires tax expending over its useful life.

Rents. This includes your office rent, equipment rental, and studio rental—but not your car rentals.

Repairs. This is the place to list business equipment repairs, which means fixing something that is worn or broken. Patching a hole in your roof or parking lot is a repair; adding a new roof or paving the parking lot is a major improvement and should be under that budget and tax listing.

Services (Contracted Professionals). This is the place to budget and tax-deduct the cost of any outside service provided by a lawyer, CPA, bookkeeper, assistant, or model. They must be bona fide businesspeople who provide similar services to others. Ask to see a business license, tax registration, and stationery sample.

Supplies. Expendable props, items for marketing, and things necessary for business in general, but not a specific project or job. Do not include office supplies.

Taxes. Any tax you must pay to be in business. Retail taxes, such as you pay on film, should be included with the cost of film, not in this budget or tax area. Talk with your CPA about specific tax deductions in this area.

Travel and Transportation. Costs incurred in getting to locations (but not business auto expenses). Include location car rentals and their gas; air transportation to a job site; taxi fares; a car with a driver; and even sailboats if they are a normal and necessary means of transportation in completing the job. Budget the cost for commuting to and from the studio or office, but don't include it as a tax deduction unless the CPA approves. Location accommodations, food, and beverage should be included in this category.

Note that you may also need to budget for expenses and list tax deductions that relate to your individual needs. For instance, I list location accommodations and related expenses in their own separate category. The IRS Schedule C tax return form, for small businesses that aren't incorporated, has a special category to list such deductible items. It follows the standard deductions listing.

■ HOW TO BUDGET

I suggest establishing an annual budget around the Schedule C topics listed above. The first year in business you will just be guessing what's needed; the second year is based on what happened in the first year, and so on. If you've been in business a while, simply use the previous year's figures with a small growth markup added. If you're just starting or have never spent money for a certain category, estimate out a generic job and use that amount times the number of jobs you hope to complete.

For example, if you plan to shoot aerial photography for annual reports, call the local flight service and get hourly rates; figure about three hours for a normal job. Multiply this by the half-dozen aerial shoots you hope to complete next year.

Of course, the amounts spent for any given item may differ from your budget. If you think in terms of budgeting each business activity and back it up with research from similar or previous jobs, things will start following a pattern. Future budgets should reflect what you've learned from the past.

Keep an active budget for your office expenses, as well as for all shoots, proposals, and marketing. Each should be tied in to the master budget. Keep everything on a word processor or computer that can perform simple math calculations for you.

Checkbook vs. Budget. Assign each budget category a separate column in your checkbook spreadsheet so that every check will be immediately expensed. Some computer programs keep a constant running total for each budget item in the checkbook, so you always know how much is being spent. If not, you can easily tally things up individually each month or each quarter. Year-end tax computations are simple with such programs, as are future budgets.

Financial Statements and Loans. Keeping budgets and checkbooks that individually expense items by category is the primary method of establishing pro forma and financial statements. Both of these items, which pretty much show what's happening in your business, are the key to getting loans for equipment and lines of credit for jobs, but not for the little extras like food and rent.

A pro forma is an estimate of income and expenses generally used by individuals whose business's income fluctuates significantly over the course of a year. While the estimate is usually generated for a particular quarter, and sometimes includes a growth estimate, it can also be applied to reflect anticipated earnings for a month, a year, five years, etc. Getting a loan or a line of credit to operate your business is dependent upon your ability to show the bank a good pro forma and some assets. This document will give them an idea of your operational and growth plans. Keep it simple and

positive. Don't plan to make hundreds of thousands more next year than you did this year.

Your pro forma should also be reviewed in planning potential income for a photo project. How much will it cost? How much do you stand to make in gross income? What will be your net profit (what's left after expenses)? Can you keep doing business and live on this income profit?

$ Will the bank loan me enough money to make all of this happen?

Where is the Money (and How Can I Get My Hands on It)? These are the real questions on most businesspeople's minds. As the bank robber replied when asked why he robbed banks, "Because that's where the money is." Capitalization, or getting the money to start and expand in business, is mostly a matter of budgets, pro formas, and financial planning, right? Try telling this to a banker who loans money to people who don't need it and are ready to pledge assets that more than double the loan value.

The first thing lenders look at is your ability to repay the money, or your assets that can be grabbed in case the loan isn't paid off. Your well-presented financial statement, profit-and-loss (P&L) statement, business plan for the next three years, inventory of equipment and images, receivables, and client list are all things that will help with loan applications.

The money may be in banks, but these folks are often reluctant to lend it to those who run an unusual business such as freelance photography—without substantial collateral. You may have to look elsewhere. Begin with the people who offer interest-free money, including your family, friends, and non-photographic business associates. Don't play the starving artist, or you may receive a stern lecture and a hundred bucks for food. Or worse yet, you may go hungry.

Credit unions, credit cards, investors, and business professionals are possible sources of capital. Doctors, lawyers, CPAs, pilots, and other professionals often enjoy making small investments in creative businesses. They will undoubtedly want to participate in an occa-sional photo shoot, preferably involving hot models in hot locations. This could turn out to be more trouble than getting cash from the bank.

A word of caution about loans, lines of credit, and credit cards: Make sure you understand all the terms of payment, interest, late charges, fees, and the possible penalty for early payoff. Don't be shy or feel that the loan will be jeopardized if you ask questions. Make sure you can live with *all* the answers. People who lend money want you to be comfortable with the terms.

■ CAPABILITY

What do I need to be a successful photographer? One of the photography schools? Art school? Darkroom and shooting classes at the local college? These are questions many photographers come up with in their quest for making it big. They feel that capability means the basic ability to see and make great pictures. Unfortunately, some of our better colleges, photo schools, and graphic-arts professors perpetuate this misconception.

Obviously, a photographer must be able to make great images in order to earn the Big Bucks. However, the basic capability to make money with this great photography often has little to do with creativity.

Business administration, bookkeeping, and writing are among the basics of a photography business. Add in a little business law, accounting, and journalism, and you have the balance.

Most of this administration doesn't sound like anything a photographer should get too worried about. "Come on, we're artists aren't we? If we can shoot great images and get a *Time* or *National Geographic* assignment, the money will flow and the business end will be covered, right?" That's what the average photographers think, and it has kept them in business, but it hasn't made them a serious threat to the Big Bucks business.

Business smarts is where the hotshot photographer moves into overdrive and overtakes the also-rans. A semester or two invested in a few local college programs and picking up on basic business administration *will* pay off.

5. SURVIVING COMPUTERIZATION

■ PHOTOGRAPHERS AGAINST COMPUTERS

The adaptation to computerization can ensure your survival in the marketplace. And the best part is, you don't need to be a computer expert to make computers do your work.

Several years ago, during a seminar for independent business owners, one of my clients demonstrated the ease with which computer word processing could be mastered and utilized. The computer was amazing. It could spit out original typed letters—matched to a client mailing list—so fast that a whole new marketing plan developed before my eyes. The speaker told us that businesspeople who fought computerization would eventually fight for survival in the market. Today this is more true than ever before.

The computer has become as important to the business and art of photography as any other single tool—including the camera!

I purchased a basic word processing computer immediately following that seminar. I was the first photographer in town to have a computer, and my fellow photographers said it was crazy to buy one instead of cameras and film. Of course, that machine quickly became a boat anchor and was replaced with successive bigger, better, and more expensive computer systems. Obviously, the computer changed the course of my business, and business in general, for the better and for all time. Now who's laughing?

Unless you want to spend a lot of time crying, get computerized before going into any business—especially photography. While a camera only creates an image, a computer system is needed to maintain a business—and to work with and sell images. And, if you don't sell images, you don't get to create images for very long. You probably won't eat very well either.

■ BUSINESS COMPUTING

A computer will help your business operate better, with fewer people, and for less money. This means spending more time shooting and less time administrating. I use several business computers in my office and on location. The daily work accomplished with them replaces at least two full-time employees. With today's excessive employee-taxing systems and demand for perfect communications and records, the initial expense of a computer is very low when compared to the never-ending cost of another employee.

We use Macintosh computers to write and produce all correspondence, e-mails, client mailings, sales proposals, business plans, and schedules. We also use them for location and client research, travel reservations, and purchasing some supplies. Each person in our office has their own business computer. We use PageMaker software, a large-screen monitor, and a laser printer to create business forms, flyers, advertisements, and similar printed materials.

We use a Macintosh laptop computer for correspondence, shooting schedules, e-mail, and budgeting while traveling to and from assignments. Trac Industries' Slide Typer captioning system is used to print captions directly on 35mm mounts.

Finally, we utilize a powerful Macintosh system for image manipulation, design, storage, and file transmission. The same computer is used for maintaining our website. It could also be used for

video editing, but we prefer to use the huge machines at a professional production house. We also utilize the services of a good computer designer for the majority of our image manipulation.

Today's computers can do as much as your imagination and pocketbook allow.

We don't have game software installed in our computers. While such programs are amusing, they can also be time-consuming. We're in business to earn enough profit so everyone can play computer games at home. Our systems do have music-playing capabilities, so we can listen to CDs of our choice while working.

You can be up and running with a good, basic computer system in less than a week. The basic business and communications functions can be performed by a single desktop computer. And the best part is, you really don't need to be a computer expert to make these basics work.

To start, learn the programs you need to complete essential business and communications functions. A word processing program like Microsoft Word is essential. Such programs allow you to create and output proposals, letters, e-mails, mailing lists, and hundreds of other written tasks. I love word processing programs. They check your spelling, context, and grammar and provide a dictionary, thesaurus, and other great tools.

Learning to operate your computer and software is easy. Every manufacturer has easy classes that will bring you up to working speed quickly. The better computer systems teach you on the job.

■ COMPUTERS AND FINANCES

We use Microsoft Excel, a "smart" financial software program that can do a complete and accurate budget proposal for the most complicated photo or motion picture project imaginable. After entering the specifics of the job, like the number of days, crews, setups, and so on, Excel crunches the numbers to come up with a budget. Nowadays, we can accurately estimate the final costs for most projects, put them into writing the client will understand, and make a profit.

One of the smartest things computers do is math. Taxes, too.

How smart is our financial program? We use Excel and Quicken for our checkbooks, which means the only mistakes are forgotten entries or typos no one has caught. It produces a clean and complete check register every time we write a check. It can also be tied into a P&L statement program, which tells us how much money we're making so far this day, week, month, quarter, or year.

At the end of the year, or whenever a taxing bureaucracy needs us to fill in a tax form and send them all our money, we simply tell our financial program to do the work. Zap!—in a matter of seconds, we've got all the information. Our MacIntax software does state and federal income taxes almost as quickly as we can delete information from the previous year and enter this year's numbers. Best of all, the computer doesn't make mistakes. In fact, it will tell you the mistakes it thinks you've made, such as forgotten entries, incomplete forms, and forms that are missing. It also has all of the current tax regulations, which allows you to make decisions without calling the CPA every five minutes. The IRS likes these software programs because of their accuracy. You'll like them because of their step-by-step ease.

Once my taxes are completed each year, I take a few minutes to compare the past three years. The computer will run a sheet showing gains and losses in profit, as well as major changes in expenses. It allows me to produce an estimated budget for the coming year. Banks and other lenders like this kind of information.

Don't worry about putting your CPA out of business because you have, or are planning to get, financial software. Unless you want to become a CPA, too, you'll only have time to take care of the financial basics of operating your business. That will certainly mean doing the taxes, budget, and estimates. My CPA likes it that I do all the financial entries and first-round work. That makes his job easier, faster, and less expensive. It also gives us more time to discuss tax planning and strategies for expenditures and the like for the next year.

Guess what? We've only started to scratch the surface of what computers can and should be doing for your business.

■ COMPUTER MARKETING
Your computer is a sales force just waiting for you to provide a little direction and client information.

Market Planning and Development. Computers and word processing programs were made for client mailing lists, which are the very heart of a good marketing system. If you don't use it for anything else, the thing will pay for itself in new business opportunities. There

are thousands of sources for photo buyers' names and addresses; a few are listed in chapter 13. You can also purchase ready-made lists from creative publications and professional and marketing organizations. Several companies specialize in lists that are on CDs or DVDs. All you need to do is describe your business, the client demographic you want to target, and the location in which you hope to do business, and they will create a very good mailing list for your promotions. While this means of advertising is highly effective, you'll need to hold tight to your patience and stick with the plan until it starts producing clients. Accordingly, be sure to resist the temptation to overfill your mailing lists, just because the names are available and they seem like attractive potential business. That can be very expensive in time, postage, and printing costs.

Eventually, through sales and client contacts, you will develop a useful and valuable series of lists of your own. In the beginning, I suggest developing a specific mailing list for each market, rather than a single large and unmanageable list. The following categories will cover most markets for starters:

✓Advertising agencies
✓Public relations agencies
✓Design agencies
✓Business corporations
✓Publishers
✓Media
✓VIP
✓Personal

Within the above list you should categorize, by their specific titles, individuals who may be potential photo buyers or decision makers. Key titles should include:

✓Photo or graphics buyer
✓Art director
✓Creative director
✓Advertising manager
✓Marketing director
✓Sales manager
✓Public relations director
✓Editor
✓Publisher
✓Photo editor
✓Art editor

The Marketing Plan. Use your computer to draw up a working marketing plan. This should start with current business goals, including to whom you want to sell, where you want to work, and what you produce. These items should be reviewed and refined on a monthly basis. Each time you review these basic goals, ask yourself if the client lists reflect these goals. Are you making regular use of the lists? Are they updated and improved as your business changes and grows?

You should also formulate a business development plan, which you can store in a computer document. To do so, follow the steps outlined in chapter 6.

Computerized marketing plans and client lists create opportunities to sell your work.

Sales Efforts. With a simple computer, a photographer is capable of producing hundreds of original promotional packages, tailored to each recipient, in a single afternoon. You can easily write one hundred or a thousand original letters and sales proposals, complete with envelopes, in a day. Each will have an individual's name, company name, address and personal references within the body copy. These names come from your mailing lists. This means that each of your potential clients receives a one-of-a-kind package. Think about it. One thousand original sales letters in a single day. With a good proposal and client mailing list, this could be a good start toward making Big Bucks. This same computer application can be used to write postcards, flyers, and other marketing materials. It is one of the most important ingredients in a good sales program.

Client selectivity is simply a matter of having the right list, with the right information to sort. The more detailed your mailing list, the more options there are for being selective. And, remember, you can purchase mailing lists for every type of business. Want to hit a specific city, state, and country? Your client list can be sorted, by the computer, into a single zip code, a single city, a single state, or any combination. You can sort by categories, by telephone area code, or by company and product. Looking for a high-end client? You can purchase a Fortune 500 mailing list of marketing directors. You can use as many subcategories in a mailing list program as desired.

Mailings, and mailing lists, should be addressed both to an organization and to a specific individual within it (e.g., ABC & D Advertising, Jane Doe, Creative Director). Personalizing your mailings and mailing lists almost always gets the package opened and examined. There are so many mailings these days that materials simply addressed to the creative director at an advertising agency, or the photo editor of a magazine will most likely be tossed without a look.

An average commercial organization mailing list should look something like this:

✓Company name
✓Individual name
✓Job title
✓Address
✓Telephone number
✓Fax number
✓E-mail address
✓Website address
✓Products
✓Advertising agency
✓Design agency

An average agency mailing list entry should look something like this:

✓Agency name
✓Individual name
✓Job title
✓Address
✓Telephone number
✓Fax number
✓E-mail address
✓Website address
✓Clients

An average editorial mailing list entry should look something like this:

✓Publication name
✓Individual name
✓Job title
✓Address
✓Telephone number
✓Fax number
✓E-mail address
✓Website address
✓Circulation
✓Editorial content

Using Sales Lists. While not every client will take your telephone calls or give a personal interview, most will open first-class mail and interesting packages. With a good computer system you can send everyone on your mailing lists an original first-class letter with a new sales pitch idea every month. Think of the sales possibilities this opens up without your ever having to leave the office. Before computers, it would have taken a dozen full-time people to equal these efforts.

Follow-ups. A computer also helps you to be persistent. That means following up every mailing with another mailing or personal contact. Pretty soon, people will recognize both your name and your work.

Once a client has made contact with you, for any reason, provide an immediate written follow-up. This can be a short thank-you note, a letter listing ideas, a confirmation letter, or a full-blown proposal and budget. The computer makes this easy with a pre-written sample letter for every occasion. You fill in the name, add a personal note, and the computer does the rest.

Promotions and Press. Your mailing list should contain media listings for publications and news organizations that photo buyers, art directors, and editors read. Every time you do something newsworthy, write a press release and send it out. A mention in the media is another sales call. Reprint the mention, with the publication's title, and send it to your clients. The computer does everything but come up with the newsworthy events. I even keep an active file of ideas and projects—in the word processor, naturally—that have the potential for being developed into press releases.

■ THE WORLD WIDE WEB

The World in Your Computer. The World Wide Web (a.k.a. the Internet) is a television, library, bulletin board, and shopping mall all within your computer. It's also an extensive entertainment center, the world's largest library, millions of billboard advertisements, and stores selling just about any product you can imagine. You can find information, provide information, show and sell photos, and sell or buy almost every product imaginable—all inside the Web.

Photographers and the Web. Want to know how to price a photo shoot or stock image? There's a site with thousands of suggestions, all based on other photographer's sales. The same goes for purchasing equipment and supplies. All the best professional photo equipment and material outlets have websites featuring extensive catalogs. They also feature safe and secure ordering systems. Want to see the world's leading photographers work? Most of them have a website. The mega stock agencies have sites that show and sell millions of photos.

There are dozens of sites on the Web specifically designed to help and inform photographers.

Most commercial websites also include instant e-mail contacts that allow users to ask specific questions, follow up on orders, and request notification

when new products are introduced. Some of the sites include chat rooms, which allow users to write and receive instant messages with others using the same site. Do you have a problem or a need? Someone has been there before and will help you.

Web talk may sound confusing, or impossible if you've been living in a cave somewhere. However, it's really not all that difficult to manage. There are special search programs, called search engines, that will find sites for you. They are like a big telephone book, giving you lots of choices and a little information on each site to help you make a choice. All you do is enter a subject in the search field.

When I got started with the Internet, I treated it just like a television with a keyboard instead of a remote control. It takes only a few minutes to realize the Web is a powerful tool when used properly.

The World Wide Web is one of the most exciting marketing tools ever!

Marketing with the Web. There are several ways to market your photography using the Web. The best is to establish your own website, which displays and encourages the buying of your photography. You will hear how easy it is to design and set up your own website. While this may be true, keep in mind that the people who buy images are usually designers who see the best of the best. Hire a good website designer for your site, preferably one of the designers who uses your work. Experienced web page designers know what works computer-wise, and what doesn't.

Think of your website as another portfolio. You might include pages of your very best images reflecting subjects you want to photograph, a biography, client recommendations, recent assignments, personal work, and similar materials. Start by taking a look at pages featuring your competition, other leading photographers, and the better quality stock agencies. This should give you some ideas.

Make sure you have several ways for potential clients to contact you listed in the site. A quick click directly to your own e-mail is essential. And, most important of all, ask viewers for the sale or assignment. Make it easy for them to buy your work.

Other Web Marketing. Some photographers like to send e-mail images to potential clients from time to time. This is a good way to send your images to a lot of people for very little cost. Keep in mind that photo buyers are very busy and can become annoyed at what they think is "spam." Make sure they purchase the type of work you make. And make sure your stuff is short, good, and marked as a promo in the subject.

There is a good side to sending e-mail images to designers. This is the way many of them already receive images from stock agencies and photographers, so they may take a moment to see how your work looks. If the page is interesting, they may check our your website or request additional images. Always give them a way to be removed from your e-mailing list. This may hurt your feelings, but if they don't want your mail, it's best. It will also keep them from calling to complain, or telling their designer friends you mail spam.

You can place images on photo sites specializing in marketing to photo buyers. The cost to be included in such sites is often low and the method can be productive. Make sure the site has a method of selling the images on your page directly to clients. Otherwise, you need a good system by which potential clients can contact you.

There are also sites that offer wholesale art products to home and office designers, architects, commercial space rental firms, and similar places. If your work looks good on walls, which usually means it's generic, these sites may be a good place.

You can also sell the use of your images to illustrate sites for other organizations. In my case, airlines, travel agents, and tourist organizations often lease images for their sites. Always try to get some type of photo credit and copyright notice. The better clients will let you have a small hypertext link that takes interested viewers directly to your site.

■ COMPUTER BUSINESS ADMINISTRATION
It's true: The computer was originally designed to run a business.

Everything you ever wanted to conduct a successful business is available in one computer software program or another. There are studio and commercial photography business programs available, as well as stock cataloging and storage programs. You can also buy stock image and assignment programs—not to mention a wide variety of bookkeeping, employee, and tax programs. (An employee software program helps small businesses simplify, calculate, and estimate things like hourly wages, salaries, overtime, vacation time, comp time, health insurance, sick leave, liability insurance, and retirement benefits. Sometimes such programs are a part of a larger business office management program.) All of these, and more, are reviewed and adver-

tised in dozens of monthly computer magazines. Most of the better photography computer programs are reviewed frequently and advertised in most issues of *Photo District News.* You can also find them advertised on photography websites.

Record Keeping. Every time you create correspondence, proposals, or similar materials on your computer, it acts as your filing cabinet. In fact, document storage is considered the most basic business use of a computer.

Stock photography record keeping is one of the best time-saving capabilities of a computer system. Image information can be recorded in a system and cross-referenced by subject matter, in such a way as to enable anyone to find the right shot for an immediate client need. By assigning a unique number to every stock image, you can also develop lifetime sales values, sales records, and a simple filing system.

Record keeping for photographers covers a wide variety of uses, which include the following:

✓Active clients
✓Appointment calendars
✓Assignment or job development
✓Assignment or job completion
✓Checkbooks
✓Contracted services
✓Equipment inventory
✓Inactive clients
✓Invoices
✓Mailing lists
✓Office supplies
✓Payables
✓Photo supplies
✓Profit and loss statements
✓Receivables
✓Sales records
✓Schedules
✓Stock library
✓Stock submissions
✓Suppliers
✓VIPs

Accounting. Bookkeeping, invoicing, taxes, and other financial operations are often the primary reason businesses purchase computer systems. Such use is usually the first thing computer salespeople will discuss, pointing out how easy it is to keep a checkbook, figure employee taxes, and so on. They're right. A computer and the proper software can make it easy to accomplish most financial tasks.

To me, figuring taxes and keeping the checkbook have made the computer worth its weight in Nikons. Make an entry, say for a check to pay a supplier, and the system subtracts the amount from your checkbook and adds it to the proper tax-deduction file. If all your payables and receivables have been entered in the system, year-end tax computation is simply a matter of letting your system do the job.

One of the best things about most accounting packages is their ability to churn out a profit-and-loss (P&L) statement each month, quarter, and year. This immediately tells you how the business is operating financially. Your P&L statement will split fixed overhead and assignment costs into separate categories and show any profit for the period. Obviously you must make a profit most of the time in order to keep doing business. Some P&L statement programs will analyze your figures and show where additions or cuts need to be made.

Job Tracking. The busier you are with selling, planning, shooting, and delivering jobs, the more difficult it is to keep track of costs, materials, time, and profits. A simple job-tracking program can do this task on a daily basis. Spend a few minutes each morning reviewing the computer schedule, appointment calendar, job progress, material needs, and assignment development. The computer will never forget something it has been asked to remember, list, or file.

I print out a working progress copy of jobs and schedules on a weekly basis. Copies are made for any assistants or staff as needed. This is my daily and weekly work plan. I consult and revise it as jobs are completed or accepted. In other words, I make a list of things to do, and go down the list with the help of a computer that never forgets a single item that's been entered.

It's an easy task for the computer to catalog all of your jobs and provide an overall chart or scale by year, or for five years, and so on. With this, you can compare averages of time to complete jobs, costs for materials, number of employees involved, profits, and any other category desired. This same program is ideal for stock image production, sales, and uses.

■ COMMUNICATIONS

The following are examples of the type of communications you can easily produce with the assistance of a good computer system:

✓Agreements
✓Bids

✓Budgets
✓Collection notices
✓Confirmations
✓Correspondence
✓Delivery memos
✓Editorial text
✓E-mail
✓Financial information
✓Follow-ups
✓Images
✓Invoices
✓Press releases
✓Proposals
✓Promotionals
✓Statements
✓Stock lists

Once you've produced a communication, you can use your computer to send it through the phone lines (or whatever connection you use to connect your computer to the outside world), producing instantaneous computer-to-computer (e-mail), computer-to-fax machine, and computer-to-website correspondence. Of course, your computer can receive answers in a similar manner.

There are also a number of websites you can subscribe to for such things as assignment and stock needs. Some provide postings by prospective clients; others are electronic mailboxes; while others offer information services covering photography, hard news, travel, sports, and much more. These services are also available by normal mail and fax services.

While telephone, fax, and "normal" mail are fine for many projects, communications via computer, Internet, and e-mail are nearly instantaneous, which means you can include pictures or attach documents that include very good images. This type of communication is important when an art director wants you to see their ideas or layouts right away, or you want to send samples from a session to an anxious client during the shoot. The quality of sending images this way has become so good that digital photographers frequently send their images for immediate use by clients and news organizations only moments after they are created. In our need for immediate gratification and information, a photographer who can accomplish such speed of image delivery can make Big Bucks.

■ FORMS, ETC.
The computer can be used to produce graphic materials, such as forms and flyers. For years all of my business forms have been produced on a computer system right in the office. This includes such items as:

✓Accounting ledgers
✓Advertisements
✓Books
✓Business cards
✓Cartoons
✓Checks
✓Copyright use transfers
✓Delivery memos
✓Envelopes
✓Estimates
✓Expense sheets
✓Flyers
✓Invoices
✓Letterheads
✓Model casting sheets
✓Model releases
✓Notepads
✓Petty cash vouchers
✓Phone logs
✓Promotions
✓Property releases
✓Purchase orders
✓Stock photo logs
✓Stock photo requests

■ SLIDE CAPTIONING
Computer slide captioning will change the way you administer stock photography.

It's easy to shoot hundreds of rolls of film, but not so easy to caption the resulting thousands of slides. There are many computer programs available that imprint excellent stick-on caption labels. This makes the job easy to do and makes the slides easy for potential buyers to handle.

When I started shooting and selling stock, we used a typewriter to make small caption labels. A rubber stamp was used for my company name, address, copyright, and related information. Each slide took about two minutes to caption. Lots of slides went into the file with little or no caption information. Often they went in with just my name and copyright stamp.

I saw the Slide Trac computer in action at a *Photo District News* convention in New York in the late '80s and was blown away. I immediately purchased their best system. It prints several lines of type directly on the wide sides of a 35mm slide mount—whether paper or plastic. It can number slides and has a memory for

frequently used caption information. It will complete a slide in just a few seconds, or do hundreds of the same caption at about one per second. (See the resources section for more information.)

Today, every slide I shoot gets an immediate complete and accurate computerized caption. This precise captioning system has made the administration of stock images simple for me, my agents, and my clients. If you can make it easier to do business for a client, odds are they will do more business with you.

■ GRAPHICS

A computer can also be used to produce and program multimedia shows, video programs of still and motion picture images, and website portfolios—all for your own promotion and client sales. The more sophisticated systems allow you to mix music and images for a very professional show.

If you've been in photography very long, you already know the computer plays an important part in the storage and sending of images. It has also become a tool to fix photography, much the same as an air brush did in earlier days. For example, it's a simple matter to remove a telephone pole or even change the color of an object, such as a person's eyes.

■ IMAGE MANIPULATION AND LIBRARIES

Computer technology now has the ability to digitally enhance and manipulate images. This can be as simple as making the image's sky a brilliant blue, the water a deep green, color correcting for poor lighting, and retouching to remove unwanted objects. A good artist can remove or add sunglasses, change a one-piece swimsuit into a bikini, and, yes, completely remove the suit. Knowing how to use the manipulation systems does require some serious study and practice.

The most popular computer program for photo manipulation is called Adobe Photoshop, and it is a wonder. In addition to enhancement, we can also create composite photos, making a single image out of several other image segments.

■ PHOTO CD LIBRARIES

There are thousands of specialty photo CDs available on the market and in private collections, with every kind of subject imaginable stored on them. They can be an excellent market for industrious photographers. In addition, several stock agencies have their catalogs available on low-resolution discs, for their clients to view and make comps. There are photographers who have changed professions to enter this realm of digi-

tized image manipulation and library development, feeling it plays an important part in the modern world of electronic photography. The better designers, advertising agencies, and similar image users have created their own libraries of special images made for their clients.

A note of caution if you plan to enter the explosive arena of producing photo discs: Many disc producers contract photographers on a work-for-hire basis, keeping copyrights and most of the future profits for themselves. Treat the creation and marketing of photo discs as you would any other assignment or production of stock images. Make sure you understand what is being created, who owns what rights, who pays, and who gets paid. Make sure you can and do live up to the contract you sign.

Many photographers, including myself, maintain photo CD libraries of their images. Most of these discs have each image available in three or four resolutions, ranging from low to high reproduction quality. My discs are travel oriented, based on countries I cover and books I've published on specific locations or subjects. I use these photo CDs to deliver images via the Internet, for examination, and for final use. I can also transfer such images to another disc and send it overnight to a client for the same reasons. While my discs aren't for sale, disc sales have become a good market for buyers of stock images.

■ COPYRIGHTS AND ELECTRONIC IMAGES

It's important to note that the copyright ownership questions regarding images that are composited or created from other images (i.e., in which an original image is significantly altered in some way) are driving most of the professional photography associations and commercial shooters a little crazy. In such images there are layers of copyright ownership, all of which may or may not remain with the image creator. Pay attention to the fine print in these contracts, and make sure you retain the copyright to your images. Don't be fooled by fancy talk about major changes in your images being owned by the organization that theoretically "enhanced" your image.

Image development costs and copyright questions have driven many major photo users and mega stock agencies into their own photo production businesses. Images produced for these corporations are done by employees or under work-for-hire contracts. It's an easy way to make a few quick bucks as a photographer, but the larger and longer-term profits go to the company. Remember, the company is footing the bill in

advance. It's almost always a take-it-or-leave-it deal, if you make the decision to participate in these projects.

Several copyright lawsuits are making their way through the courts, all attempting to determine who owns what part of a manipulated image. The primary questions arise when an electronically created image uses existing images to make a completely new image. While, in the end, courts have generally sided with the original creator of an image, who knows what will happen next? Most of the big photo users and sellers have the bucks to keep searching for a court that will give them the rights to your images.

If your images are used in websites, on photo discs manipulated by clients, stored electronically by agents, or in any other manner, they can be easily duplicated and manipulated—and may be used in this new form without compensation to you. *Always* put your name and copyright symbol on all of your photos. Demand that the users of your images do so, too. Follow up with invoices to organizations that use your images in any manner. Just because your image is a small part of another image doesn't mean it's no longer your image.

Make sure you watch for and keep track of where your images are used electronically.

Make sure your contracts, delivery memos, and invoices spell out exactly what a client may and may not do with your images. This paperwork should limit a client's use to exactly what's on the invoice. If they want additional electronic website use, storage in their photo library, or other unknown future uses, make sure your invoice and other paperwork says they must compensate you for such uses.

When it comes to electronic photography, and the many uses and copyright questions, a subscription to *Photo District News* is worth its weight in gold. The publication addresses all of the current concerns, legal decisions, and other related information.

Electronic Copyright Owner Beware. As this book went to press, freelance writers, illustrators, and photographers of a major daily newspaper had filed a class action suit, accusing the paper of unfair and deceptive trade practices. According to the complaint, the paper attempted to coerce the freelancers into signing a contract demanding all rights to publish in all mediums to all past, present, and future freelance works created by them for the paper—with no additional compensation. The paper said that freelancers not agreeing to the demands would never be hired again.

The above contract demand is not unusual. Do not be surprised or offended when you receive such a contract or requirement from a prospective or active client. To them it's just business. Large corporations, including mega stock agencies, consider photography to be a product and photographers to be suppliers. They want to own what they pay for and not have open-ended deals hanging around their neck for the next ten years. This is especially prevalent with the creation of electronic images. Again, be sure you understand and can live with the terms of every contract.

■ SELECTING A COMPUTER
Computers are available in systems, just like cameras.

Just as there are a large number of photo equipment manufacturers, there are literally thousands of companies selling computer products. Before making any computer purchase, do some homework. Talk with your business counselors, local photographers, and friends. Ask what systems they use and recommend. Visit a few computer stores to see what's hot at the moment. Talk with one or two of the major software dealers advertised in *Photo District News*. Talk with the designers and photo buyers who use your work.

Everyone will have an opinion on which computer system and software programs will do the most for the least investment of time and money. As with camera systems, you get what you pay for in computers and programs.

Macintosh and Microsoft. Throughout this book I mention Macintosh and Microsoft. They manufacture most of the computer hardware and software I use and mention in this book. I feel they are the best in the business and have the products and reputations to back up my opinion. No matter what the federal government may have against Bill Gates, I think he's a wizard and deserves everything he's earned. There are also some very fine products produced by other manufacturers. Much like selecting a good camera system, your choice will be predicated on the type of work you hope to accomplish. And, just like camera equipment, if you buy cheap, inferior computer products, you'll be sure to buy the best the second time around.

What You Need to Start. A photographer's computer system generally includes the following:

✓Computer
✓Monitor
✓Printers (b&w laser for paperwork, color for photos)

✓Scanner (to acquire images as digital files)
✓Software (word processing; financial [accounting, checkbook, budgets]; graphic page design; Internet browser/e-mail; photo manipulation)
✓Telephone modem
✓Fax capability
✓Image storage
✓CD and DVD drives and burners

Simplicity. Computer people often say that their system is user-friendly, which really means it's easy to understand and easy to use. Having used several different systems, I can't say enough about the simplicity Macintosh has built into their system. With a few minutes of instruction, most beginners can be left alone to use the system and teach themselves. When something is complicated or won't work, the Macintosh has an immediate help file that can be opened to figure out what should be done next.

When considering computer system options, have the salesperson show you the ropes. Sit down and try to perform a few simple tasks. Write a letter, draw up a typical invoice, lay out a promotional flyer or a proposal. Is it easy to use? Easy on the eyes? Are there several type fonts available? Is there a variety of accessories and programs available? Are there a series of free or low-cost classes available?

Economics and Expansion. Don't expect to run a major marketing program and photography business on a thousand-dollar computer system. For this price you can write letters, surf around the web, and play a few high-tech games. Computer systems are sophisticated business machines that cost money to purchase, operate, maintain, and expand. They will be a major investment.

Quality computers aren't cheap, and they tend to expand into large systems.

Costs for a basic system like the one described earlier (computer, monitor, and simple printer) can be reasonable to get started. These basic needs can likely be met for less than the cost of a basic camera and lens shooting package. A good software package, on the other hand, including word processing, accounting, and graphics programs, will cost substantially more. A big storage drive will also be necessary if you want to build a good photo library. By the time you get beyond the basics, you'll also need a computer guru to help sort out the products and prices.

■ **SOFTWARE PACKAGES**

There are thousands of good computer software programs available. A dozen or so companies produce programs specifically for commercial photographers. The best of these are advertised and reviewed in the leading industry magazines. Always talk with someone who has practical experience using any software program in which you have an interest.

I use the following software programs. The names may change (and similar products may be available through other manufacturers), but you'll get an idea of what's needed:

✓Word processing (Used to produce correspondence, proposals, purchase orders, invoices, scripting, scheduling, press releases, and some mailing lists.)
✓File systems (Such programs work with word processing, allowing you to file mailing lists, client lists, estimates, and purchase orders, and to store documents and important data.)
✓Financial program (Allows you to complete taxes, simple accounting, checkbook balancing, invoicing, financial statements, budgets, and proposals.
✓fotoQuote (Used for stock photo pricing.)
✓Adobe PageMaker/Designer (This program is used to create graphic layouts, including forms, stationery, flyers, advertisements, and books.)
✓Adobe Photoshop (Used for image enhancements, construction, and to acquire images for scanning.)

Software Copyrights. Software is copyrighted just like your images. The creators and manufacturers receive royalties for your use and purchase of their programs. Don't duplicate software for your business use. It's illegal and unethical. As professionals who don't want our product copyrights stolen, we must respect those same rights regarding products created by other businesses.

■ **COMPUTERS ARE OUR FRIENDS**

Computers are both easy and fun to use. They are an absolute necessity in the modern business world, especially for photographers. Start with a simple system and learn as you go. Ask for help along the way. We've all been there in the learning stages and understand why you're frustrated. Making mistakes is, for most of us, the route to computer literacy. A good computer system will teach you how to use it. Learn to live with computers, and you'll learn to love them.

6. YOUR BUSINESS PLAN

Plan for success and there's a chance. Fail to plan and you risk failure.

■ THE FORMAL BUSINESS PLAN

Bankers will give serious consideration to a loan application if your business plan is a practical approach to administration and profit. Consultants can provide much better suggestions and advice if they've seen a written plan. You will perform better in business, having taken the time and effort required to produce a good plan.

A good business plan is a combination of an encyclopedia and a road map. It contains the information that leads to success. How you write and read it will determine the final destination.

A business plan isn't so much a plan as it is a complete look at your business assets, marketing strategies, goals, finances, and growth. The process of considering all the aspects of your business will help provide a clearer view of the necessary goals that lead toward success.

Photographers who set realistic goals, based on a sound plan, have a chance in meeting those goals.

■ THE PHOTO BUSINESS PLAN

If you haven't already figured it out, photography is different from most other commercial businesses. We have a wide variety of creative, personal, and marketing questions to consider that aren't part of the rest of the business world. We lean toward creativity rather than "corporativity." For that reason, most standard business plans lack inspiration and relevance to photography. In fact, most plans revolve around business and financial questions that are aimed at getting investors and bank loans rather than building a solid business.

■ YOUR BUSINESS REVIEW

Your photography business plan is little more than developing, in writing, a series of financial, operational, marketing, and creative goals. Doing this requires making an honest review and inventory of yourself and your business.

Spend an afternoon with an experienced business advisor reviewing your business, using one of the models in this chapter. Small business owners, successful freelancers, CPAs, and bankers tend to be the best people for these sessions. Don't bother taking notes. Record the conversation so you can listen to it several times.

Have your advisor read one of the following programs, an item at a time, while you respond. The initial session will take about two hours, which includes a little time for conversation. Answer each question as best you can without the help of any references or resources. Ensure that your answers to the questions in these programs are spontaneous and honest. They will be the basis for developing and writing your goals and plans for business in the future.

The review programs are outlined on the following pages.

■ START-UP PROGRAM FOR PROPOSED BUSINESSES AND NEW BUSINESSES

(for businesses less than a year old)

Starting a new business is a little like raising a child. At first, you only have an idea of what to expect or plan. Soon, things take on a life of their own and you're along for the ride. Later, things settle into a known pattern, which you control or are controlled by.

I. Outline Your Assets
- What are your creative talents?
- What kind of photography are you doing?
- What kind of photography have you done?
- Is this a specialty type of photography?
- What is your photography knowledge?
- What are your business abilities?
- What is your business experience?
- What is your educational background?
- What are your mental strengths?
- What are your physical assets?
- What is your financial strength?
- Does your family offer moral support?
- Does your family offer financial support?
- What friends can you rely on for support?
- Do you have influential contacts?
- Have other family members started their own businesses? If so, how long have they been in business?
- Has anyone in your family ever gone bankrupt?

II. Market Analysis
- What are the potential markets for your photography?
- Do you have any serious prospective clients?
- Are your clients local, regional, national, or international?
- Is your family involved in, or does it own, a business that might be a prospective client for your services?
- What are your proposed clients' best-selling products?
- What do these products cost the consumer? Are they a high-end product?
- Do you personally use any of these products?
- Who are the consumers/clients of your clients?
- Who are the leading photographers in your proposed market?
- What are the general trends in your chosen market?

- What are the economic trends in your market?
- What are your favorite things about this market?
- What is the future of your proposed market?
- What part does photography play as a sales tool in your proposed market?
- How many businesses are there in this market?
- How many photographers specialize in this type of photography?
- Does your market use stock photography?
- Do any local stock agencies serve your market?
- How many photographers are there in the local agencies?
- What are the leading trade organizations for clients in your market? Can you purchase a mailing list comprised of their members' names, addresses, and other contact information?

III. Your Market
- What kind of photography sells best in your proposed market?
- Does your work compare to that of the best photographers in this market? Can you compete with them?
- What is the average photo day or job rate in this market?
- What will you be charging for a day or job rate?
- How many days do you expect to be selling in the first year?
- How many calls should be made in a day/week?
- How many calls do you think it will take to make the average sale?
- How many days do you expect to be shooting in the first year?
- What is your first year's anticipated gross income?
- How did you arrive at this figure?

IV. Business Outline
- Do you have a business budget? A personal budget?
- How long-range is your business budget?
- Do you have the necessary business equipment? Is it paid for?
- How old is your business equipment?
- What is the ideal business equipment?
- Do you have adequate photo equipment? Is it paid for?

- How old is this photo equipment?
- What is the ideal photo equipment?
- How much space does your business require?
- How much can you spend on rent?
- How much will the monthly utilities cost?
- How much will you spend on advertising and promotions this year?
- How much will you spend on telephone services each month?
- What do you need, financially, to survive personally each month?
- What do you need, financially, to survive in business each month?
- Can you use a computer?

V. Capitalization
- How much money do you have immediately available?
- Do you have a source of income (or cash) other than photography?
- How do you plan to finance your photograph business?
- If your first year is profitable, what will you do with the money?
- Assuming it's a disastrous first year:
 - Do you have backup plans?
 - Do you have a cash reserve?
 - How much money do you owe right now?
 - How many credit cards do you have?
 - What are their credit limits?
 - What are the balances due on these cards?
 - What is the name of your banker?
 - If you needed business money and the bank said no, could you survive without the money?
 - What is your credit rating?
 - Have you ever gone bankrupt?
 - Would you hock the family jewels to start this business?

VI. Market Entry
- How will you announce your entry into business?
- How will you announce your entry into the market?
- Which potential clients will you call on first?
- Have you drawn up a prospective client mailing list?
- Who are your preferred clients?
- What is the ultimate assignment or job in your market? How much would it pay?

- What are your prospective clients' trade publications?
- What self-generated assignments do you plan to shoot? Can these assignments be done in cooperation with a client? Can they be done for stock?
- Describe the ideal portfolio to compete in your market.
- Describe your portfolio.
- How much did your portfolio cost?
- What does the average portfolio cost in your field?
- What is the single best way for you to generate work in your market?
- What does your competition do to generate work in your market?
- Do you have the annual reports from several businesses in your market?
- Who is the number one user/buyer of photography in your market?
- Are you a good enough shooter to compete?
- Name the reasons a client will want to work with you.

VII. Progress Planning
- What is the best source of information about your market and clients?
- How do you plan to improve business?
- What is the best source of business advice for your own growth?
- Are you a member of ASMP or PPA?
- What are the advantages of membership in these organizations?
- Describe where your business should be in five years.
- Describe how your photography will develop in that period.
- What is your strategy for the future?

■ REJUVENATION PROGRAM FOR AN ESTABLISHED BUSINESS

(for businesses up to five years old)

Starting and running your own small business, in my opinion, is more valuable than the best business degree. Nothing can prepare one for the reality of business more than physically taking the plunge. Learning from early mistakes is the basis of a mid-business review.

I. Creative Talents

- Describe your portfolio.
- Describe your best-selling images.
- What is your strongest creative asset?
- What is your weakest creative point?
- Describe your personal photography.
- How do you rank among the photographers in your market?
- Who is the best photographer in your market?
- Who is the best business photographer in your market?
- How does your creative standing compare with your business standing?
- Describe your specialty.
- Describe your creative growth in the last three years.
- If you could change places with any photographer, who would it be? Why?
- Describe this photographer's images and clients.
- How does your work compare?
- Do you share a specialty with this particular photographer?
- Describe your stock file's size and categories.
- Describe your stock sales.
- What is the most important thing about photography?
- What is your attitude about the business of photography?
- What is most exciting about your own photography?
- What is the most exciting thing about photography in general?
- What is the most exciting thing about your business?

II. Business Organization

- Describe your business.
- Describe your studio or office.
- What do clients think of your working space?
- Is your best work displayed in your working space?
- Is your studio convenient?
- Put a value on your products.
- Put a value on your services.
- Describe your P&L situation for each of the past three years.
- Explain why your P&L is in its current shape.
- What is the working capital balance in your checkbook?
- Name your biggest sale this year. How big?
- Name your poorest and/or slowest-paying clients.
- What was your gross income last year?
- What was your net income last year?
- How does this compare with the previous year?
- What is your projection for next year?
- Describe your various employees' functions.
- How does their pay compare with that of other photographer's employees?
- Are they happy?
- Are you happy with their work?
- Describe your contractors' functions (assistants, stylists, etc.).
- Describe your business equipment inventory.
- Describe your photo equipment inventory.
- Do you have the business/photo tools to compete?
- Are you good at business administration?
- Describe your credit card balances.

III. Your Market

- What is your position in the market, compared to other photographers?
- Are you considered one of the best?
- What can you do to improve your ranking?
- How many clients have been working with you for over three years?
- How much of your business is repeat business?
- How much of your business is one-time jobs?
- Are you happy with your client base?
- Are your clients happy with you?
- How many prospective clients can you talk with right now?
- Describe your latest marketing effort.
- What is your next marketing idea or promotion?
- How much did you spend on marketing efforts last year?
- What is your marketing budget this year?

- Is your chosen market lucrative?
- Who is your best client?
- What is the average income each month from this client?

IV. Business Satisfaction
- Outline your original starting goals for your business.
- Have you met these goals?
- What are your goals for the coming year?
- What are your goals for the next five years?
- Is your business fulfilling?
- Are you happy with the growth of your business?
- Are you happy with your own creative growth?
- How do your clients describe you in their introductions?
- How do you describe your business to potential clients? Friends?
- Describe your standing in the community.
- How do you compare with your role models in photography?
- Is photography giving you all that you expected?
- Will photography be your business in ten years?

◼ REORGANIZING PROGRAM FOR A SCREWED-UP BUSINESS
(for businesses of any age)
If it's time to reorganize your failed (or failing) business, start by setting new goals.

I. Setting New Goals
- How long has it been since you evaluated your business and established some serious new goals?
- Are things in a slump?
- Can you pinpoint why things are going well or why business is in a slump?
- Is your business administration strong?
- Are the taxes paid in full and on time, every time?
- What can you do to streamline business operations?
- When was the last time you updated your office forms and documents?
- Have you shown a profit for the last three years? Why or why not?
- Describe your market.
- Is your market considered a growth market?

- Are you exploring new outside markets?
- Are there areas of your market that haven't used your work?
- What is the primary method of selling your work?
- What are your secondary sales methods?
- How do other photographers sell in your market?
- Describe the differences between you and your competition.
- Have you considered changing your sales techniques?
- Describe your personal photography.
- Have you added any new creative shooting tricks lately?
- Have you tried any creative approaches to sales? Business?
- How did you make your first sale?
- How did you make your most recent sale?
- How do you plan to make your next sale?
- How did you make your best sale?
- How much stock did you shoot last year?
- How much stock did you sell last year?
- Does your business need new tools in order to compete?
- Have you been involved in any lawsuits?
- Have they had a positive or negative effect on you? On business?
- Are your associates and employees growing with the business?
- Are you growing with the business?
- Have you reviewed any prospective assistants' portfolios lately?
- Have you visited a photo art school lately?
- Have you attended a photo conference lately?
- Do you subscribe to Photo District News?
- Are you a member of ASMP? PPA?
- What have you done to improve business and personal creativity lately?
- What can you do to cut business overhead?
- What single business investment would make you the most money?
- Describe your most successful project.
- Describe your best client.
- What percentage of your time and income are based on your best client?
- Describe your worst photography and business experiences.
- Describe your ultimate business fantasy.
- What are the two hottest photo marketing ideas you've seen lately? Why did they work?

What is your estimate of their cost? Can you come up with something equally exciting?
- How many sales calls did you make last week? Last year?
- How many new clients have you acquired in the past year?
- How many clients have been one-shot jobs during the past year?
- Do you like the business of photography? Why?
- Does photography seem to suit you? Why?
- What is the most exciting thing about photography?
- What can you do to expand this excitement?
- What is the least exciting thing about photography?
- What can you do to improve this area?
- What is the single most profitable thing you do in photography?
- What can you do to expand this type of work?
- How does your most profitable area compare with your most exciting area?
- Can you find ways to combine these areas?

■ PLANNING FOR SUCCESS
No businessperson in their right mind plans to fail. Some don't plan to succeed, either.

Developing business goals is easy. The review just completed provided an outline of what you have to offer and the current state of business. Use the answers to make a list of where you would like your business to be at this time next year. These business goals should be written in the present active tense, as though the desired result already exists. For example, in the marketing category, your goals might include:

✓I make six new client sales calls per week.
✓I make four weekly calls to current clients.
✓I mail one promotional piece each quarter.
✓I call each person on my mailing list every six months.

Your own answers should be based on what you want and expect next year for the following categories:

✓Assets
✓Business operations
✓Clients
✓Creativity
✓Debts
✓Equipment

✓Income
✓Investments
✓Marketing
✓Personal life
✓Products and services
✓Projects

I review my basic goals often—never less than twice a month. I read and repeat the goals two or three times during a session and visualize them in my mind's eye.

Using your own list of business goals, try meeting them in every business activity and transaction. Of course, there will be goals that can't be met, just as some goals will be exceeded almost immediately. Do your best to meet goals, and don't despair when something isn't completed. Set a few new goals at the end of each review.

Organization. By keeping daily, weekly, monthly, and yearly goals written down, it's easy to evaluate how things are going. Of course, each list has different priorities. Your daily list contains things that must be completed immediately. The weekly and monthly lists involve the longer-range projects and marketing, and so on.

Organize your time and projects around completing the list one goal at a time. Sooner or later, everything on the list will be more a reality than an ideal.

■ REAL BUSINESS PLANS
I know that this goal-setting isn't the type of business plan bankers and investors, or you, might have expected. However, these people will expect you to meet such goals in order to succeed.

First, you'll need the following:

✓Business financial statement
✓Small business administration loan application
✓Personal financial statement

Fulfilling the information requirements of these forms is one of the most complete, and difficult, business plan outlines available. They take a lot of time to think out and prepare, but will round-out the formation of your business goals. Money and banks aren't the answer to a successful business. Sound business decisions and effective sales efforts are.

Standard Business Plan. If you're seeking money or financial approval, I suggest using a standard business plan outline in addition to the above completed information. Keep your answers simple and complete.

I. The Business
- Outline your industry and field
 The ideal situation for your specialty
 The reality of what you can do

II. Your Company
- The business format
 Why you want this format
- Your business goals
 Where, when, how much
- Officer's and partner's backgrounds

III. The Product/Service
- Describe the product/service you will offer
 Outline costs and expenses for sales
- Describe the process and equipment needed to produce the product/service
- Explain any uniqueness you have to offer
- Show product/service price cost and sales structures
- Describe needs and growth expectations (over the next three years)

IV. Marketing and Sales
- Define your market and ideal customers
- Outline the plan to reach this market
- Describe sales, advertising, and promotion plans

V. Financial
- Budget for:
 Operation and administration
 Legal and tax consequences
 Marketing, sales, and promotion
 Screw-ups and slow downs
- Outline desired and proposed financing
- Outline the potential risks and profit
- Project your three-year financial profile

7. PHOTOGRAPHY AND THE LAW

Working within business laws and regulations is a lot more productive than the alternative. It's also a lot cheaper.

■ LAWS VS. INDEPENDENT BUSINESSES

Sometimes it seems as if it's us against the laws that regulate small businesses. Is there a conspiracy to keep freelance photographers from earning a simple living? Everywhere we turn there's another legal roadblock or loophole someone uses against us. While the situation is pretty much the same for large businesses, most of the small folks don't have the resources to fight, keep up, and quickly recover.

Memorize the phone number of a good lawyer and call before there's a problem. Make sure the lawyer is successful, experienced in the arts, and a tough SOB.

Today, independent businesspeople, including freelance photographers, have a host of legal options available in their fight (and it always boils down to a fight) against heavy-handed legal actions. Not only is there a growing interest in legal representation in the arts by a few hotshot attorneys, but our professional associations have begun taking stronger legal stands. As a result, we're winning some important decisions.

The world's population is growing rapidly, and more and more people are entering into small businesses like photography. Add this to the fact that communication is almost immediate and we're on the carpet about fifteen minutes following a stupid, perhaps illegal, business mistake. Would that our time on the legal carpet were limited to fifteen minutes! Unfortunately, these actions can last a very long time, and in the legal business, time is money—even if you're the eventual winner.

While there isn't an easy solution to the growing number of legal problems photographers face, with a little foresight we can take some steps that will lessen the blows. This means two things: (1) spending time getting informed on the changes and developments that legally affect our business, and (2) spending some time with lawyers. A little humor goes a long way toward improving your attitude on the laws of small business. Most of those laws would be humorous if they applied to someone other than yourself.

An independent publisher contracted me to do a three-month shoot in a tropical location. The job was interesting, and I borrowed money to cover expenses rather than asking for an advance. I was naive enough to think that asking for advance expenses might cost me the assignment. Upon completing the shooting, processing, editing and captioning, I presented the publisher with an invoice. After about three months of invoicing, calling, and pleading for payment, I realized they never intended to pay. Luckily, I held the images.

My first freelance job was a near legal and financial disaster because I was overeager for the assignment.

I hired a lawyer, filed a suit, and went to court. The publisher denied signing the contract and said I did the shoot on speculation; fortunately it was notarized. We were personally attacked in court. It is amazing what people will swear to under oath. The judge ruled completely in our favor. However, the lessons and expenses were just starting.

Following the judgment, the publisher declared bankruptcy, closed the business, started a new corporation and immediately went back into business producing and selling the same products. I couldn't prevent the new business from starting or collect from the old one. Then my lawyer presented me with an invoice that was several times the amount agreed upon for handling the matter. After I questioned the amount, he asked if there was anything in writing to substantiate the quote. There wasn't, but I offered a cash settlement or another opportunity for him to appear in court. He accepted the cash. Lastly, the bank that loaned me money to cover expenses in the first place wanted payment in full or my equipment, which had secured the deal. We found another lawyer to convince the bank to accept a longer term of payment. It took a while to pay everything off, but this early lesson about the legal system has paid off many times. I call this experience my masters degree in the real world of small business.

Lawyers. My brother, formerly an experienced lawyer and now a tough-minded judge, told me this only half in jest: he says that every independent businessperson needs a smart lawyer with the instincts and attacking ability of a tiger shark, because that's exactly what you'll be facing on the other side of the table in legal actions taken against you.

Ever wonder why sharks never attack lawyers? Professional courtesy.

The smart businessperson knows that lawyers need to be more than attacking sharks—a whole lot more. Their responsibilities are as wide-ranging as those of a commercial photographer. To communicate effectively with legal counsel means educating yourself on their roles in the business community.

Advice and Protection. The most important role of lawyers is to advise clients. This means talking with them before problems develop. How do you know when it's a problem before it's a problem? Obviously you don't know, so you need to take advantage of the lawyer's role to protect. This means having your lawyer look at the way you do business and your paperwork to spot potential problems.

An experienced lawyer should examine all estimates, image delivery memos, invoices, photo releases, collection letters, and any agreement or contract you intend to sign. The professional photo associations provide excellent forms and formats for some of these documents. I've even provided some basic sample forms in this book. Most photographers modify them to suit their needs. As you'll see, the forms I use are simple and straightforward in nonlegal terms. You and your lawyer may desire more strict legal language.

The more your lawyer knows about our business and about your business, the better the advice. If you're involved in a copyright legal action, don't rely on the lawyer who has been writing your family wills. Violation of copyright, trademark, logos, and the like is a serious, expensive legal business and requires extensive knowledge and experience to fight.

Say a client loses your original images and wants to pay two or three hundred dollars for pictures you feel are worth $2,000 each. This is serious business. Talking with a lawyer who specializes in these types of actions, before they arise, could help you solve any problems quickly—or to avoid them altogether.

Representation. Mostly, lawyers represent us when legal actions are taking place. This means they are acting on our behalf and in our best interest. For me, this also means appearing in my place whenever possible, since I don't like the stress and time away from work it takes to fight with other lawyers. I have come to admire and appreciate their relationships. They have a common respect for each other and understand that a given case isn't personal, it's business. They know this relationship means they might meet again in future actions, perhaps on the same side. It also means they can talk and settle differences reasonably. Don't interfere with this professional relationship and understand that in the end, it works in your favor.

Photographers often have difficulty keeping cool enough to handle legal situations and negotiations. The best advice I can give you about any legal action that you are unable to solve directly and quickly with the other party is to get out of town on an assignment, and to let a trusted lawyer settle the dispute in a reasonable manner. The lawyer represents you completely and, if you happen to participate, does all the talking. The net result is that the lawyer gives you his or her best advice on what moves to make next. Sometimes this means litigation and going to court, and sometimes it may mean accepting less than you feel is adequate. Ask your lawyer to spell out the time, costs, and potential results of any action.

Use your head when being represented by a lawyer. Don't let the shark attack until and unless there is little chance that anything else will work. Once your shark attacks, the other side's shark will have no choice but to defend, which means an attack against you. Once a shark bites a chunk out of your north end,

you'll find that the south end often has difficulty making sound decisions.

No legal problem is so serious or seemingly impossible that it won't look less threatening in the morning. No problem is so small that it can't be legally fought into a major expensive impossibility through neglect and presumption. Let the lawyers bite chunks out of each other's north ends, while your south end heads south for the week.

■ HOW TO HIRE A GOOD LAWYER

Find a good lawyer early in your business career, when things are going along just fine. If you wait until problems develop, there will be some expensive time spent educating a new lawyer on your business and the problem. The key word here is *expensive*. If you do have a problem that may require legal advice and help, take care of it as quickly as possible. The longer you allow a problem to sit, the less likely it is that it will be settled in your favor. In fact, there is no known small problem that won't become a big one through neglect and disregard.

A personal reference or professional association referral, such as ASMP, is the best way to find a good lawyer. Just for the record, a good lawyer is one who has experience with the arts, meaning copyrights, lost slides, and all of the other things mentioned in this book. A good lawyer will also try to keep you out of court. Be wary of those who would immediately sue, even if that's what you're demanding. Remember that some sharks are quick to attack anything in sight. Look for the lawyer who pulls on the flippers and bares the teeth only when it's impossible to avoid a fight.

Schedule an appointment to get acquainted with a lawyer, keeping in mind that her or his time is for sale just like yours. Don't be shy about asking the price for this or any other session. Be honest and say that you are shopping for an attorney and their name has been recommended by so-and-so. The first meeting should take less than thirty minutes, during which time you share the basics about your business, growth, and areas in which they can provide counseling. In turn, he or she will tell you what to expect from their services—what you pay for advice, the cost to review or write documents, and the cost to defend or initiate and try a lawsuit.

Select an attorney you are comfortable talking with and in whose ability you have confidence. Since you have gotten a recommendation before meeting the prospective attorney, you also know something about her or his experience. Winning a lot of lawsuits isn't

necessary, but it's nice to have a big stick in reserve. The average lawyer will advise you to make every attempt possible to reach a settlement; therefore, you should seek someone who can negotiate and debate successfully.

Once an attorney is *your* attorney, he or she needs to know everything about your business. Give him or her total honesty if you expect the same in return. Lawyers will, and legally must, keep all of your secrets. More important, they base advice on what you tell them, so don't hold back something that may change your liability and limit their ability. Let them do their job while you do yours.

Do Your Legal Part. Photographers often overlook their responsibility in providing liability protection to themselves and their clients in the making and use of images. You should make sure your paperwork is solid in the event of any legal question. Model and property releases are the number-one area of concern. The client expects the photographer to obtain or have releases. The photographer may think that the client's employees don't need to sign releases. For the record, a company doesn't automatically have the right to use an employee's images or likeness. Some employment applications include generic marketing and photo releases. Take no chances with releases.

Copyright use transfer is another area of growing concern. This is a place where you can kill two birds with one piece of paperwork. Every invoice I send out has the exact use rights listed in the same size and same area as the photo fees, plus the words *these use rights transfer to the client upon payment in full of this invoice*. It also says that any additional use, including electronic publication, is considered separate and requires compensation. They have to pay if they want to play.

Foreign Legal Problems. If you work in foreign locations, there may be times when legal help is necessary. Have a name to call should a problem arise. Your regular lawyer may have an affiliation with an international lawyers' association. The U.S. Embassy can make recommendations about lawyers and doctors, too, for that matter. ASMP and PPA have members in many lands, and their legal counsels may be of some help. A foreign lawyer can help with official reports on lost or stolen equipment, payment disputes, customs, local taxes, and crimes that you may encounter.

■ AGREEMENTS AND CONTRACTS

Anytime you agree to make photography for a client, that's basically a contract. From that point on, things can get more complicated on what really constitutes a

legal and binding contract. Oral agreements for more than $500 are expensive to enforce under the Uniform Commercial Code. They are not impossible to enforce.

Read, understand, and agree with every written communication between yourself and every client. If you don't agree with something, make a change on the document and initial it. Never leave anything to chance; the client certainly won't.

Purchase Orders. My lawyer suggests that a client's signed purchase order and check for advance expenses constitute a written agreement. Cashing the check generally means you enter into the agreement. Read the fine print on purchase orders before cashing that check. If you completely agree with the terms, return a signed copy, and head to the bank to see if the check clears. If you don't agree, cross out and initial objectionable items and type "purchase order accepted subject to changes" above your signature. It might be best to send purchase orders with such changes to the person who negotiated the job, rather than to the accounting department, since they may not agree to your changes. I always hold the check until these changes have been approved.

Work-for-Hire. Your client, through purchase order or other written communications, may expect to own all the rights to your work because you are "sort of" their employee. It may be written into one of the many documents that change hands in slightly different terms, but it means the same thing. The client wants to own all rights to the work. However, they won't treat you as an employee, meeting all the federal and state tax, unemployment, social security, insurance, vacation, and similar requirements. They want you to cover all these expenses, plus provide equipment, materials, and creative knowledge, and then give them the images and go home. Make sure you can live with all the terms of an agreement before signing.

I once bid on a job to shoot a photographic library of an entire state. The client wanted all rights to a hundred images of a hundred specific subjects. There were some benefits, which included shooting unlimited stock, keeping all images beyond the one hundred, VIP treatment at many events and properties, and the potential for other work in the same agency. All of this included a high photo fee and liberal expenses. I spent a great deal of time bidding, with the understanding that being a state resident wasn't required. The agency called, saying I had the job. A few days later, after I had purchased the materials, the state called and said

they were sorry but the job had to be awarded to a state resident. After several weeks of shooting the job, the contracted photographer saw an article on work for hire. He met with the agency and refused to continue shooting under their signed agreement. The agency eventually kicked his rear end in court, and the state now employs full-time photographers to make their images.

I found through this experience that governmental bodies, just as other clients, often change their minds, so ask for a letter of confirmation before spending any time and money. Also, if you accept a job, do the job as agreed. Every time a photographer backs out of a job, fails to meet an agreement, or creates a similar problem, the business of photography suffers. I'm not suggesting that you accept any conditions, such as work-for-hire. I am saying you must meet all the conditions you do accept.

Should you or shouldn't you accept work-for-hire jobs, in which the client owns some or all of the images? Look at all aspects of the potential job. Are there stock possibilities? Can you share copyright ownership? Do they really mean all rights? Is this a blockbuster fee or job, and is this a great client? After careful consideration, make the best possible deal and then live by it to the letter. Otherwise make an exit. If you give up something, such as unlimited rights, make sure there's something else gained, like the right to shoot unlimited stock with the client's models.

This is an imperfect business trying to make its way in an imperfect business world. Do your best to complete every effort exactly as promised.

Cover Your Assets. Once a basic agreement to produce photography is reached, I immediately send the client a letter of confirmation with my interpretation of the job's terms. This gives me the opportunity to cover any areas of concern before, or instead of, a written contract. The following items should be covered in confirmation letters:

✓Specify exactly what will be photographed, when, and where—perhaps with the client's shot list attached.
✓Establish who has the responsibility for approving changes in the job and resulting cost adjustments.
✓Include the expense estimate and requirement for up-front payment.
✓Establish the exact rights and uses the client will receive upon payment in full for the job. State that

future rights, including electronic publication, are separate and require compensation.

✓ Send a thank-you note for the job, along with a pledge to provide your best possible efforts.

These letters need not be in legalese to make their point. It makes sense, however, to have your lawyer help with some of the language. Personally, I like to keep things simple and informal, as follows:

Dear Client:

I am pleased to have been selected to produce photography of the New Widget for a one-year advertising campaign on behalf of the Same Old Widget Company of Mill Town, USA.

According to your creative director, Mary Pleasant, shooting will begin at 9a.m. on the first of July, at the Same Old Widget plant in Mill Town. I have received Miss Pleasant's layouts for the principal shots and expect her to supervise at the site. The photo team, myself, and production assistant have scheduled three working days on location to complete this project.

We understand that a purchase order and check in the amount of $0,000, for one-half the photo fees and all estimated materials, travel, and related expenses, will be forthcoming before we purchase materials or begin work. A complete invoice will be presented along with our selection of images. In the event of a cancellation or postponement on your part less than 00 days prior to the photo team's departure, the photo fees paid to date will be forfeited.

The Same Old Widget Company will receive written one-year unlimited use rights to the selected images upon payment of the final invoice. Additional rights, including electronic publication, are available and negotiable.

Thank you for choosing my photography for this project. I am looking forward to working with the professionals at So-and-So Advertising.

Sincerely,
Photographer So-and-So

Remember that business is business. The letters of confirmation, agreements, purchase orders, and contracts you sign may come back to haunt you in a court of law. Large corporations (small ones, too) do not like entering into bogus deals with flaky suppliers, which is how they may perceive your failure to complete any part of the project. On the other hand, they may feel it's perfectly okay to ignore many parts of an agreement they signed. This leaves you with the option to pursue other means of getting the client to meet the agreement.

■ RATES, RIGHTS, AND FIGHTS

You own the copyright to a photograph the second you push the shutter (the moment of creation) unless you sign a written agreement to the contrary. That's the law.

This looks good in big type but doesn't always ring true in small type. The argument is rarely a question of who owned a copyright at the moment of creation. More than likely it's going to hinge on the later transfer of that copyright, or some other understanding to the contrary. Quite often you will find a transfer of copyright clause on such things as purchase orders, letters of agreement, contracts, payment vouchers, and on the backs of checks. By the way, crossing out fine-print claims on the back of checks is legal.

To avoid any questions, read, understand, and agree with every written communication between you and the client. If you don't agree with something, such as one of these copyright transfers, make a change and send them a note in advance. Never leave anything to chance, or to be settled at a later date. Some photographers ignore the fine print until a lawyer, usually someone else's lawyer, has it enlarged and included in a threatening letter. Don't transfer your copyrights away simply because you have been too lazy to read the fine print.

■ THE COPYRIGHT

Always include a copyright sign (©) in front of your name on every image, or image mount or printed use—no matter whether the image is headed to a client, stock agency, your file, or the trash. The copyright sign © is generally enough for you, the image creator, to legally retain copyright ownership, unless you've signed those rights away. Using it is the first and best indication that you own the copyright. The lack of this symbol, or your name, may cause photo users, buyers, and potential copyright infringers to think otherwise about your copyright ownership. The lack of the copyright sign doesn't mean you don't own the copyright, but it's a sure sign of a beginner.

Delivery memos, estimate forms, and invoices should include a little fine print of your own that states

that clients are responsible for your copyright protection at no cost to you, for all images used. Very few professional agencies, magazines, corporations, etc., fail to include overall copyright restrictions on their materials, which includes your images.

Once an uncopyrighted image goes into the public domain—meaning it's printed, displayed, or part of a visual medium—it may be a goner as far as your rights are concerned. You may have recourse if this has been caused by someone other than yourself. The image, however, may be lost forever, and you can bet that a good lawyer will try to prove public domain.

For the best protection, you should register the copyright to images with the federal government. This can be done individually, for important images, and in groups for more general subjects. Complete information on this process is available, along with a single application, from the Copyright Office. You can also download any copyright form and instructions from their website:

Copyright Office
Library of Congress
101 Independence Ave. SE
Washington, DC 20559-600
www.copyright.gov

Should You Register Copyrights? In a word, yes. And, here's why.

You do *not* need to register a photo's copyright in order to own the copyright, as I've already mentioned. You own the copyright to an image the second you push the shutter release button, unless that copyright has been transferred to another party in writing. However, simply owning a copyright may not be enough.

First off, if you have a copyright infringement, where a person or organization uses your photo without your knowledge, permission, or payment, as owner of the copyright you have the right to take legal action to collect payment. Such legal action will most likely take place in a civil or small claims court in your city or district as the collection of a business debt or similar type of claim. You need a lawyer to determine which of these courts has jurisdiction and is best for your action. In the end, you will probably pay more in legal expenses than the court will award for improper use of the photo. There's an outside chance the court will award you legal fees as well. You will not collect any damages for the infringement. The bottom line is, the final payoff won't be enough to make the legal action worth all the time, headaches, and trouble.

If you have a copyright infringement and your photo has been properly registered in advance with the U.S. Copyright Office, your right to legal action can be pursued in a federal court. If you prevail in a federal legal copyright action, it can mean being awarded payment for the photo use, a fine for the infringer and a triple damages award. An attorney experienced in copyright infringement cases, where the infringement is obvious and the image is registered, generally pursues and obtains a settlement. In such cases, the infringer finds that defending a legal action in federal court isn't worth all the time, headaches, trouble, and potential liability.

Digital Registration. Most photographers begin by registering their very best, most salable and valuable images. They generally do this in groups of ten or twenty photos, as I've described above, with a contact print sheet or photo CD. Infringers often argue that the value of a single image is thus reduced by the number of other images that have been included in the same registration. While the Supreme Court will eventually settle this dispute, infringers are also aware that fines and triple damages have not yet been reduced by the number of other images included in a registration.

A copyright registered image is more valuable, period. Just as a model- or property-released image is more valuable. Take the time to do the paperwork.

The Library of Congress and Copyright Offices have just barely gotten involved in the digital age. They can play or read compact and digital discs that have been copyright registered. At the moment they cannot accept such registrations online, but that may change in the coming years.

The digital revolution has changed the way photographers can register images—especially in registering multiple images. Instead of registering ten or twenty images using a contact sheet, you can now register a compact disc containing a hundred or more images. With today's technology, it's possible to produce a photo disc with a thousand low-resolution images, for that matter. However, it might be better to stick with an easier-to-control, smaller number of images.

Why I Register Copyrights. At a recent Getty Workshop for Artists, their lawyer talked about the importance of copyright registration. She said, in so many words, that one of Getty's most profitable areas of income was collecting payments for copyright infringements. She didn't call them *infringements,* rather, *improper use of images without permission or payment.* In most cases, a call from one of the agent's attorneys, explaining the improper use and potential

liability should a federal legal action be taken, resulted in the client paying double the normal image use fee. These calls are made in a friendly manner that usually results in both a payment and a future customer that has been educated about the proper use and ownership of images.

Registered images are a potential profit center *and*, if handled correctly, a sales tool for future business. That's why I register my images.

How I Register Copyrights. I register one hundred images at a time with the Copyright Office. Their visual arts registration forms can be downloaded from their website or obtained by writing to their offices in Washington, D.C. Instructions for completing the form are also available through the same resources. They do not, however, tell you how to make multiple image registrations on a single form.

I have the one hundred selected images scanned to a Kodak Photo Disc at a local professional or custom lab. I then transfer the smallest resolution file to a separate CD, make a backup copy of that disc, and print out two color pages each of the index or numbered image thumbnails. In filling out the copyright form I use the original Kodak Photo Disc serial number as the title; I use the job title, book name, or other reference as the alternate title. I include the total number of images being registered with the title. I also say that a compact disc and a list of contents are attached.

Keep a copy of the registration form, photo CD, and index pages. Soon you will have a file drawer full of these registrations. You may never need to use one of these registrations, or take a legal action for infringement; but if an infringement occurs, your lawyer will thank the day you registered the images.

The Reality of Copyrights. I know that many clients want to own all the rights (often called a buyout) to a certain image or images. For a multitude of logical reasons, often called money and future work, photographers find themselves transferring away copyrights. If you're selling all rights to images, make sure of two basic things: know what the client really wants and what they are willing to pay for all rights to the images. Normally, we sell certain usage rights, such as one-time-use rights, to our images.

Additional uses, electronic uses, unlimited uses for a certain period of time, and all rights are all different situations and should be valued accordingly. That means a certain percentage fee increase for each new or additional use. Of course you can, and should, negotiate these terms to the satisfaction of all involved parties.

In the exchange of any use rights, you should also determine what rights you will retain to the images being sold and used by the client, no matter which rights they are purchasing. For example, you should retain the right to use images in your own promotion, not just in your portfolio, and all rights to third-party uses and sales. Remember when selling all rights, that unless specifically stated otherwise, the client may in turn sell the images to others, perhaps even a stock photo agency who will compete against your sales.

In the sale of any image uses, be very specific about what is being offered and what is being purchased. In the case of an all-rights sale, the clients may feel they are purchasing every photo made in the shooting. They could mount that argument if it isn't spelled out in the agreement. The same goes for second printings and electronic publication. I always recommend that a written agreement be initiated when you are selling anything more than simple one-time or one-campaign photo rights. Even then, it's a good idea to spell out exactly what is and isn't being purchased.

No matter what rights you've sold for a given image, the improper, illegal, or outrageous use of that image may cause you to be named in a legal action. Add a clause to your delivery memo, letter of agreement, confirmation letter, and other transfer-of-use rights that makes the client responsible and liable for their use.

The ASMP has done a great deal of research, legal lobbying, client negotiation, and photographer educating in the area of photography copyright ownership and work-for-hire. In cooperation with Polaroid, they have published *Who Owns the Photograph,* an excellent information source on negotiating with clients for photo rights.

■ SO HOW MUCH $ DO YOU RATE?

How much? What's your day rate? Is this going to cost a small fortune? What do you tell the client when asked how much an image or job is going to cost? Even a casual mention of a certain rate may be construed as an offer. We know that verbal contracts may not be binding for larger amounts, but do you want to pay a legal fee to find out? Do you want to lose the job because you made an offhand guess at a price or rate?

Problems in quoting prices usually arise when you're on the job and additional work must be done immediately. Logically, you should have covered this obvious possibility in a confirmation letter, shooting agreement, or pricing memo to the client. Conversations such as these often take place in a distant loca-

tion when the client's local representative, who may not represent the client in financial matters, wants some additional shooting. I say make your best deal and drop everyone involved a brief note stating that the job has expanded, as has the expenditure of materials and the photo fee. Always carry extra copies of your letterhead for this purpose.

■ THE PHOTO RELEASE

Just like your camera, don't leave home without a book or two of photo releases for property and people. Don't use one without the other.

A photo release is a basic and important tool of the business.

A travel photographer, on assignment in Tahiti for a cruise line, shot a couple sunbathing on the beach with the ship in the background. The image was used many times on brochure covers, posters, and in advertising. This professional often ridiculed the need for releases in a foreign land and when people were not the main subject of a composition. The advertising agency assumed there was a release, until the client was served legal papers. Guess what? The couple were married, but not to each other, and they were both trial lawyers. The cruise line painfully settled for well over $100,000.

The fact that you have a photo release, for property or person, makes an image infinitely more valuable. It also establishes your intent to sell the photos in a commercial manner. Beyond a doubt. With today's litigious society, using a person's photo or similar likeness, without a signed release, is risky and foolish. There have been some not unreasonable claims that a magazine cover is in fact advertising to sell the magazine, not editorial reporting. The same goes for spectacular images of news events being used over and over to advertise the medium itself, long after the event has ceased to be news.

Obtaining a signed release can quickly eliminate the probability of legal action for the normal commercial use of a photo.

Just for your information, however, a signed photo release does not allow any outrageous, lewd, or irresponsible use of your photos. You cannot use the image of a family at a picnic to illustrate an AIDS article or story without a specific release. It will probably cost more money for this kind of use, too.

There are many such areas that require a special or specific release for use. For example, my Los Angeles agent had a client who wished to consider the photo of a brother and sister in jogging clothing, she sitting on his shoulders, for a promotional poster for a movie titled *Getting It On*. Even the client said that the standard release didn't cover this situation. Always call your models in the event of an unusual use request, and ask for their specific written permission. Run a couple having fun at the beach in an article about divorce, incest, rape, battered wives, and the like, and you may be in court, release or not. This may also be the case when an image is manipulated in any way, such as pasting one person's head on another's body. Common sense should prevail in these situations.

You may also need a more detailed release in shooting certain subjects, such as nudity, poverty, valuable objects, private property, celebrities, police activities, military operations, and so forth. If you think society or the local community might frown on a certain activity portrayed in specific images you create, get a release for that specific shoot and attach a Polaroid. This may include nude photography, editorial coverage of real or simulated criminal activity, medical procedures, legal procedures, and similar subjects.

No release will completely eliminate the possibility of a legal claim or guarantee your winning in the event of such an action. But having one is a strong defense.

Foreign Releases. My basic photo releases and minor (children under eighteen years old) photo releases are translated and printed in the language of any country in which I'm working. I also get specific language coaching on the proper pronunciation of the release contents, so that it may be read to potential signers and models. This has come in handy a number of times.

Imagine photographing a quaint flower vendor and his donkey on a small Greek island. The image is used by an international cruise company in their U.S. brochure. The flower man's cousin visits Athens and sees a copy of the brochure in a travel agency. He shows his cousin, who sees the opportunity to be paid by this big, rich company. Next time the ship is in port they approach the captain, brochure in hand, and raise hell. The captain tells the company marketing manager, an advertising agency representative, who yells at the photographer. Play it safe by getting a release.

Employee Releases. Get a simple model release from every person, employee or otherwise, who appears in a commercial shoot. Doing so protects both the client and yourself. As mentioned earlier, just

because someone works for a company doesn't give them the right to use an employee's photograph for commercial gain. This has been upheld in more than one court.

I have obtained a blanket employee- and property release to use images for stock sales. When photographing employees, I show the company release and ask for an individual release, too.

Get Everyone Released. What do you do about photos taken at crowded events, say the Boston Marathon, or New Year's Eve in Times Square? At times like these, it's impossible to get everyone's release. Can you use these images for a commercial advertisement? Nope. If even one person can identify themselves, and that's the court test, you may be held liable for damages or a settlement.

It's pretty obvious that some photographers, and ultimately their wealthier clients, often take chances and use images of crowded events in commercial ads. They assume, probably correctly, that no one is going to sue when they advertise around the Boston Marathon using a picture of the huge starting line, especially if it's a community service use. In such cases, your delivery form and agreement, which states that no photos are released unless accompanied by a release, should provide some personal protection in the unlikely event of litigation.

Minor Releases. Courts and juries are particularly interested in the protection of underage children, and justly so. Minors cannot sign their own releases, which means that a parent or legal guardian must sign. The age at which a person may sign a contract or release varies from state to state. Under eighteen is always a good rule of thumb for minor releases. Don't take any chances; use a release specifically for minors.

Editorial Photo Releases. There are many photographers who shoot news events. These photojournalists may never need a release to sell a news photo to *Time* or *National Geographic*. It's possible, however, that photographers would face legal action if a news image were used by a commercial organization without a release.

Obviously, it's difficult to get a release when shooting in the middle of a war, drug bust, presidential campaign, and other sensitive news events. That doesn't mean editorial photographers shouldn't carry a booklet of photo releases and use them as often as possible. Think about it. Advertising agencies are always using simulated news events in their campaigns, often at great expense to obtain proper model releases after the fact. If you have releases, news photos are more valu-

able. In fact, if you have them, you should send them to your stock agency.

I know it may spoil the moment of making candid photos to get a release. But, if you haven't been served legal papers or appeared in court, then you don't know what a spoiled moment is all about.

Think I'm Kidding? Think all this release stuff is overrated? A photo library disk company purchased images made of a couple and their family. The family shot was used extensively in commercial advertising. However, the couple didn't want photos of their child used commercially and signed releases only for themselves. When all the dust had settled, the disk company settled for a cool million bucks. Doubt if they got any of it from the photographer, but you can bet he's on their hit list for legal action.

This proves a point about royalty-free and other electronic photo libraries. Just because the fine print says photos are released doesn't always mean it's so. Smart photo buyers are asking for copies of the releases when images are used in expensive campaigns. I get calls every week asking for copies of a specific release before a client will make a big purchase from my stock agent. I don't mind because if my photo mount says the image is released, then I have the release. And, no, I don't have any royalty free photo discs, so please don't write and ask.

How Important Are Releases? The major stock agencies no longer accept image submissions that are not adequately model-, talent- and/or property-released. If you are a regular contract shooter for any agency, this usually means they have supplied the release, available in a variety of languages, which must be used and submitted with images.

The short-form picture release, provided in the back of this book, doesn't always satisfy the legal departments of large agencies. If you are with one of these agencies, ask for their release and save a lot of discussion on the matter. When reading the agency release, which often contains more than a thousand words of legal jargon that protect and release the agency, you'll soon see why my release is called the short form. My form is simple and has never failed in the few challenges that have arisen. As always, check with your lawyer before using any form or release.

With an adequate release, your image is simply more valuable and less susceptible to a legal challenge by a person or property owner. Take the time to get a release in advance of shooting.

■ WHEN ALL ELSE FAILS

No matter how serious a problem, disagreement, or legal threat—by even the giants of commerce—things are never so desperate that a settlement isn't possible. Always attempt, in a calm discussion or letter, to settle a dispute. This should be done directly with the person(s) involved and doesn't require a lawyer. Most likely, your lawyer will have advised you to pursue this course first.

I once negotiated directly with a corporate counsel for a major credit-card publisher/travel organization. They claimed that a copyright violation occurred when I used the cover of their brochure, which featured an image of mine, in a promotion. Even though the company had provided me with color separations, which contained the image and their copyrighted materials for the promotion, and had corresponded regarding the matter, the lawyers didn't agree that I had permission. Fight in court or negotiate were my choices.

We agreed that I would send a simple letter to my client mailing list allowing that the company did not endorse my work. It was this or pay $10,000 for the use of their materials. This letter turned out to be one of my best promotions, with many positive business responses. It was better than the promotion that caused all the trouble.

When Things Heat Up. Okay, so things have heated up and a client no longer wants to negotiate. This usually means their legal shark is circling around you, with blood in his eye. Of course, this is the time to call your lawyer and give a brief outline of what's happening, followed with copies of relevant documents and your evaluation of everything. Your daily log may be of value in providing dates, calls, and appointments.

Once your lawyer is in the picture, it's time for you to get out of it. Your involvement here is typically dismissed through a letter, furnished by your attorney, that states: "I represent Joe/Jane Photographer in the matter of such and such. All future contact regarding this matter should be made with me and not my client." At this point, it's time for you to get back to the business of photography and stay out of the legal proceedings.

I can name no fewer than a dozen photographers who have become so obsessed with legal actions that they literally quit working. All of their time, energy, and emotions were put into legal actions. Very few of them knew as much about litigation as they did about photography. As a result, their businesses started to falter, and they began to live for a possible income from the legal settlement—*any* settlement.

No legal settlement, unless it's a multimillion-dollar deal, is going to replace your career and photography business—or your sanity, for that matter. Placing yourself in the middle of a legal action will tear your heart and soul out. Don't do it. Funny thing about these actions is lawyers thrive on them, but they are educated in the business of fighting legal sharks. Let them do it.

If your administration, records, standard practices, professional photo organization membership(s), and other business standards are in place and functioning, legal actions should not overwhelm your life. I know that some organizations can be very aggressive in their discovery motions, which means they can ask you to tell them everything about every image they lost (f/stop, color of sky, sales history, film, processing, filing, insurance, and so on) and everything else in your business. Take some comfort in knowing that your lawyer will attack them in the same manner. Relax and let the professionals do their job.

The Take-It-or-Leave-It Deal. Listen closely to your lawyer's advice. He or she will suggest what your options are, what each will cost, and will give an educated guess regarding the eventual outcomes. Weigh these carefully, make your best deal, and live with it.

Know what legal costs can be to fight a major company for the loss of nearly three hundred stock images? Over $200,000 was spent by a single photographer answering three thousand discovery motions, attending hearings, gathering documents, and switching attorneys—all before his case went to court. This photographer is one of those who was forced, by the legal actions, to practically give up a thriving travel photography business to stage his fight. This photographer was part of a major stock photo loss by a publisher that involved several photographers and stock agencies. Rather than accept a settlement, which was far less than the company-signed delivery memo, he chose to fight. The case was eventually settled, sadly without setting any legal precedent.

No matter how big the company, how tough their lawyers, or how many millions are involved, there will come a time when a "reasonable settlement" is offered. The fact is that no one can predict what a court will decide, and even a settlement for less than face value may save face. In some cases, this will be a take-it-or-leave-it offer, in others it may be open for negotiation. This is where lawyers do their best work. Let them negotiate. It may be a lot more profitable than the cost of discovery motions—certainly a lot less than losing and paying for your legal services anyway.

Frankly, in my experience with the legal system, I've found that a settlement is far less distracting and expensive than a court case. You're in business to make and sell images, not to sit around law offices and courtrooms.

The Real Fight. It's a favored practice of big-time corporations to drag things on so long in a legal case that it will wear down everyone but themselves. The best way to handle this situation is to answer their requests as briefly as possible and keep working on your business. Let the lawyers fight and wear each other down.

Shipping Your Images. While the possibility of losing images during shipping is less than 5 percent, are you covered if the odds hit? The most serious loss potential, financially, is with our own federal government. Shipping images by the U.S. Post Office, even by insured, registered mail, may bring a surprise if there is a loss. Postal regulations, which are expensive and difficult to fight, limit payment for film and slides to the value of the materials only, no matter how much insurance coverage you have purchased. Check it out before shipping.

Perhaps you use one of the highly visible and private air freight companies. Most of these organizations severely limit the amount they will part with in the event your images are lost. Because they consider our work to be art and of extraordinary value, their payoff limit is usually about $500 per package, no matter how much insurance has been purchased. They often fight such claims. However, you can take on freight companies legally and often successfully. This is the time to ask your lawyer to fight for a percentage of the potential settlement. A number of these cases have been settled, especially when the shipper had utilized the company's insurance coverage. They settled because a court or jury is likely to side with the shipper who did purchase insurance in good faith. And such a court judgment would set an impossible legal standard for the air freight companies.

Processing Labs. What happens if your film is destroyed by the lab following an expensive photo shoot for your best client? Do you have any legal recourse? Of course, you can always start a legal action, perhaps with the help of your by now unhappy client, but will it do any good? Despite the disclaimers we see in labs, the answer has been yes for some persistent photographers. Even the Great Yellow Father lost a disclaimer suit, brought by a lawyer–photographer. Disclaimer generally means they will give you a free roll of film when your roll of film showing a volcano destroying a village gets lost. The better you are established professionally, with a track record of income and experience, the better your chances of a settlement or successful lawsuit.

In 1989, one New York lawsuit against a major lab resulted in the awarding of more than half a million dollars for the loss of some three hundred negatives. The images had a provable commercial editorial value. The result has been that most labs set a limit of liability before accepting work. Courts generally don't like such limits when they are substantially less than the value. In the end, this particular lab went bankrupt and the photographer took legal action against the owner and accepted an undisclosed settlement.

I suggest that you work with a proven professional custom-processing lab in the first place. Such a lab will be taking serious precautions against the little things that cause film to be lost or destroyed. Its owners will also be easier to negotiate with in the unlikely event of a problem. You, on the other hand, should separate shoots into several processing batches, identify all rolls, shoot a slate frame (your business card works nicely) on every roll in case of loss in the lab, and take other precautions that help labs prevent problems.

Collecting Debts. Slow and nonpaying clients can lead you to a new career in the collection business. If you followed my suggestions in chapter 3, the estimated expenses and a portion of the photo fee were paid in advance. Collecting the balance, probably your profit, from these slow-paying organizations is a financial art. Remember, you hope to do future business with this client, so don't send Bruno the Enforcer, or your lawyer, over to their offices to make collections until all else has failed. Instead, ask your lawyer to write a friendly pay-up-or-deal-with-me letter as your first serious attempt to make difficult collections. The cost for this letter is about $100 and may be all that's necessary. The next step, which is the point where you probably lose future business from this client, is to completely turn the matter over to your lawyer. This generally means either a serious letter or litigation for your potentially former client.

If you are forced to take legal action to collect, call your work *goods* or *products* rather than a *service*. It is important to have the judge rule on this point immediately. Under the commercial codes of most states, if a photographer produces a product at the direction of a buyer and delivers that product, the buyer can accept or not accept the goods. If the product is accepted, it must be accepted at the contracted price. Trying to

collect for services is much easier for your client to defend against.

All of my paperwork, estimates, agreements, delivery memos, and invoices carry the phrase *use rights or copyrights transfer to purchaser/client upon payment of the invoice in full.* This means that you have the option to take copyright infringement action against a nonpaying client. This action involves a federal court, carries per-use penalties and, interestingly, is not a difficult legal action for an experienced lawyer to take.

■ COPYRIGHT INFRINGEMENT

Aside from the nonpayment invoice copyright clauses, infringement cases aren't that uncommon. The potential infringer must first get their hands on your images. This is easy. Some sources include: copies of portfolio drop-offs, color separations taken from printing houses, knock-off copies made by unscrupulous lab technicians, out-right theft by visitors and employees, and unintentional second uses by even the best of clients.

Lately, the most blatant copyright infringers have come from the many arms of state governments, such as universities and even some travel divisions. These people feel that the Eleventh Amendment of the U.S. Constitution grants them immunity against lawsuits for the recovery of money damages. Several courts have agreed in cases involving unauthorized use of copyrighted materials. At the same time, these courts have also allowed photographers' injunctions stopping further infringements.

When dealing with a government-related organization, cover yourself in writing before handing out images that may be copied. This protection may be available in your delivery memo, invoices, or an enclosed letter saying that the agency agrees not to make unauthorized or uncompensated use of the specific images being examined. The ASMP has been active in trying to correct the problem, and their legal counsel suggests the following language for your documents:

(The Organization) hereby expressly consents to the jurisdiction of the federal courts with respect to claims under the U.S. Copyright Act by (Your Name) and his/her legal heirs, legal representatives, and assigns.

■ LOST OR DESTROYED IMAGES

Most of the legal actions photographers enter into involve the loss or damage of their images. Rarely does an edition of *Photo District News* not include an article about lost images and subsequent legal actions.

The value placed on images by photographers is high and difficult to prove when considered in a major loss. Only photographers with a long record of business can quickly establish the potential lifetime sales value of their photographs. And even these people don't have an easy road legally. Settlement usually consists of months, possibly years, of haggling back and forth, and almost always results in loss of the client.

We photographers provide our best images to clients so they can create marketing campaigns aimed at making their products successful. Somehow, images get lost, stolen, or destroyed. What happens? Overreaction on both sides. Most clients immediately cut off the photographer from all communication and future work. Sort of a punishment in advance for who knows what. Then the client may even say, we never really meant to sign that agreement or delivery memo stating the images were worth X amount. Meanwhile, the photographer wants the images returned, or big bucks, and business to continue as normal.

Just for the record: photographers want to make Big Bucks selling images, not collecting for the loss of images in a legal battle.

The hassles about image values, never mind responsibility for loss, come because most organizations do not or will not provide adequate protection for materials under their control. This is not limited to clients. Photographers themselves should exercise the same care they desire from the customer. All too often, clients leave images sitting around on desktops, in unlocked cabinets, and in unsupervised mail rooms.

I can't understand an organization that will pay hundreds and thousands of dollars to use images but will not provide the basic security to protect them from loss. Can you see these same people leaving negotiable stock certificates sitting around on desks? Or not having valuable papers insured? Why don't these organizations have insurance coverage for photography—especially when these images are a major part of their business? If they did insure and secure them properly, then the insurance company could fight it out with photographers and their lawyers, while the creative business continued as normal. Such carelessness is just a waste of time and money.

Obviously, there are clients who take exceptional care of images.

There have been major legal cases concerning the loss of photographers' images. For years, I clipped and collected reports on these legal settlements and precedents being set in courts. *Photo District News* provided an excellent survey of the major image loss and copyright cases in their tenth-anniversary issue. Not much has changed in the twenty-first century. On the positive side, there have been awards that backed up the standard delivery memo valuing images at $1,500 and more each. On the negative side, all of these decisions were expensive in time, money, and emotional drain to both the photographer and client.

Every photographer who has fought over the value of lost slides finds the same resistance to any across-the-board valuation of images. Rarely will anyone roll over and pay this amount when several images have been lost. Obviously, there are some major photo agencies and big-name photographers who are able to command a higher rollover offer.

The best news about a standard value being accepted is the clout it brings to the negotiation table. New York attorney Joel Hecker, who participated in several of the cases I've mentioned, is my choice as the best shark in these waters. He is a master at quickly cutting through all the emotional problems that are created when there is a major loss. The first thing he does is establish the potential liability an organization faces should the matter reach litigation. He then establishes that his client is successful, that the images have a high lifetime sales value beyond the industry standard and, most importantly, that he is ready to play hardball.

If you have legal problems related to the loss of images or copyrights, it may require a lawyer experienced in this area. Expect to pay a retainer fee and let them handle the legal business.

In reaching any settlement for lost or damaged images, you are being compensated for that loss, not for ownership of the copyrights. Make sure the agreement has a clause stating that copyrights to the images are still yours. This may prove valuable should the images be found or mysteriously appear in print at a later time.

■ BUSINESS FORMATS

Setting up or changing the format of your business is the first thing you should talk about with a lawyer and a CPA. Initially, this means listening to advice and deciding to be a sole proprietor, partnership, corporation, or other type of business. Following this decision, it means taking a look at your liability in administrative paperwork, documents, assignments, and related business activities. But this is only the tip of the iceberg, so to speak, when it comes to legal advice and protection.

Anytime you are considering major moves or changes in business, be sure to include both your lawyer and CPA. There are always legal and tax liabilities involved in business changes and developments. Your lawyer can often simplify the paperwork and will always have your best interests in mind.

Real estate changes, drawing up wills, estate planning, insurance protection, sales contracts, copyright transfers, marriages and divorces, deaths and births, major new clients, audits, an accident, a fire, winning the lottery, and other major events should be discussed with your lawyer. While many of these occurrences are of a personal nature, they will directly affect your business posture, legal liability, and tax liability. Play it safe and talk with your business advisors when such developments take place. Following their advice could ensure that the developments are of a positive nature.

■ BUSINESS ETHICS

Remember that the way you operate your business will affect the next photographer to come along, just as yours has benefited from the goodwill of previous photographers.

Free Pictures. Take the name, address, and brief description, perhaps on a release form, of the people to whom you promise to send pictures, then follow up on your intentions. I'll probably be the next photographer who wants to shoot the quaint little market lady in Puerto Vallarta, Mexico. If you forgot to send her photo she'll be sure to let me, and all the other photographers who happen along, know about this oversight and not let future photos be made.

The promise of a free picture, in return for modeling in your stock, assignment, or other commercial photos, especially if a release is signed, constitutes a contract. Say one of these people sees a brochure with their photo on its cover. You can bet they will want compensation. Sending the free print helps cover your right to use the image commercially. It also makes sure you can shoot the subject again on future visits.

Credentials. There are a few photographers who claim to be shooting on assignment for well-known publications, and who take advantages that could result in legal action. One such photographer claimed to be shooting for *National Geographic* in the small fishing village where my father retired. This person had talked his way into free room and board, unlimited use of local transportation and fishing boats, plus

VIP treatment from the mayor. In meeting him, my father asked if he carried a letter of introduction from the magazine. He also mentioned that his son, who sold images regularly to NGS Books, would be visiting that weekend. The impostor fled town within the hour.

Few major corporations, publishers, or agencies with names everyone recognizes send any contractor into a location without proper credentials. This usually includes a letter of introduction, a press card, and expense account so their photographers won't have to bum freebies. And, such assignments always include advance local introductions.

There can be serious legal repercussions for photographers who claim to be shooting for an organization but are not.

If you don't have credentials, don't make claims that could get you arrested. When someone provides a photographer with a free anything, thinking this shooter will get their town or business in *Time* magazine, it's cause for attention. Sooner or later, someone will tell the local deputy, who may call the magazine.

This is especially true when a dirtbag says he's shooting for *Penthouse* or *Playboy* magazines and isn't. The editors will not be happy about someone using their name under false pretenses. Neither will the pretty girls or their big brothers.

Lawyers and the law can be confusing, intimidating, and infuriating to the unsuspecting, uninformed, and uninterested photographer. The legal system is there to protect and assist you in business and life. While it may be difficult to live with, the alternative is unthinkable.

8. LIFE AND DEATH AFTER TAXES

The one thing you can count on in life is taxes. For a variety of reasons, this has always been perplexing to photographers. If you think the tax maze is a problem, then it's going to be a problem.

■ TAXES

Every business day of your life is tax day. Taxes affect every monetary transaction in every business. When we meet clients to discuss a job, purchase materials, complete a shoot, invoice the client, and deposit the check, taxes play a not-so-silent role. How and when you choose to deal with the tax-related portion of these transactions will determine whether they are a problem or not. For the most part, tax problems are the result of not paying attention to organization and record keeping and, obviously, not filing tax returns.

As a business, you are legally obligated to secure and file the proper tax forms, be they federal, state, city, or otherwise. Fail to meet any taxing body's rules and regulations and you will be spending a great deal of time and money on unprofitable activities such as audits.

Pay your taxes on time, in full, and before any other expenses. The IRS has little patience or humor for those who ignore this basic rule of business.

The more you understand about the various tax regulations and the complexities of their accompanying forms, the fewer potential problems will develop. This knowledge doesn't require that you yourself become a CPA, but it does mean retaining a good one.

■ CERTIFIED PUBLIC ACCOUNTANTS

Certified Public Accountants (CPAs) are people whose job it is to know everything about taxes. Find a good one before starting a new business or at least before filing your next tax return. On the basis of the data received, CPAs provide information and advice on all financial aspects of a business. For instance, they will advise you on how and when to properly expense the purchase of photo equipment. They will help you separate business and personal expenses. CPAs can also prepare and interpret your monthly or quarterly P&L statement and help you plan future cash flow needs. It's important to be thorough, though: giving your new CPA all the financial and operational information that is unique to photography and your business is a must.

The primary question most independent businesspeople ask a CPA is usually, Is this a legal deduction? Or they may want to know what to do in the event of an audit. While such questions are natural, they are not aggressive enough. You should be asking: Can you get this accepted in the event of an audit? Will including this deduction, or other information, trigger an audit? Will you be there to take the heat for me in the event of an audit? Obviously, you want to prevent audits first and survive them second.

In considering your deductions, remember that most CPAs will not prepare materials that are in direct violation of regulations or law. They face even tougher penalties than you do for improper and illegal actions. There is a fine line between being aggressive with deductions and breaking the law. If your CPA will sign the year's return, things must be proper.

I am fortunate to have an astute CPA. In addition to being very knowledgeable in accounting and tax matters, his interests, like my own, include travel, photography, and beautiful women, not necessarily in that order. He was a major partner in one of the West Coast's largest retail camera stores, sole owner of a photofinishing store, operates a charter boat, assists a famous travel photographer on tropical swimsuit shoots, and is himself an avid photographer. In other words, he has practical knowledge of the financial operations of photography-related independent businesses. I don't have to spend any time educating him on the uniqueness of a location photographer because he's been on several shoots. Try to find someone who is interested in you as well as your business.

CPAs Are Not Bean Counters (Bookkeepers). It's my opinion that the independent businessperson with no more than four employees is their own best bookkeeper. They should control the flow of money and keep track of basic financial operations, up to and including initial preparation of tax forms for CPA examination and approval. If you expect to provide an accurate budget or job quote to a client, you must have a working knowledge of financial matters, including how much cash you need to make a profit on each job. For me, this includes signing all checks, reviewing incoming bills, and originating client invoices. Seeing a list of accounts payable just isn't the same as reviewing the bills you must pay. You can delegate the basic gathering of invoices, collections, check writing, and invoice writing to an office manager, but you should take an active hand in the overall financial operations.

If you're neither interested in, nor capable of, keeping basic financial books and records, a CPA's office will be able to provide these services.

CPAs Are Not Lawyers. CPAs have an extensive knowledge of the legalities related to financial, business, and tax matters. Often, they are retained by lawyers to answer complicated accounting and tax questions. However, if you've done something illegal, such as defrauding the government out of taxes or writing lots of checks on someone else's business account, a CPA will most likely advise you to get a good lawyer.

CPAs are not lawyers and, unlike lawyers, have no bounds of confidentiality when it comes to information, records, or materials you've provided. That means they must and will answer questions about your financial matters if so ordered by a court or the IRS.

All of this legal business leaves you with several choices. Never tell or show a CPA anything that might expose you to legal action. Or, upon getting the bad news, immediately have your lawyer retain your CPA to assist with the case. The information they are privy to falls under lawyer–client confidentiality.

I strongly suggest discussing any financial legal maneuvering with your lawyer and CPA before problems arise. Even better, don't do anything stupid enough to get yourself into such a predicament in the first place.

■ FIGURING COSTS AND TAXES

Everyone knows that personal federal taxes must be filed and paid by the 15th of April following each taxable year. This is only the half of it. Many independent businesses are required to figure and pay estimated taxes on a more frequent basis. Most states, counties, and cities have some type of tax that must be paid on a monthly or quarterly basis, in addition to the year's end tax.

It's almost un-American not to take advantage of every possible legal deduction available to your business. In doing so, it's almost un-American not to expect an audit.

The successful photographer should always know exactly what it costs to be in business, which includes tax liabilities. At the end of every month, or quarter, subtract from your gross income the fixed overhead costs, job expenses, and probable taxes, and the result is profit. Having this information on hand eliminates potential financial surprises. Figuring taxes on a regular basis is just another part of business administration.

Overhead costs generally include rent, full-time employees, utilities, debt service on business loans, and similar monthly costs. Most of these items are tax-deductible and remain the same throughout the year.

Job expenses are determined, obviously, by and on each job, and include such things as film, processing, props, equipment rental, models, assistants, transportation, and so on. This is an area where photographers may be vulnerable to tax problems. In an audit, which generally takes place three years from the job, it might be difficult to assign a specific expense to a specific project. Eliminate this potential problem by assigning an individual job number to each project and marking it on every receipt, check, and invoice.

My own job accounting method is to use a large envelope for each shooting project. As receipts come

in, the amount and job number are noted on the envelope, and the receipt is placed in the envelope.

Problem-area expenses include such things as entertainment, marketing materials, petty cash expenditures, non–job related auto expenses, long-distance telephone sales calls, and the like. These are areas where money can stray from business purposes, into your own pocket, while being deducted as business expenses. Taxing organizations such as the IRS do not like money to go astray for any reason. Your best bet here is to commit to good record keeping that shows the business use for each expense and deduction. Assign each purchase to a numbered budget account, and mark receipts accordingly. Back this up, when appropriate, with notations in your daily log. This may take a little time, but the alternative will be expensive.

In determining income on a monthly or quarterly basis, a general pattern and breakeven point will eventually develop, by which you can compare similar periods' expenses and income. If there is a major discrepancy in expenses or income, you should track down the cause. Financial problems, including business failure, occur just as frequently through uncontrolled spending and growth as they do from a lack of income.

Cash May Talk. Photographers often pay cash for their services and materials, which is hard to track in an audit. Try to keep cash payments for any business expense under twenty-five dollars. When you make any cash expenditures, always attempt to get a receipt. If this isn't possible, write yourself a cash-payment receipt that describes the business expense, with job number attached, plus the name and address of the recipient.

In my own business, which often involves foreign locations, larger cash payments are the only option available. For instance, a driver, interpreter, or guide may require immediate payment in the local currency. I cover these situations with the best possible written records. This includes writing myself a cash payment receipt, getting a signed receipt from the vendor, and making a daily log entry. The IRS will judge these expenses along with other record keeping. The better your overall organization, the less probability of a denied deduction.

Cash Accounting. Your business and tax financial system should be done on a cash basis. This means you count income when a check is received and deduct an expense when the money is spent. It's a simple and straightforward way of doing business.

On the cash basis, you may not receive a check in the same year that it was written. For example, let's say that you receive a large check on January 10th, dated December 10th of the previous year. Do you count this as income for the year in which it's received or the year the check was written? Keep in mind that your client will be sending a Form 1099 to you and the IRS, listing the amount in the year the check was written. In this case, I count the income in the year it is received, as it can be established that the money was not available until the date you received the check. This might cause an audit if your tax return shows an income amount substantially lower than the total of Form 1099s received. You must have a copy of the check, deposit slip, and related information to back up the transaction. It might also be a good idea to attach to these records the stamp-dated envelope it came in.

Now, on the other hand, you may need a few last-minute deductions this year, so you can write checks for deductible expenses on December 31 for immediate deduction. Just make sure the deductions are not for things that are really next year's expenses. Pay off your lab processing bill, an assistant's invoice for the last job, and similar items. You cannot deduct magazine subscriptions, early rent payments, or association memberships for the next year. A credit card charge made for a business expense this year, even though paid off next year, is a deduction this year. Remember that credit card interest is very high when you make minimum payments.

■ RECORDS

Good record keeping is the very basis of business administration. This is especially true when it comes to taxes, and more so when it comes to the IRS. Good records mean good organization. The place to start your complete and accurate record keeping is with the business checking account. Many smaller businesses like to utilize a One-Write check system, which enters each check into those tax deduction/budget categories we just mentioned. This can be kept in a simple computer program with check-writing capabilities.

The toughest IRS auditor will be much easier to deal with if you present them complete, accurate records of your business transactions.

The IRS Schedule C lists the basic items most independent businesses utilize for deductions. It follows that if the IRS has made provision for deducting certain items in their tax forms, they must be acceptable deductions. Again, let me stress that you must be able

to show that expenses and deductions are normal and necessary for your business.

Checkbook Listings and Comments. The following deduction categories are the same budget items listed in chapter 4 on administration, and are pretty much taken from the IRS Schedule C tax-return form. Most one-write check systems and computer accounting programs can be quickly adapted to these listings. I've included a few comments on each item as it may relate to your tax deducting.

Advertising. The cost of advertising in creative books, magazines, on the Internet and through other marketing media.

Bank Charges. The charges your bank imposes on business accounts. To simplify accounting, include the cost of checks provided by the bank. This is generally included with office expenses. Do not include bank interest charges.

Capital Expenses and Improvements. All office equipment, furniture, photo equipment, and major improvements made to business property. Even though you must pay the full amount this year, the cost for these items will have to be depreciated over their useful life in your tax return.

Car and Truck Expenses. Gas, oil, car wash, parking, and simple maintenance. Major repairs should be listed under *Repairs.* Lease payments for business cars should be included. There are some top-end limitations for luxury car expenses.

Commissions. Sales commissions you pay to agents and others. Don't include your stock agent's commission unless you issue them a check. And don't include payments to employees.

Dues and Publications. Professional associations and publications, such as yearly directories. A reference book that is used in more than a single year is not a publication, rather a business expense. This is generally included with office expenses. Smaller amounts can generally be deducted immediately, but an extensive professional library is a capital asset that may require expensing over its useful life.

Employee Benefits. Health, vacation benefits, retirement, and other non-salary/non-commission items paid to or for your employee, not yourself.

Entertainment. Expenses for a client, potential client, assistant, supplier, employee, and similar person, for a working business meeting over breakfast, lunch, or dinner. You will only be allowed to deduct a percentage of such items. Good records are important in this category. You should record meetings in a daily log and make pertinent notations on a credit card receipt, such as the business being conducted at the lunch. Other entertainment can include the theater, concerts, movies, and similar events that you can argue are ordinary and necessary to your present and future business. As mentioned earlier, expensive wines, lavish catering, Caribbean trips, fancy yachting events, and other similar items, even though necessary to business, may be a little more difficult to get past the tax people.

Freight. Air expressing of images to your clients and shipping of supplies to your location shoot or studio. This is generally included with *Office Expenses.*

Goods & Materials to Be Sold. Film, processing, props, and items necessary to produce your products or services. Include any sales taxes you must pay since they are a deductible business expense.

Insurance. All insurance you need for the business, employees, contractors, and rentals, as well as auto insurance on a vehicle used for business (or a percentage of the insurance equal to the percentage of business use) is deductible. You may generally deduct employee medical, equipment, liability, and property insurance. Your own health and life insurance, although necessary for business, fall under special requirements for deductions. Check the current deductibility of any insurance with your CPA or consult a tax publication before filing a return.

Labor (Wages). This includes your employee salaries, but does not include contracted help.

Office Expense. In addition to the other items mentioned earlier: postage; petty cash items; window washers; stationery; flyers; production of advertising materials; office supplies; sodas for visiting clients; paint for existing walls; temporary displays; small Christmas gifts (under twenty-five dollars each), and the like. Keep accurate and complete written records and receipts for these items.

Rents. Your office rent, equipment rental, studio rental, business equipment rentals, and car rentals.

Repairs. Any business equipment repair that involves fixing something that is worn or broken. Do not include any equipment improvements. For example, patching a hole in your office roof is a repair. Adding a new roof is a capital expense, or improvement, and must be capitalized. Your deductions for real estate property improvements must be capitalized over 31.5 years, even though your lease may be far shorter, which seems unreasonable. I suggest you try to get the landlord to make major improvements and raise your rent to cover the costs, which is immediately deductible.

Services (Professional). This heading includes the cost of any outside service such as lawyers, CPAs, bookkeepers, assistants, or models. These individuals must be in business and providing similar services to others. Ask them to furnish a business license and tax registration.

Supplies. Non–office supplies. Small items, such as expendable props necessary for business in general but not for a specific project.

Taxes. Any tax you must pay to be in business. Retail taxes, such as you pay on film, should be included with the cost of film, not listed in this category.

Travel and Transportation. Costs getting to a job (other than your business auto expense). Car rental, gas, air transportation, taxis, cars with drivers—even sailboats and helicopters, if they are a normal and necessary transportation item related to the job. You cannot deduct the cost of commuting from home to your studio or office.

The Tax Files. You should have an individual file folder established for each of the above expenses, along with similar files for income. When making payments, note the date and check number on vendors' invoices. Should any questions regarding a specific receipt come up, you will be able to easily locate both the receipt and canceled check. These files will also be easy to whip into shape for tax filing purposes.

The Daily Log. Your daily log of appointments, meetings, calls, assignments, and other important events, such as your wife or husband's birthday, is the place to make those notes that will affect your finances and taxes. For instance, list any money used in parking lots and meters, where receipts aren't available. If you keep a regular log it will be invaluable in establishing your whereabouts, marketing efforts, and entertainment for business and meetings.

■ POTENTIAL DEDUCTION PROBLEMS

As mentioned earlier, you must ask yourself whether each deduction stems from an ordinary and necessary expense to your business. While this is the first and best test in determining an acceptable deduction and the most important yardstick for listing one, it is unfortunately not the only one.

Keep in mind that IRS agents aren't stupid, so don't play dumb when planning or making deductions. Always follow the advice of your CPA.

There are a few areas that photographers have found immediately trigger IRS attention. While our expenses and deductions may be completely legitimate, the way we take care of requirements may not meet IRS standards. We also are involved in an unusual business with many unusual material and location needs. While we may hire a sailboat for photos, for instance, the IRS might assume it was rented for a pleasure cruise.

Travel and Entertainment. These are areas in which the IRS just loves to take a very close look at your business requirements and receipts. Be cool. Don't try to write off your vacation as a necessary business expense by saying you're a travel photographer, unless you can produce several travel-related invoices and printed pieces. There are photographers who shoot still life advertisement studio subjects most of the year and then shoot location scenics for a few weeks in Hawaii, sending the results to a stock agency for potential sales. If you take a similar working vacation, make sure to generate some serious sales or the IRS may call it what it was—a vacation. Writing off thousands of dollars in travel expenses over two or three years, and showing a few hundred dollars of related income, is asking for trouble.

Transportation. Normal transportation for a specific job, be it an aerial photo plane, location rental jeep, or a sailboat background prop, is a deduction. Just be ready to prove that it was normal and necessary. First-class air travel to a location shoot may or may not be accepted. Say the trip takes fifteen air-hours from your office to the shooting location, and you're expected to immediately start working. In this case the deduction may be okay. More than likely the client must make this decision, pay the tab, and take the heat for deductions.

In shooting a distant location or subject, you may want to travel and stay first class. This may be all right if you can provide a reasonable explanation. You may want to point out that traveling in business and first class usually includes unlimited amount of excess baggage allowance by many airlines, no matter what their official policy. This often makes up for the additional cost of the fare. First-class air travel also allows more room for in-flight work, such as correspondence, location, and subject research, equipment checkouts, and simple relaxation. You may wish to accept what the client pays for coach fare and pay the difference yourself for first class, deducting the additional cost.

As we all know, traveling ten or twelve hours by coach requires about two days for recovery. Whoever plans seat size and knee space at Boeing must be about five feet tall. It's certain they don't make many long coach-class flights themselves.

Auto Expenses and Depreciation. Auto expenses and vehicle depreciation are among the many things examined in an audit. That's because this is an area that may include personal expenses. The best way to eliminate any problems is to have a company car that is used only for business. In doing this, all the expenses, insurance, parking, and so on, are much easier to track and deduct. There are some upper-end deduction limits for the use of luxury cars.

Keep a mileage and destination log in all of your cars and make an entry for every business use. At the year's end this log can be separated into business and personal miles traveled, making your deductions and depreciations for vehicles quick and easy.

Commuting from home to studio is not a business expense, nor is it business use of your car. If your sole office is in the home, driving to a shooting assignment is a business use and deduction. I make specific personal and commuting mileage entries in my daily log.

An auto burglar alarm, built-in security box, and secured parking expenses are both reasonable and deductible. Major equipment losses are also deductible in the event that you don't want an alarm or insurance.

Entertainment. Entertainment is an area that makes political and IRS hay in the press and in your audit. It's okay to entertain clients, potential clients, suppliers, models, and the like, so long as it relates to business. I've found that such entertainment, if well thought out, does result in better business. For example, I try to host a nice, not lavish, lunch or dinner, in an expensive restaurant with plenty of atmosphere, for a client before or after a major photo shoot. This allows me to say thank you for the job, give them an overview of how things went, and make a sales call for future work. I know the deduction will be reduced by a percentage but feel it is a normal and necessary part of my business.

Some businesspeople like to entertain clients at football games, the opera, pool halls, Las Vegas, on expensive yachts, at the movies, and other places. The more expensive and exotic your method of client entertainment appears, the more closely it will be examined. If the auditor smiles, you can probably get it past; if there's outright laughter, try looking them in the eye and offering a reasonable explanation; if they fall on the floor in hysterics and point it out to other nearby auditors, get ready for some serious negotiation. Your best bet is to have your CPA face the music on such deductions.

Depreciation of Equipment. Depreciation of equipment is also a sensitive area in the business of taxes. Photo gear, cars, and computers are the type of equipment abused in many tax deductions. While they are perfectly acceptable as deductions in a photographer's business, an auditor may desire a closer look to see that things are being handled correctly and that the items do not include any personal use.

The IRS has an equipment table that lists general types and the number of years over which items may be depreciated. I have found that this table doesn't always relate to my specific equipment use or longevity. For instance, I replace most of my daily working cameras much faster than the table allows for depreciation. Since my replacements fall into a very normal long-term pattern, I deduct these purchases over their real life. I can easily and quickly back up this area with paperwork and receipts. The auditors have accepted this depreciation because I have kept such excellent records and established continuity. On the other hand, many photographers make out because their equipment lasts years beyond the IRS table listings.

There is a current provision for depreciating a large amount of business equipment in a single year. You might wish to hold classification of all equipment depreciation until the Schedule C form has been figured the first time. You might need to adjust the depreciation schedules, which is acceptable, to fit a tax strategy.

Employees and Independent Contractors. These are a prime area of concern to the IRS and most state revenue departments. Whether full- or part-time, any person who makes the majority of their income from your business is an employee. This is the position most governmental bodies take, and they will levy back-tax penalties and plenty of paperwork if you don't agree. The IRS has a publication (Circular E) that explains the various tests that must be met for employees and contractors.

An independent contractor is just like you: they have a business license, tax registration or resale permit, business stationery, and invoices. The principal test of an independent contractor is in accepting jobs with several clients.

If you begin to utilize the contracted services of someone on a constant basis, say two or three times a week, they may be considered an employee in an audit. Your choice is to seek a few other contractors or pony up with an employment position.

I send a version of the letter that follows to independent contractors.

> *Dear Freelance Contractor:*
>
> *I have accepted an agreement to produce photography for XYZ Corporation. As a second photographer* [or production manager, location manager, etc. (Calling them an assistant may also be calling them an employee)], *you will be working with me on this project as an independent contractor. Our immediate creative direction will be from the XYZ marketing manager.*
>
> *As the prime contractor, I will have the overall responsibility for photography. You will be responsible for production [or lighting, logistics, backup photography, etc.]. Each of us will be expected to provide our own ideas, direction, insurance, and equipment for several situations to be specifically listed in the job memo.*
>
> *To simplify the project, I will present an overall invoice to XYZ, which will contain your invoice to me for time, equipment, and related expenses. Because you are an independent contractor, I will not withhold any taxes nor provide insurance coverage. I will issue you a Form 1099 at year's end showing all payments. To meet strict state and federal requirements, I need a copy of your business license, tax registration, social security number, and proof that you provide similar services to other clients (i.e., business card, stationery, and promotional flyers). Please sign and return the enclosed copy of this letter along with these items.*
>
> *I look forward to working with you on this project.*
>
> *Sincerely,*
> *Photographer So-and-So*

Most contractors should already be aware of the problems associated with independent status and will cooperate with your requests. No matter how good your letter or agreement, make sure they really are *independent*. If one of these people makes their entire income from your business, they will no doubt be considered an employee.

Many states consider models, stylists, and the like, to be employees for insurance and unemployment coverage. Try to have the client billed directly for such outside services. Most of my clients have knowledgeable accounting departments and can deal quickly with the forms and requirements.

Several states, especially California and New York, have very strict requirements as to who is and who isn't an employee or contractor. This is such a hot tax topic and audit-causer that it's best not to guess. Talk with your CPA in advance.

Speculation and Inventory. In most normal businesses that make and sell their own products, the cost of such production cannot be expensed, or deducted, until the year in which they are sold. Their products are inventory, which opens up a different tax situation. Imagine the potential problems this would cause stock shooters, whose images might sell over several years, sell many times in a single year, or never sell at all.

Thanks to a special act of Congress, through a consensus amendment, photographers can speculate on shoots and do not generally have to consider their stock images as inventory. As a self-employed photographer, you can deduct the expenses of making images for sale as long as they are incurred in the normal course of business. This prevents doctors, retired pilots and teachers, and others with established incomes from spending giant amounts of money traveling around shooting photos for possible stock sales. The IRS is likely to call this type of activity a hobby rather than a profession, unless you show a profit.

This ability to write off photo expenses is also extended to artists, the authoring (writing) of book manuscripts, and similar activities. It does not allow production costs for motion pictures, videos, magazines, and books, all of which must be capitalized. For example, you can deduct all the writing, photography, rough drafting, and marketing of a proposed book. The printing, binding, and storage, however, must be capitalized over the life of the book.

You can thank the people at the professional photo organizations for their campaigns on behalf of commonsense photography tax legislation. Their intensive lobbying efforts were largely responsible for the Tax Correction Act just described.

Homes with Offices. This is another area that tax auditors examine closely. Their first concern is that a business is established in your home, not just a hobby activity. Making a profit is the best way to eliminate an auditor's major concerns. If a home office is the sole office of your full-time profitable business, there should be no problem.

If you have a downtown studio and an office in the home, be ready to prove that the home office is necessary. In my own case, a home office has been necessary for several reasons. My downtown office and studio is very busy with the sale of stock and the administration

and production of assignments. This activity makes it impossible to work on things that demand quiet concentration, such as writing correspondence, completing complicated tax forms and filings, researching trade publications, and producing very detailed job proposals and bids. In the home office, I maintain a separate business telephone line, answering machine, fax machine, word-processing computer, calculator, business library, and working file system. I consider this home office a small business expense and take only a few reasonable deductions as a result.

I don't depreciate any part of my home as a business expense, even though this is permissible. Doing so would have expensive tax consequences when the home is sold.

◼ PROFIT PLANNING

If you want to make money in any business, it requires profit planning. This means paying attention to the costs of being in business. That's essentially everything we've been discussing in this chapter. Mostly it's knowing exactly what you need to gross in order to cover all expenses and make that profit, for every working day on every job.

Although the day-rate method of quoting jobs seems to be dying out, it's still one of the best ways to average out your expenses and income against profit and loss. If you aspire to make $200,000 per year, for instance, that means making about $2,000 per working day. The average photographer will have an unpaid planning and a postproduction day for every paid working day. In a year this means one hundred planning days, one hundred postproduction days, and one hundred paid working days. The average year is rounded out by giving yourself sixty-five days off for holidays and weekends.

Profit means bringing in more money than you spend as a business.

The best way to start making a profit is to reduce the possibility of a loss. This means examining and controlling every possible activity. Try to eliminate lost materials, too much overhead, wasted person-power, unnecessary credit card interest, and unproductive non-assignment time. Establish a base price for all materials and a base rate for your time or stock images. Start high in setting prices; you can always come down.

Do not, however, spend all of your financial planning on the area of eliminating losses. Don't get so caught up in the minute costs of every item, strict time scheduling, and job planning that you forget what it takes to make money in the first place: sales. If you're going to take a few chances with spending, make sure it's in the area of marketing and sales. Send out an extra flyer or postcard, make a few more long-distance telephone calls to buyers, take more art directors to lunch, and update your mailing lists. Expenditures in marketing and sales should be considered an investment, not an expense to cut and reduce when things get tough.

Speaking of profit, even the IRS allows that a business is a business, rather than a hobby, when a profit is made every three or four years. New businesses should project about three years of investment before they have repaid costs and show a profit. If you expect to make Big Bucks, things had better be looking pretty good client-wise and profit-wise in about two years, looking great in three years, and fantastic in five years.

Otherwise you should be looking for another line of work, anyway.

◼ FILING TAXES

If you've kept track of the various business transactions outlined earlier, tax filing periods should simply be a matter of compiling various receipts and invoices, perhaps via your computer, and filling in the forms. Of course, we know it's never that simple.

Tax Forms and Planning. If you really want a scare, drop by an IRS forms office around the first of March. This is the time most businesspeople start picking up the paperwork and publications for upcoming tax filings. If the jam of gloomy people isn't enough, the overwhelming number of forms will do the job. I doubt if anyone really knows how many tax-related forms, instructions, and publications exist. That may be a result of the illogical numbering and lettering system. Of course, the IRS doesn't have to show a profit to stay in business.

There are many excellent guides covering tax form and the planning and filing process. My first choice for information is the IRS. They have a publication or instruction sheet available for every form. If you follow their instructions, and, of course, your CPA's counsel, things should go smoothly. Their yearly *Tax Guide for Small Business* is one of the most complete information sources available. It's free for the asking.

Only a few of these many forms are necessary to the photo business. In addition to the year-end forms, there are three or four areas and forms that photographers need to understand in advance. Tax planning

includes knowing what happens and what is required for every business activity you undertake. Reading and researching the forms will show you how to plan and what to do in every transaction. Talking with a CPA is a must in this area.

Schedule C Form. Most of my basic budgeting and tax planning is centered around the Schedule C (form 1040), which is also a simple profit or loss form. While this isn't required for corporations, its use as a worksheet is handy for smaller businesses. I use each year's completed Schedule C as the basis of my next year's planning and budgeting.

The IRS looks carefully at your Schedule C for any unusually high areas of deductions. For example, my own business involves extensive air travel, which clients often require me to include on their invoices. This means both my expenses and income are artificially inflated. I attach an explanation of the unusual amount of travel expenses, noting they are all business-related and reimbursed by clients. Even at this, an auditor may want a closer look.

My CPA advised me that a loss on the gross income line, which is called adjusted gross income, will generally draw an audit. This is the figure you get when the cost of goods is subtracted from all receipts and sales. This gross income comes before any business expenses have been deducted. In other words, the basic cost of materials to produce your images, excluding expenses, should not be higher than your income. Sometimes business expenses, which come after the gross income figure, do result in a loss.

Depreciation of Equipment. All businesses depreciate any major capital expenses on Form 4562 Depreciation and Amortization. This is the form where you list such purchases as an automobile, cameras, office machines, real estate property costs, and improvements. While the form is not too complicated, the information is important for future years' tax planning and deductions. The IRS provides separate instructions for this form.

Form 4562 is also where you must justify automobile use and related expenses. An advance examination of the requirements in this form will tell you exactly what's needed throughout the year. It's very difficult to reconstruct automobile expenses that took place three years ago when it comes time for an audit. Having the exact information available will significantly reduce the length of an audit.

Once an item has been completely depreciated and used in your business, it may still have enough value to be sold or traded. The income for this transaction must be reported on Form 4797 as the sale of business property, and on your 1040. Don't include the income with your photography income; otherwise it may mean paying unnecessary self-employment and social security taxes on the amount.

Contractor's Income. You must report payments to any person or company that is not a corporation that total more than $600 in a given year. This is done using Form 1099. Assistants, models, processing labs, rents, repairs, and any other business expenses you pay a non-corporation must each be issued separate forms, with a copy sent to the contractor and the IRS. If you fail to issue the form, it can mean a fifty-dollar fine for each omission.

As an independent unincorporated businessperson, you should receive several 1099s around mid-February each year. These will include fair market value of any trades or bartered work. Make sure the forms accurately reflect your income from the issuing party and accurately reflect your reported income to the IRS. If they are incorrect, notify the issuing company immediately for a new one.

Royalty and 1099 Income. There are several boxes on the 1099 form that can list money paid to you. If income is listed as nonemployee compensation, make sure it's listed as that and included with your Schedule C Income. If it's listed as royalty income, which some stock agencies and book publishers do, make sure it's listed with royalty income. This is a sticky area, because the income may or may not be what is reported. However, the IRS will look at your incomes in these different areas and match the amounts with the 1099 reports from the organizations issuing them to you. The numbers must match *and* be listed in the same category, or you'll get a note from the IRS wanting to know why they don't.

Estimated Taxes. The IRS requires businesses and individuals to pay estimated taxes if income is more than five hundred dollars in a given year. Estimated taxes must be paid on all income that is not subject to withholding by an employer. You will be assessed a penalty for underpayment and overpayments, which seems unreasonable to me, but they don't ask for my opinion.

Personally, I find preparing my taxes three or four times a year, and paying any estimated taxes, more work than it's worth. There's an easy way to eliminate these estimated tax computations, forms, and payments. When I pay taxes on the 1040 form for a given year, usually around April 1st, I immediately file an estimated tax payment for the same amount paid, plus

ten dollars, on the same form. In other words, I have just made a double tax payment. The IRS accepts this "safe harbor" payment and will not assess any penalty if you make more in the coming year than the previous year. On the other hand, they will fine you for filing estimated returns that are too high or too low. Of course, this additional payment with my 1040 means not having the money to work with for a few months. It also means I can pay attention to the business of making money rather than wasting valuable time on multiple tax computations.

■ AUDITS

The best general advice I can offer on all tax matters, forms, and filings is to be on time, accurate, and complete. Elimination of these basics will almost certainly cause one of the least productive expenditures of time and money: the tax audit. No one enjoys an audit, not even the auditor, who must put up with unhappy, nervous, and sometimes abusive taxpayers.

The chances of a independent creative business being audited are better than most professions. Today, local and national governments need tax dollars more than ever for the projects they think we need. The auditors for these bureaucracies always seem to find more money due than we have paid in taxes. And freelance photographers are an easy target. That's probably because we're in the unusual position of selling services, stock inventory, and products, wholesale and retail. That sounds like several businesses, which offer several opportunities for mistakes. And photographers make as many mistakes in their tax computations as any other business.

The best way to avoid an audit is to make a profit and pay taxes. The IRS is more interested in people who make a profit and don't pay taxes.

Photographers often pay little attention to the details of business expenses, good records, and receipts. Making photos of exotic places and subjects, like renting classical dancers for a Bangkok location photo, will cause tax people to have a hernia of the eyeballs. Plus, photographers often think they are cool and don't really have to explain trips to Tahiti for shooting stock photos. The IRS doesn't appreciate cool.

The Selected Ones. Every tax return and information form is examined and compared to the average return. And on the average, photographers don't fit and seem to be among those frequently selected for audits. That's because our travel expenses are high; we deal with a great number of photo buyers who often make mistakes on our invoices and forms; and because some of us choose to live and work in the same space.

Of course, we can be selected for an audit on a random basis, too, which means a general look at one's entire business and personal financial life. These random audits make up those averages the IRS uses.

The profile audit is something that more specialty photographers face these days. These are conducted on unusual businesses—especially those doing something exotic—to establish a complete set of tax guidelines for others in the same specialty. For example, you may be an underwater photographer, a paparazzi (celebrity ambusher), a celebrity who is a photographer, an anthropological research photographer, or a travel photographer. Any specialized field-within-a-field may trigger these audits. They are lengthy, difficult, and expensive in both time and money. I highly suggest letting a CPA handle the entire audit should you be unfortunate enough to be selected for a profile audit.

Audits are also initiated when there are major changes in a business. Let's say you have a great year and make twice as much as the previous year, which means twice as many deductions. Say you have a poor year with twice the deductions and the same income. Odds are, such fluctuations will trigger an audit. Fall out of the normal tax return, file late, fail to pay, fail to file proper unemployment insurance, have too many independent contractors and no employees, or do anything unusual, and it may become audit time.

A final word about what causes an audit. Make sure the income you report on a tax return matches the amount of deposits you've made in checking, savings, and other financial accounts. If your deposits are much higher than the reported income, you will get an immediate audit. The IRS won't wait three years. And make sure you claim all your income, no matter what the source. Failing to report income of any kind will not make the IRS happy.

The Audit. What to do in the event of an audit and during an audit has been the topic of countless articles, books, guides, seminars, and late-night prayers. There's really not much to worry about if you've kept proper records, filed returns on time, and paid the amount of taxes that a CPA thinks is correct. The IRS is looking for people who abuse the system, not photographers who play by the rules.

Even if you are well-organized and work within the established tax routine, the IRS may send its letter of

greetings. Don't worry, thousands of audits are conducted every year, and most come and go very quickly. Yours should be no different—but don't hold me to this.

In the event that you receive an audit notice, make an immediate appointment with your CPA. This is the time to retain a CPA if you haven't done so in the past.

Giving advice on and handling audits is what CPAs get paid to do, so let them do it. Let the CPA represent you in any meeting with the IRS. This is perfectly fine with the IRS, and it will relieve you of being put on the spot, having the cold sweats, missing important work, and facing any unpleasant questioning. At the very least, take a CPA with you to the audit for on-the-spot advice on procedure and your obligations. I say this because auditors tend to ask leading questions that you may misinterpret. Your CPA is experienced in these matters and can help answer questions correctly.

Your notice of audit should be specific as to what information and records are required. After talking with your CPA and before setting up the audit appointment, give yourself a quick audit. Examine all of your records for the item or year in question. Make absolutely sure you can back up every expense and deduction claimed and filed on the return. If you've found any business expenses or income not included in the return, perhaps lost in a job file, include them with your materials. At this point, let your CPA take over. In fact, let him or her go to the audit alone while you're taking care of your photo business. The IRS will grant as much time as is reasonable for you to get records ready, but don't expect more than a few weeks.

Trade-Outs. All tax auditors will look for income that is not contained in your returns. This will include such things as work for barter (trade or exchange), unusual numbers and amounts of cash transactions, or lots of foreign income, which may include foreign bank accounts and tax shelters. Keep in mind that for some successful and retired people in other professions, freelance photography is a tax shelter or hobby income for themselves or their spouse.

If you accept anything other than money for photography, claim the fair market value as income just as if it were money. That's what the IRS will do when they discover you have done a barter or trade transaction. This is true even if you make the exchange for business-related items or purposes. In my own work, there is a tendency for resorts to offer accommoda-

tions in return for additional shooting beyond the basic contract. I'm not crazy about this idea, as it causes potential tax and record keeping problems.

Going Solo. If you are stupid enough to take on an IRS audit alone, follow the written requirements to the letter. Bring no more or no less information and records than they have requested. Offer short, simple, and complete answers to their questions. If you are unsure or unable to provide the correct answer, say so or ask for a later appointment to allow time to get the information. If you have any question about what's going on, say so. Auditors, contrary to popular belief, are human beings and have a job to do, which they want to complete quickly and efficiently. If this isn't the case, ask to see the auditor's supervisor or schedule a later meeting and bring a CPA.

The Extras. If you're preparing for an audit and all the records are complete, there may be a few additional things that will help. While I don't recommend providing anything the IRS doesn't request, there will come a point in the audit when the CPA can't accurately describe your business. At times like this, it might be appropriate for the CPA to have a sample of your promotional flyers, a few of your clients' printed materials (with your photos), printed proof that exotic location photos were used by a client and—here's the clincher!—a photo of your sick grandmother.

The Penalty. In the event that your return is not accepted as filed, there may be some additional taxes due, perhaps a penalty as well. If you've made an error in calculations, forgotten to include information or something minor, expect to pay the tax and interest. If you've done something a little more aggressive, like including your family vacation as a photo shoot, expect additional taxes and a penalty. If you've done something that the auditor considers a serious violation of law, expect serious trouble. You have the option of appeal to a tax court hearing for any conclusion reached by an auditor. Your CPA and lawyer should be consulted in such cases.

Be advised that all governmental organizations have computers that talk to each other. If you've done something unacceptable to the IRS it's probably unacceptable to the other taxing authorities, and they will also be sending you an audit notice.

The IRS has plenty of time and people to check out every tiny detail of your business. The better your organization, records, and preparation, the less likely they will be to take advantage of this superior position.

9. WHY PHOTOGRAPHY SELLS

■ CREATIVITY VS. SUCCESS

Creativity is important to the art of photography, but don't allow it to drive you out of business. Instead, make it your business. Try to apply some creativity to business and some business to creativity. Innovative ideas about the business of photography have provided more than one success story. For example, Winner's Circle photography at the local racetrack. A sharp businessperson realized that every horse in the winner's circle was a money winner at that moment. The horses' owners and their friends could be a quick sell for a picture that commemorated the win. This was one of photography's more creative business ideas, and one that requires little creativity in the production.

Why Photography Sells. Photographers often equate the degree of difficulty in making a picture with its value. A shot that takes hours to set up and shoot might only draw a yawn from potential buyers. But a quick snap of your daughter playing in the backyard mini-pool could have all the art directors in an ad agency calling you a genius. As my old grandpappy would say, go figure—which is exactly what you should do. Figure it out.

The snapshot that has all the art directors excited was exactly what they were looking for at that moment. At a later time, the more difficult shot could also become their perfect shot. You see, art directors, editors, and other photo buyers have a built-in need to change their minds at least once in any given project. Would you believe twice?

There are photographers who can read a photo buyer's mind, and they are the ones who make the Big Bucks. Believe it. You see their work everywhere—in both ad campaigns and in magazine features.

You can learn this little mind-reading trick. Photographic clairvoyants do it in several ways. They know exactly how to make an image with a market value and what the market will be for that image. You read what's in the mind of the average photo buyer by first reading the materials produced in their agency publications. This is too easy, right? Their own materials give away the very type of materials they buy. Of course, the minute you copy a style they already have available, they will bid you a farewell. Your job is to create yet another link in their artistic quest for something new, different, and exciting. Their job is a never-ending search for a new and exciting image. Some of them are also looking for a cheap image.

Your job is easy. Just read photo buyers' minds and be at the right place with the right shot at the right time. Works every time.

The best art directors create new images for their own market. Seek out every possible opportunity to listen to these art directors and other photo users/buyers. This may be at a portfolio review, a job proposal, a seminar, or a lunch. These people will tell you what they need, what their market trends are, and what you should be shooting and selling. The trick is to listen to their wants rather than telling them what you think they need. Photographers who are really good at making marketable images on their own are sought after by many sources, especially stock agencies. Just one of their good marketable images will have several potential markets and several potential sales. Obviously, these photographers are also good at promoting these skills.

■ PHOTOGRAPHY AS A PRODUCT

Most image buyers consider photography a product. They have a marketing need and we supply images. They pay for the product and use it to fill their need. This means we're dealing with photography on a money basis: so much product for so much payment. The client automatically categorizes us like so many shoes in a shoe store. If there were as many shoe stores in my area as there are photographers, people would be wearing shoes on their hands, too.

Much of this treatment as product suppliers comes from the stock agencies, which are selling a fixed and known product at a fixed price. We show them the goods and they either buy or look for other goods.

Producing a product for sale involves one of two things: creating something that is in demand or creating a demand for something. Until your market and reputation are so good that there is a constant demand for work, you must create a product for an existing or known market. Think of the many ways marketable images are being sold right now with photography outside the agency, magazine, and client sales. Art litho prints hanging in galleries, postcards, posters, photo books, the World Wide Web, and photo discs are some photography products that exist or were created for sale in a known market.

By thinking in terms of product, rather than creativity or art, you are also forced to think about the business approach. This isn't as much fun as shooting pictures all morning, but knowing about markets means learning what's in the minds of photo buyers.

I set product-producing goals. That means shooting X number of images, strictly for their commercial value, each month. The subjects of these shoots are found in my agency and publication research, through talks with art buyers and via my own wide range of interests. I keep an active list of potential photo subjects with my daily and weekly schedules. Whenever there's a gap in assignments or other work, I plan a shoot around one of these subjects. While most of the images end up as stock, many clients are interested in seeing them because I've already advised potential users that a special shoot is planned. Many of these potential buyers will provide suggestions for these speculation shoots, which always means a sale. This product producing keeps me sharp, which the client demands, and busy, which my psyche demands.

■ PHOTOGRAPHY AS A SERVICE

Why are certain airlines such as Alaska, British Airways, or Singapore, regularly chosen over other air- lines that fly the same aircraft on the same routes and for the same price? Service. Should it be any different for your photography product?

Successful businesses are the result of three things: quality product, competitive price, and superlative service.

If you want complete success, combine a quality product with the best service possible. You'll be surprised at the effect this has on both business and income.

The Basics of Service. If you always deliver top quality photography at a competitive price and meet each deadline, preferably with a friendly smile, there will be food on your table. It doesn't take a marketing genius to figure this out, although many business-people are miserable failures at meeting even the most basic level of services.

Service is delivering what you promised when the client needs it and at the price quoted. And, in a professional manner.

If you're going to call yourself a pro, then provide professional services. The following is my list of ten basic rules of professionalism:

1. Be on time for all appointments and meet all deadlines.
2. Dress and act better than the client might expect.
3. Be prepared for every client meeting.
4. Know something about the client's product.
5. Know something about the client's market.
6. Know something about the client.
7. Follow up when you promise something.
8. Confirm important details with a note.
9. Come in on or under budget.
10. Remember who pays the bills.

If these rules seem like little more than common sense, that's because they are common sense.

The Client's Marketing Goals. Every client to whom you hope to sell photography has, in turn, a market in which they hope to sell a product. Your photography is one of the tools the client hopes to use for this sales effort. It's not the only tool and may not even be the best tool. It is, however, the tool you are providing. It's your job to make sure the photography they utilize does the job for which it is intended.

The more you know about a client's market and sales efforts, the better your expectation in meeting their goals. Read about the company's goals in their public advertising and sales literature. Call their public relations or sales office and ask for information. Start a client file. Subscribe to their magazine. Buy a few shares of stock. Use your imagination.

Businesspeople like to deal with suppliers (which is what we are) who don't require a lot of time being brought up to speed on their company. If a potential client thinks you're a little too slow on the uptake about their business, they may also think you're a little too slow for the project at hand. Listen to what they're asking and telling, and show them a little savvy at the right time.

■ IDEAS SELL PICTURES

National Geographic magazine has always been a magnet for talented photographers, and as a result, the people who are on staff and under contract are among the best photojournalists in the world. Ever wonder how the editors determine who to hire for an assignment when there are so many good portfolios to sift through? Bill Garrett, a former editor and an outstanding photographer himself, says the photo editors at *National Geographic* are up to their necks in talented photographers, but only ankle-deep in talented ideas.

Try to present some interesting ideas to a prospective photo buyer. This means an intelligent approach that includes their editorial concept, product, or markets. Do this in a portfolio meeting, via letter, at a social lunch, or anytime the client offers to listen. The ability to develop and share ideas may mean an opportunity to strut your stuff. And, as I've said before, opportunity is all we need.

Make sure you can outline ideas and projects quickly, or the opportunity may be lost. Always say, "I'll follow up with a note on this project." This note will give you a chance to explain the idea in detail and retain its authorship. The latter usually means getting the shooting nod.

Coming up with ideas to sell a client's services and products is a basic part of marketing to any client. Help a client sell their product and services using your photos naturally. With an advertising agency, this may include speculating with the agency to gain them a client. With a magazine, it may include shooting a speculation idea to get their editors' attention. This goes right back to the concept of creating a demand or market for your work.

Once, a recreational park hired me to shoot a one-time consumer sales brochure. In the process of researching the client and making the images around the park, I found they played lots of rock-and-roll music because their customers were mostly teens. I suggested that a multi-image television spot, using lots of wild stills from the park, be produced with a hot rock song backup and advertised on MTV. While this was a new media and medium for the park, they loved the idea. It worked, too, and I got to direct the commercial.

I know photographers who carry a portfolio of sample brochures, postcards, calendars, and similar printed materials around to small hotels, motels, restaurants, and tourist attractions. Their sales pitch is to collaborate with the client in shooting a special photo for something like a postcard. The card can be used for promotion, or for sale at the front counter, or can be sent out to commercial mailing lists. First, the photographer offers to share the profits from postcard or poster sales, but the idea is to sell the cost of the photo shoot. Sounds pretty small-time, right? How does $150,000 profit sound for an average year of selling postcards?

Sooner or later, there will be an opportunity to discuss a client's marketing goals. Usually, you will be given an outline while examining a proposal or portfolio. This is the time to offer ideas to help meet the client's marketing and sales goals with your photos. Even if the client has tried everything you suggest, they will appreciate the educated interest in helping. Just make sure this interest is educated.

■ BEST-SELLERS

The users of photography determine the best-selling images. You only have to look through one of the more popular general interest magazines to see what and where the best-selling photography is today. This type of research is the first step in producing your own best-sellers.

Best-selling images are created by the marketplace, not the photographer.

In reviewing top-selling images over the years, it's been my experience that the best images aren't always the best-sellers. These are images that sell over and over again, the ones with a continued commercial value, but generally not Pulitzer Prize winners, or any other prize winners for that matter. Often, they aren't even flashy images. Mostly, the best-sellers convey a

feeling of warmth, of welcome, of contentment, and of satisfaction, which is *always* successful in selling a product.

Your Photo Interests. My business of selling images related to travel isn't an accident. It was planned because I like to travel, explore cultures, meet people, and make photographs. The adventure of travel enhanced my love of photography.

There are a number of successful photographers who are not primarily in the business of photography. For example, Kenny Rogers, the singer and actor, is an excellent photographer. His images and books have become a successful business in themselves. This is a common practice for other not-so-famous professionals, including doctors, dentists, police officers, pilots, salespeople, and anyone else who has both the desire and access to interesting photo subjects.

My point is that you should be making and selling photos of subjects in which you have an interest. There is no need to search the world for something exciting or exotic to photograph in order to earn a living in photography. The subjects are literally in your backyard.

If your images make people want to buy a product, the client will buy your images.

Your Personal Photography. Your personal photography—the making of family photos, the general recording of things that are important to you, and artistic experimentation/testing—should always be part of your career.

Try to schedule a little time every so often to make personal images. Evaluate and compare these images with your business of commercial shooting. Are you applying the same creative eye to your commercial work? Are you growing as an image maker? Are you still thinking and seeing images? Are you applying personal interests to the making of commercial images? Are you happy with your commercial work? Are you happy with photography as a business?

Your Best-Sellers. Every successful photographer has a number—hopefully a growing number—of images that seem to sell over and over again. The more you know about these best-sellers, the more of them you can produce.

Best-sellers beget more best-sellers. If you have ten images of different subjects or situations that seem to be continual sellers, they should be the basis of at least one portfolio.

At the end of each year I review the total number of images sold, the total number of clients sold to, and the number of times each top-selling image has sold. I separate stock from assignment, although both contribute to best-selling images. Overall, this research gives me an idea of what sells well and in what markets they sell the best. The number-one question is, of course, how much money does a best-selling image make? The second question is, how many times and places does it need to sell to become a best-seller? An even more important question is, can I plan and count on shooting more of these best-sellers?

Remember that an image sells for reasons that go far beyond quality or even impact. It must be the right image in front of the right photo buyer at the right time. Repeat this process enough times and you can earn a great deal more income than is needed just to put food on the table.

10. SELLING IS ALSO AN ART

The art of a salesperson feeds the art of the photographer, rarely the opposite. You're not in business to make photography, but to sell photography.

There are literally thousands of markets available for good photography and good photographers. There are also thousands of photo buyers within those markets. In order to succeed in finding and reaching these markets, you must be as creative at selling images as in making images. Nothing is more important to your success than persistent selling. You must sell in order to get the assignments that allow you to shoot great pictures. Young photo businesses can expect to spend about 75 percent of their time selling and administrating in order to shoot 25 percent of the time. Eventually, sales efforts and images will build up your reputation. At this point, the time spent making images may become equal to the selling.

No matter what they may say now, the world's leading commercial photographers established their reputations by selling themselves and their images. Open any major magazine on the rack and examine the photography in advertising and editorial pages. There will always be a few outstanding shots and a few that belong in the round file. How do those below-average pictures make it into print? Simple. Because the photographer was better at selling than at shooting. Some businesses, including a few photographers, have achieved huge successes by the skillful selling of average products.

The ability to make great, marketable images shows good sense in creativity and business.

Once again, don't get me wrong. I think quality images should be the basis of why you enter business in the first place. However, the ability to sell these quality images will ultimately determine your degree of financial success.

■ MARKETING IS NOT SELLING

If your business is going to succeed, you must know and understand clients' markets, marketing goals, and priorities. In order to succeed in sales efforts, you must not only meet the client's needs but should also understand that their needs must come first.

Marketing is planning on which doors you should knock. Selling is knocking on those doors.

Selling successfully means knowing where the most receptive markets are located. Within those markets, you must be persistent in sales and offer the right products and services. In other words, you must plan to be in the right place at the right time with the right photography and ideas.

■ PLAN FOR SUCCESS

I can't say it often enough: never call, visit, or make a proposal to a client without knowing something about their products and their self-image. Research their business plans, financial growth, future markets, and product development. The informed photographer will be able to discuss relevant ideas during a portfolio or sales meeting with a prospective client.

You can easily find out about client business goals, products, and publications. Just ask them. That's right, call or write their offices and ask for

a copy of their most recent corporate annual report. While you're at it, ask for copies of recent product sales brochures and consumer magazines.

In marketing, the better you plan before getting started, the greater your chance of making a sale.

With a few exceptions, most companies want to sell themselves to their stockholders. Their annual reports generally show photos of products, properties, and company leaders. The financial information will tell you where they spend their marketing dollars. Read a little further and you'll see which products may require some new ideas and photography. Sales materials show the type of photography they use to promote products.

If you're interested in selling editorial images to a certain magazine, read the last dozen issues. Most will have an established editorial format and content. In order to sell to these magazines, you must understand their format and editorial goals. Of course, they will be looking for new ideas and ways to support their established policies while improving the overall look.

Marketing Strategy. Client research is as much common sense as it is sales planning. The real art of selling comes in forming a strategy to determine what you hope to accomplish and how it will be done. This is a basic part of your business plan. Start thinking about your own marketing strategy by writing down the following questions:

✓What am I selling?
✓Where will I sell it?
✓How will I sell it?
✓What tools will I use to sell it?

The answers to these questions are both easy and complex, as is the making of great photography. Try to answer them as you read the remainder of this chapter.

■ MARKET SCOPE

Sooner or later, your style of photography will lead toward certain markets. These might be in the areas of fashion, photojournalism, product still life, travel, corporate business, location, portraiture, or one of several other possibilities. Your shooting, and sales efforts for that matter, can't be all things to all markets. It's simple. In developing a market scope, concentrate on the organizations that use the type of work you produce.

The Markets. Where do you want to sell photography—locally, regionally, nationally, or internationally? Most photographers would like their sales to be in all of these areas. Stock agencies have found that a good image can be sold several times in several different locations for Big Bucks. Your assignments and jobs may be desirable in several locations, as well.

Sometimes the city in which you choose to live and work also determines your market scope. For example, New York City and Los Angeles aren't local or regional markets. These cities are the national market. Deciding to work in one of these cities means to be in the national market, which includes competing with the best of the best. The cost of locating in these cities is so high, for client and photographer alike, that it generally prevents the smaller business from succeeding.

Of course, you don't have to live in a given market in order to sell in that market. Modern communications, agents, reps, direct mail, the Internet, and other factors make selling in national markets much easier today. In recent years, San Francisco, Miami, Seattle, Honolulu, Dallas, and Chicago have drawn top businesses and photographers away from New York and L.A., thus creating new major marketing areas. Many travel photographers are now able to live in the areas they used to spend hours traveling to by air.

The question is, where do *you* want to sell your photography? The best approach may be to think regionally and to make a few moves toward national markets. This makes the overall planning easier, and the selling less expensive than in attempting to be all things to all locations. It also keeps your options open.

The first step in market planning is to find out who buys the images.

Who Buys in Your Markets? My first activity when entering a new market is to establish a set of potential client lists. I use the following known photo-buying categories to compile work lists:

✓Advertising agencies
✓Design agencies
✓General business corporations
✓Marketing agencies
✓Multimedia producers
✓Public relations agencies
✓Publishers
✓Trade media
✓Magazines

I use the following resources to develop initial listings for these categories:

✓ *Standard Directory of Advertisers*
✓ *Standard Directory of Advertising Agencies*
✓ *Photographer's Market*
✓ *Literary Market Place*
✓ AT&T 800-number directory
✓ City telephone books
✓ Internet search engines

These resources will help you find the major organizations that do business within most market areas. They also provide information on company size, financial strength, advertising budget, media direction, personnel, phone numbers, addresses, and other related information.

Starting with the *Standard Directory of Advertisers,* I develop a mailing and phone list of the larger and more visual organizations. The directory listings include the advertising and public relations agencies and their account representatives. Cross reference these listings with the *Standard Directory of Advertising Agencies* (which includes public relations agencies). This should also provide names in art and graphics departments. Generally, a polite call to these people will result in the names of designers, art directors, and other photo buyers. Some major advertising and design agencies provide professional photographers with listings of the people in their creative departments for the asking. Bingo, your list is already starting to take shape for sales efforts.

The books I recommend can all be found online at sites like amazon.com.

In every region there should be several trade publications catering to the marketing and advertising fields. The local design associations, ASMP, and many commercial organizations within the business community usually have informative newsletters. A stop at the local library, Chamber of Commerce, or Better Business Bureau should produce sample copies. Subscribe to and read the most promising of these source materials for current information. Most publications make their mailing lists available—at a price.

Your marketing and mailing lists are the basic tools to find and track clients. Keep them up-to-date and well organized. I suggest using a computer with word processing and mailing list capabilities to compile marketing lists. This makes quick entry, maintenance, and printouts a snap. Just don't waste valuable time and list space on industries and organizations that simply aren't interested in the kind of photography you produce.

■ HOW TO SELL YOUR PHOTOS
Selling requires getting your work in front of the people who buy photography.

Many businesses feel it's enough to offer quality products, professional service, and competitive prices, but these are only the minimum expected from a creative business like photography. You're also in the business of selling ideas, through the use of photography, that will meet a client's marketing goals. You must get these creative products in front of the people who *buy* creative products.

Sales Efforts. The best way to pitch sales is through direct contact with potential clients as a means to present your work and ideas. The opportunity for direct contact requires informing potential clients about who you are prior to the request for a portfolio visit. This can be done by sending out direct mail flyers that show off your work, a website, e-mailed samples, and advertising and promoting in the local trades publications and directories. It also requires making a great many cold telephone calls to ask for appointments.

If you sit around waiting for the telephone to ring, it won't. The more calls you make, the more calls you will receive.

No single sales effort or method is enough to guarantee complete success. You must be persistent in all sales efforts. In the end, the persistent salesperson often lands the job as quickly as a less persistent though more qualified person.

Interviews. A portfolio presentation is a photographer's employment interview. Portfolio presentations are covered extensively in the next chapter. In any meeting, an experienced art director will be looking at you just as closely as he or she examines your work. Are you the kind of professional with whom their organization wishes to associate? Are the images presented a true representation of you and your current work?

Be positive about your work, and be ready to suggest a few shooting and market-related ideas to the client. However, for the most part, let your images do the talking.

Proposals and Bids. If an art director or editor starts talking about shooting concepts and compares your work to their clients or publication, chances are an assignment is on the horizon. This is the best time to ask for the order. Always make at least one attempt to snare a job out of an interview, even if the client doesn't bring up the prospect. They can only say no, maybe, yes, or we'll call if something comes up.

In today's competitive world, a job discussion may mean making a bid or written proposal. The subjects of bidding and negotiating are covered in chapter 3. In any event, always be ready to talk rates, because most photo buyers will want to know how much you charge to shoot. Relax. It's a natural question and you can provide a generic answer. By now, both you and the client should know what a photo assignment is worth, so ask if they have a standard rate or budget in mind. Most established photo buyers will tell you their budget early in the meeting. Always make sure you understand exactly what they are buying and what you are selling.

Follow-ups. Always send a thank-you note following every sales conversation, meeting, or portfolio review. Keep it brief and businesslike. Let clients know that you're interested in talking about new ideas and markets. This, too, is another reminder that lets potential clients know you want their business.

■ SALES TOOLS

Over the years I've relied on five basic sales tools to promote my work. Descriptions of each follow.

Image. Of all the sales tools available, your professional image is the best. The image and reputation you develop and earn through advertising, promotion, portfolio presentations, previous work, and awards is the ultimate sales tool. In fact, you'll find that nothing will sell like a reputation for high quality photography and service. Do everything you can to earn and promote your own.

Advertising. Advertising allows you to create the image photo buyers see. There are a number of prime places for advertisements that will help sell your work. These include local trade publications, graphic art directories, national source books, the Internet, and art magazines. Follow these publications, even though you are not advertising at the moment, to keep yourself informed about developments within the market.

Photographers who can afford to produce and place quality advertisements should begin by looking at such publications as *The Workbook* and *Communication Arts* magazine. If I were starting a new photo business today, these would be my first choices, along with a good website. There are also some interesting photo sales sites on the Internet, which are aimed at starting photographers. Most well-established professionals have their own photo sales sites on the web, too. In the long run, this is the quickest and least expensive method of reaching the largest number of potential clients.

Advertisements should not only feature your images but should also allude to who you are. In other words, they should contain some of the personality and style that is found in your photography. Advertising may be the only opportunity you have to reach many potential clients. Make sure that your message and image come across loud and clear.

As with all forms of sales and promotion, the audience will be looking at the production just as much as they will your images. Hire the services of a good designer, perhaps someone you respect and hope to work for in the future. Make sure your ad is the best possible representation of what you stand for and shoot.

I try to generate an immediate response from art buyers reading one of my advertisements by displaying a variety of images, relative to the market covered by the publication, that are available as stock. It's much easier for an art director to request and examine a selection of stock images than it is to set up a portfolio review and sales call. If they like your stock images, the next call will be for more shots or an assignment.

Books. Producing your own pictorial books is an excellent promotion—and one that may even turn a profit. One photographer offers photo buyers an autographed copy of his latest coffee table book as an incentive to review his portfolio. I do this with potential major new clients, too. In reality, these coffee table photo books have become an impressive portfolio.

If you can't afford to do a pictorial book, perhaps a local author will want to collaborate on a publishing project. Commercial clients may be considering a corporate historical book, for example. If your work is used to illustrate any book, get as many low-cost copies as possible and use them for promotions.

Advertising Follow-up. Don't expect your advertisements to do the job by themselves without some following up. Take advantage of your medium following its initial publication. Some publications offer free reprints, others will sell them for a small fee. Otherwise, print your own and use them in a mailing. Many of these publications will also sell their mailing lists.

The quickest and easiest follow-up for your advertisement is a direct-mail campaign. Make the lead item a letter introducing your services or a new flyer that is backed up by your reprints. A less expensive way of circulating your advertisements is having them reduced to a postcard size for mailing. These cards are also good for personal notes following sales calls and related meetings.

You can also put a website or complete portfolio on a photo CD. Art directors like this system because it's something they understand and it's easy. Just make sure your site and the CD work easily and with every computer system they might encounter.

If you've got the wall space, have your ad made into a large print (20x30 inches or so) as an office display. Don't bother having large posters made as client mailers; they're expensive to produce and ship, and few art directors have the display space to spare in their offices.

Public Relations and Promotion. Public relations and promotion are the companions of a good advertising campaign. Promoting yourself is more than just using some gimmick to get attention. It means getting information out about you and your work, just as in advertising and direct mail.

One of the best promotions is to donate your images for a good cause. There are hundreds of nonprofit associations and causes that are desperate for quality photography. This might include shooting a poster for MADD (Mothers Against Drunk Driving), Greenpeace, or similar organizations. Get started with these causes by shooting a news or magazine feature story, a press release illustration, or other project. Make sure you fully understand the goals and ideals of any organization before supporting it, because the marketing people who see your work will be associating you with these same ideals.

Politicians are always on the lookout for flattering photography of themselves. As with nonprofit organizations, they're always interested in having a good photographer photograph them in action for free. Remember, supporting any political cause, or person, will definitely label you as a supporter of that cause or party.

Most advertising agencies donate their creative services to special causes and are on the lookout for photographers of a like mind. Ask around at the agency or nonprofit organization to learn who's helping whom. Drop a note to the person in charge and volunteer your time and services. And be ready to come through on a regular basis. While volunteering with a worthy cause should come from the heart, there is nothing wrong with letting your clients know, too.

Follow up all of these promotions with your own promotion. Have a photo of you, the event, and the principal players made for a news release. The organization's media people will probably help with mailing lists and production. Make copies of the best media use of such releases and send them to your potential clients. This type of promotion will let other companies know what kind of events and organizations you wish to be associated with.

Your Public Relations. Write a press release about any newsworthy item or event in which you have recently participated. Send it, along with black & white prints of you and the event, to the trade and local news media. If the event and release are worthy, this can result in substantial media coverage.

Professional photography associations, through their local and national newsletters, often run items on the activities and writings of photographers. They aren't so fussy about the news value and will run articles about your latest client session. *Photo District News* runs very good feature and news articles on noteworthy photographers throughout the business. However, they are strict about the news value and quality of materials accepted for publication.

The key to getting good media coverage revolves around the right timing, good journalistic writing and the event's news value. Writing a release is easy for someone with even a basic knowledge of journalism. Editors just want the facts of who, what, when, where, how, and how much money is involved. If you can't produce an acceptable release, get acquainted with a writer at the local newspaper and strike a deal. Better yet, take a basic newswriting class at your local community college. Learning to write a simple news release or news story will be one of the most valuable lessons you ever learn.

Don't expect major publications to run every release and photo you send on their front page. This won't happen unless the event is of national importance, in which case, you don't have to call them, they'll call you.

Don't limit your news releases and ideas to the print media. Local television stations often run features about interesting photographers and their even more interesting subjects. Mail your release and proposed feature ideas to the station's assignment editor, call if it's a really hot idea or you know the editor personally. Some photographers, including myself, have hired television freelancers to shoot and produce short fea-

tures on their work. This can revolve around an interesting assignment or location. Warning: it's expensive and difficult to get on the air, but well worth the effort when you do.

The subjects and events about which you can produce interesting news releases are many. Listed below are a few potential news release topics:

✓A new studio
✓A major new client
✓An unusual or exotic photo shoot
✓A good cause
✓A real news event
✓A photo made with a one-hundred-year-old camera
✓An award of any kind
✓A special celebrity photo
✓An exciting new product photo
✓You in an unusual photo or situation
✓You with a celebrity (model, actor, author)
✓Your exposition or show
✓Your new book
✓Your new stock agent

Word of Mouth. When a happy client tells an associate how good your work is, that's the best form of advertising. You can only create this situation by performing well. Happy clients will also suggest places where you might want to make sales calls. When you call for an appointment, say that so-and-so suggested that you call. This simple action may just open a window of opportunity.

Some photographers run advertisements and send flyers based on the endorsements of clients. These promotions are good if you have the written approval of the client. This goes for reproducing magazine covers, client advertisements, and brochure covers that involve copyrighted materials and trademarks. Having your images used in one of these pieces does not mean it can be used in your promotion or portfolio without permission. I suggest having a line in your delivery memo, invoice, proposal, bid, and confirmation saying that the images and client-produced materials may be used in the photographer's own promotion. Don't just say *portfolio,* as this terminology eliminates promotional advertising and direct-mail flyers. It's also a good idea to discuss proposed promotional efforts that display client work with that client in advance.

Sales Forces. There are the people and organizations that specialize in selling the services of creative people—agents who are professionals at selling, just as you are at image making. In theory, these agents sell you and your work to their established contacts. The best of these people can make a significant difference in your gross income. Their commission can be as little as 10 percent for recommending a client who hires you or purchases a stock shot. The rates for full-time representation are generally 25 percent of the photography fee for negotiated assignments. Stock agents generally get 50 percent of the image purchase price. This percentage may be changing as the new mega agencies produce their own work-for-hire images, or as they retain so many photographers they can dictate a higher amount for themselves.

If you already have several major clients, there may be a reluctance to part with future photo fees from these sources. There is also the temptation, by some photographers and clients, to make sales directly that eliminate sales commissions. If you're going to have an agent as a business partner, then strike an equitable deal and live up to your end. These agreements may include sharing some of the income from established (house) accounts, and possibly the right to sell stock to previously established clients. Above all, give your agents and representatives a chance to do their job without any interference.

Internal Sales Help. You may not be your own best salesperson. At the same time, you may not wish to share commissions with an outside agent. In this case, hire someone to do in-house sales tasks, especially concentrating sales time on client contacts. Employees can research mailing lists, deliver portfolios and stock, and often sell you better than you can sell yourself. Such people often become very knowledgeable about your work and valuable in their sales efforts.

The Internet. Next to the modern computer, and because of that remarkable invention, the World Wide Web (a.k.a. the Internet or the Net) has become one of the most valuable sales tools ever conceived.

Portfolio Site. Most successful photographers have websites that display their best work. While the initial cost can easily be as much as several hard copy, high quality print portfolios, you only need one site to reach thousands of potential clients. Your site can also have several different shooting style sections available. For example, you could conceivably have fashion, travel, lifestyle, still life, aerial, underwater, and industrial image galleries. Obviously you don't want so many different topics available that it scares a client who may be searching for a specialist. But you get the idea.

Portfolio sites allow you to present examples of published work, personal work, stock library topics, biographical and historical information about you and

your business, awards, references, and a host of similar topics that are valuable to potential clients. It's always easier to write this information in a website than it is to tell a potential customer face-to-face. It may also help you get new business.

Do not scrimp on the creation of a website. Hire a good designer and give them an example of what you need—and some latitude. Like a hard copy of your portfolio, art directors will look just as closely at your presentation as they will your images.

Review Competition. The first sentence of the above section says: Most successful photographers have websites that display their best work. That means you can review portfolios of the best photographers in the business and within your specialty. This can be a good learning tool and will help you work toward improving your own shooting and website portfolio.

Keep in mind that while imitation may be the most sincere form of flattery, it's not a good idea to copy the photography and website designs of other photographers. Use your examination of their work as an inspiration to create something new within the parameters of your own style.

Research. The more you know about a prospective client, the better you can prepare a sales call or shooting proposal. Like successful photographers, successful business organizations, advertising agencies, and design and art directors have websites. In addition to names, street and e–mail addresses, and the like, you can learn a great deal about a potential client's products, style of business, and previous image uses in marketing materials. You can also learn, from their financial reports, how much money they spend on various marketing programs *and* if they are solvent enough to pay for your work. Quite often an e-mail contact will be available for consumer requests, which should be used to request a copy of their current annual report and press kit.

There are dozens of excellent search engines available on the Internet. If you have any experience on the Net, most of them have already sent you some sort of promotion. I like to search at www.google.com and www.dogpile.com. Simply go to a search site, enter a company or person's name—or another topic—in their search box, and the site will do the basic research and present you with a host of options to examine. I print out the primary information on potential clients or post it to a file within my computer system for future reference.

You can also research equipment, materials, shoot locations, transportation, accommodations, assistants, talent, and just about anything else needed in a photography business. With today's secure online ordering and payment systems, you can also purchase many of these things through the websites of various suppliers. This little research tool gives you an easy and anonymous way to research prices and availability, as well.

Assignment Proofs. Wedding, portrait, and other photographers often post proofs from their shoots on websites. This allows people with access to the site's address, and possibly a special password, to examine and order their own prints. Photographers simply hand out a business card with the event's special site and password, which allows dozens of people to become compulsive shoppers. Remember to keep the images copy-blocked, or at low enough resolution to render them unusable if downloaded by shoppers.

More and more commercial shooters are also posting the best images from a shoot on their website, so that clients can see results quickly. This eliminates the risk of sending originals, which may be lost in transit or not paid for by less scrupulous clients.

Retail Sites. More than a few successful photographers have retail sales websites. Their sites sell such things as limited edition signed prints, posters, professional workshops, books, CDs, and even used cameras and office equipment. While the sites can be very profitable to the general public, it's not a good idea to promote these sites with your normal assignment or stock image clients. Send clients to your portfolio and stock gallery websites.

As a Communication Tool. Undoubtedly the most valuable use of the Internet is for communication. Today's e-mail is easier, faster, smarter, and cheaper than all other forms of communication. With it you talk back and forth in real time with clients about proposals, bids and jobs, and good quality layouts and photos can be sent each way during such conversations. Also, unlike a telephone call, an e-mail can be sent and received without going through operators, secretaries, and assistants, or interrupting a client's busy day. They are also a lot cheaper than the normal fax, telephone, air express, postal, and other methods of communications.

With e-mail you can make electronic sales calls to current and prospective clients that have a good possibility of being seen. The cost to buy or create a good e-mail client list is low, as is the cost to scan and send a few portfolio images with a sales pitch. A word of warning, though: do not send long e-mails with huge attachments. Keep your note short and to the point.

Enclose one or two small images that will sell your capabilities. Tell the potential viewer what's inside the e-mail, so they don't suspect it's from a mortgage company, porno site, or other unwanted junk communications. If your prospective clients like what they see, they will ask for more images or a full copy of your portfolio.

There are also hundreds of sites that offer photography information and news, as well as various industry associations, information on legal decisions, new markets, talent agencies, and the like. Many of these websites have chat rooms where you can talk with others who share your interests or who may answer questions.

■ PRICING YOUR PHOTOGRAPHY

Most photo buyers already know their budgets and the history of their companies' payments for photography used in various projects. Nevertheless, they will often ask you for a price to shoot a job or sell an existing image, largely because most photographers fear talking about money and will waffle down in price. Don't be a weenie. Ask what the budget is, and let the buyer know if you can work within their range.

Rates for photography are set by the market, your experience, reputation, and the client's budget.

You can't do every job for every client and fit into every budget. Be honest with your client and be honest with yourself. If the project isn't right for you, no matter what the reason, drop out gracefully. If the only difference is a small one, perhaps money, make an offer. Sometimes your ability to say no and to look for a project elsewhere is enough to sway the client your way.

One of the best sales tools is being open to negotiation. If you're asked for a day rate, offer to present a written proposal and quote for an assignment outline. Most working professionals want to see a layout or shooting outline in order to provide an accurate estimate or quote. The era of the day rate has just about passed, except for editorial and top commercial photographers.

One of the best ways to give a price quote is to base it on the client's use value. For example, a major company wants to run your image in a full-page advertisement in a national publication. How much? If you've done your homework, the answer is easy. The average one-time, full-page color rate lets you know what the client will be investing to use your photo. The image you provide should be worth a percentage of the page rate.

Trades, Barter, and Trouble. Some clients have very attractive products, which they may offer in exchange for photography services. If your business is well established and putting plenty of food on the table, an occasional exchange or barter might be okay. Remember that barters must be treated as cash income for the full value in your income taxes.

■ SECRETS OF BIG BUCKS SALES

Yes, there are a few really well-kept secrets to making sales. I say well-kept because most photographers don't bother finding out what sales are all about. If you want to make Big Bucks selling, try remembering and following these secrets:

✓Everything is negotiable.
✓Pay attention to details.
✓Listen to the client.
✓Study the client's market.
✓Study your competition.
✓Never quit trying.
✓Take care of you client's needs first.
✓Ask for referrals and introductions.
✓Make a set number of new sales calls each week.
✓Be patient.
✓Follow up.
✓Be persistent. Be persistent. Be persistent.
✓Get started right now.

Everyone seems to think there are secrets to making big sales. They're right.

11. SUCCESSFUL PORTFOLIOS

■ WHAT A PORTFOLIO SHOULD BE

Above all else, your portfolio should be filled with images that have impact and create excitement. Chances are the art directors and other photo buyers who examine your portfolio see dozens of portfolios every week. In order to be remembered, yours must be truly memorable.

You are known for the photography you show, not the photography you shoot.

Your Best Work. A portfolio should contain only your best work. Don't waste your time, or the reviewers', by showing pictures that need explaining. There is no excuse good enough to make up for poor quality, poor craftsmanship, or poor image selection.

What You Want to Shoot. A portfolio should contain examples of the subjects, style, and ideas you want to shoot. Don't put still life images in the portfolio unless you are seeking that type of work. Be specific in your image selection and presentation. Don't include such a wide variety of subjects and styles that the reviewer will be confused.

Salable Work. Once the images that represent your desired specialty or area of shooting have been selected, think about the intended market. The images you create for clients will be used in selling their products. If your reviewer is the advertising agency for a shoe manufacturer, the art director isn't interested in seeing pictures of cars or women in bikinis.

Every photo buyer wants to know, beyond a shadow of a doubt, that you are capable of shooting exciting pictures of their client's products. Most assignments are given to photographers who instill confidence, so show images that will inspire the viewer to give you an assignment.

Individuality. Throughout the process of image selection and portfolio production, try to maintain some of the individuality that brought you to photography in the first place. Art directors are creative people with an eye and respect for individuality. A shot or two of your personal work generally goes over quite well with these folks. Make sure these images also meet the requirements of quality.

■ PORTFOLIO CONTENT

Your portfolio should avoid cliché photography such as sunsets, flowers, travel scenics, and erotic subjects—unless they happen to be your specialty. No matter what your specialty, the portfolio should look like the photography of a working professional, not like that of a recent student or part-time shooter.

Good-quality, non-published prints or transparencies are perfectly acceptable in a portfolio. Low quality computer prints are not.

Tear Sheets vs. Photos. Tear sheets from brochures, annual reports, magazine features, and other published works that contain your images make for very good portfolio examples. Client-produced materials lend a great deal of credibility to your reputation—if they are top-quality images and reproductions.

I know it's difficult to show tear sheets when you're starting out, when clients reproduce your work in small sizes and on back pages, or when less-than-exciting images were selected for the

publication. Don't fret. Prints are just fine in a portfolio. Even the best-selling pros include non-published work in their portfolios. This is how they get new ideas across.

General vs. Specific. The working portfolio should reflect all of the things we've been talking about. It's your bread-and-butter display case. It's your best work and represents the type of photography you are shooting and selling. It also grows and changes with your career and clients.

Develop a different portfolio for every occasion.

The *working portfolio* should contain a limited number of images. It's far better to show a dozen great images than to show a dozen great images and a dozen so-so images. Show your most exciting work and leave them anxious to see more.

When I first started showing a book to clients, it contained about a hundred pages. It was almost impossible for me to eliminate anything of mine that had been published. After putting several art directors to sleep, I started being more selective. Today, I show a maximum of fifteen or twenty images in a portfolio.

A *general portfolio* is used for casual showings that might include a banker, lawyer, CPA, businessperson, future assistant, stock agency, book publisher, old school chum, visiting relative, or lover. It's big and loaded with examples of your widest range of work. Don't bother scrimping; include three or four dozen shots. When pressed to show something at social occasions, this book does the job nicely.

The *specific portfolio* should be built around your personal work, a new style, or images in which you have a special interest. This should be shown to people who share your interest and are potential buyers of such images. It can also be shown to art directors who are knocked out by your working portfolio. Limit the images to your specialty and try making it look like a sampler rather than a working portfolio.

Portfolio reviewers are busy people who are easily distracted. Show a portfolio that will knock the viewer out instead of putting them to sleep.

Sequence. The sequence of your portfolio image presentation is just as important as the images themselves. Start with two or three eye-grabbing shots that relate to the intended client. Mellow down with something soft, interesting, or artistic. If you shoot editorial or annual reports, stick in a short sequence. Put in at least one personal image that shows an unusual approach or style. Lastly, hit them hard with your best of the best.

The Client's Opinion. Hopefully, you'll get to meet with a client face-to-face, instead of being asked to drop a portfolio off or have your work viewed online. After everything is said and done in a face-to-face portfolio review, ask the client for an honest opinion of the presentation. Listen, evaluate, and plan to make adjustments next time. Tell them you appreciate their advice and that it will be followed. Don't make even one excuse for a critical comment. Always drop a thank-you note for both the review and their valuable advice.

Your Promos. Attach a business card to your "leave behind" items so potential buyers can reach you easily. I like to leave an interesting tear sheet, magazine cover, or other printed piece along with the promo. This reminds the client that I'm a working photographer. Some photographers like to mount or laminate their promotional work and include one or two in a portfolio. This is okay, so long as it bolsters your case rather than your ego.

Leave at least one promotional piece behind with the portfolio reviewer.

Ask the reviewer for one of their company's promotional pieces or a sample press proof that's related to the client you're after. This may open up a whole new discussion about shooting a specific job.

A word of warning: never, under any circumstances, bad-mouth another photographer, art director, graphic buyer, or anyone for that matter. It will only make you look bad. If you're asked for comments when shown someone else's work, talk about concepts and ideas, not the person or their personality. Remember that what goes around comes around, and nasty comments may bite you on the butt one day.

■ GREAT PORTFOLIO IMAGES
A portfolio should represent your current capabilities and work, not the best dozen images of your lifetime.

Being a great photographer doesn't automatically mean it will be easy to select the right images for your portfolios. Few photographers can really be objective in their own editing process. I suggest you seek the advice and assistance of an experienced art director or photography counselor. This doesn't mean turning

over the whole process, it just means having a second, unprejudiced, set of eyes.

Style and Subject. Your first job in selecting portfolio images is to pull all the best shots of each subject or shooting style. The more experienced professionals maintain a permanent working file of their best shots. Every time they edit a new shoot, the best images are selected for the hot file. This is where they turn for portfolio candidates and special sales needs.

In my field there are about a dozen subject or style categories that cover most assignments. These are the areas into which every shooting is immediately sorted for editing, making it faster and easier to select the best images. This is the way to begin editing your best work for a portfolio.

Once you've selected a dozen or so images that fit into each category, it's time to call on that outside art director. Together, you should examine each image, selecting the agreed-upon best for final portfolio consideration.

If you include transparencies, I feel that viewing by projection offers the best overall opportunity to really see a total image. Few people are skilled enough in using a small magnification glass to determine the strength or impact of an image.

Difficulty Factor. The degree of difficulty or amount of time expended in making a certain image has almost nothing to do with its portfolio impact. In other words, just because it took three days to set up and shoot doesn't mean the art director will look at it for even three seconds.

Don't let any production factor, such as lens size, cost, exotic location, temperature, time, or distance influence your ability to see the real image for what it's worth. Concentrate on the end product. There will be times when something unusual, such as a really exotic location or rarely seen subject, may influence an art director to become a photo buyer. This is more common in editorial sales than advertising.

For the most part, your portfolio pictures should speak for themselves, because quite often you won't be there to help. Either the images are your best efforts and belong in the portfolio, or they are not. No degree of difficulty or love for certain images can change this fact.

Quality and Speed. I like to make my first major image selection, say a hundred or so shots, then take a good overall look and give it a rest for at least a working day. This affords me time to reflect on the selection, which often brings to mind another element for my consideration.

Never rush the process of selecting images for a portfolio presentation. The seed you sow today will be the work you reap tomorrow.

My semifinal image selection is done quickly. I give each subject or style an overall examination and then begin to pull the images with the least impact. In a short time, only the strongest images remain. I then move to another subject or style and repeat the process. This leaves me with approximately a dozen shots in each group.

The final image selection is done with the help of my wife, Nancy, who is an experienced creative director. It should be noted that she knows our files well and participated in the initial image selections. Your art director should also be involved in the semifinal selections if possible. We each select the single image or two we like the best and discard the rest. We constantly ask ourselves, "What is the purpose of this portfolio, and does this image meet that purpose?" From these final choices, we attempt to build a sequence that will compel the viewer to pull out the assignment book or, better yet, the checkbook.

■ THE MARKET
Your portfolio is an advertisement. It should be prepared for a specific market.

Your Market. When you show a portfolio, make sure it's prepared for the reviewer's market. More important, make sure the market is one in which you are interested and capable of handling. Quite often, an art director will ask if you have any additional materials available on a certain subject. This is to see if you are really experienced in that type of shooting. It's therefore a good idea to have available a backup series of different portfolio images, aimed at the same market. This is also a good reason to return for another interview, so set a date!

Marketing Realities. Most art directors are happy with the photographers who shoot for their clients. They look at new portfolios in search of ideas bright enough to make them willing to try out a new photographer. Your portfolio is a brief and potent opportunity to compete with the photographers already shooting for an agency, magazine, or client.

No matter how good your images and subjects, the art directors are looking for style and capability. Keep this in mind when selecting portfolio images. It should be a given that your images will be of high technical quality.

Art directors look at portfolios because they are interested in hot new styles, not because they are particularly interested in new shooters.

Sooner or later most photographers develop a recognizable style. Good photo buyers may be searching for that particular style to mold into their own projects. For this reason, your research into the current images used by a market should be done prior to your portfolio selection. Don't try to imitate styles of the shooters already working for the client. Why should the art directors break in someone new for the same old shots? Show them that your style can be adapted in a whole new approach for their client.

Your portfolio should be built around an individual approach or style, so be sure to include some personal shooting, in addition to commercial images. Give the art director an opportunity to see there is more to you than commercial image-building. Show them a little excitement and life in your work.

Good art buyers will always look for a spark of creativity in you and your portfolio. They are constantly searching for new ways to present products through exciting images. Make sure your images show the range of your style. No matter how good your shoe still-life shots are, the art director will be suitably impressed by a maximum of two or three examples. Ten similar shots of any subject are never as impressive. A flow of style through a range of subjects is the best way to keep your reviewer's attention and interest directed to your portfolio.

"Who Shot This?" While looking at a selection of my published work, the art director for a major airline once asked if I had made the photographs. "Of course I made the photos," was my startled response. "Why do you ask?" He said that another photographer had been in earlier and presented a nice series of industrial product brochures as a portfolio. The art director, it seems, also moonlighted as a freelance photographer. In order not to conflict with his airline daytime job, he only shot industrial products. You've already guessed, I'm sure, that it was the art director who had made the brochure photos in that photographer's portfolio. It's a very small world, and one in which using other photographers' images will soon be detected. Don't do it.

■ PORTFOLIO FORMATS

During the early days of my career I didn't have many tear sheets to show potential clients. Instead, I would pull out a dozen or so of the best 11x14-inch Cibra-chrome prints money could buy. These prints would be full-framed images that included the black borders in the shape of a 35mm slide. In showing the prints, I would say they were just proofs from a recent shooting. Every client was impressed with the quality of my prints. That was a door opener to new business. This still works today, by the way.

The images are more important than the portfolio package, or are they?

Jay Maisel sends prospective clients a huge box of his tear sheets, promotional flyers, and other printed pieces. There must be a hundred different examples of his published work in the box. While this violates my rule of keeping your portfolio short and to the point, it's impossible to argue with Jay's huge success as a shooter and an image seller. When you have a hundred great tear sheets and his reputation you can do the same thing. Until that time, keep it short, sweet, and high quality.

The Packaging. Books have always been the most common portfolio format. They're easy to put together, low in cost, and a good way to view prints and tear sheets. Art directors will generally ask to see your book. If you elect to use a book, make sure the sheets that hold prints, etc., are always clean and scratch-free. The small cost to replace damaged sheets is more than made up for by a professional-looking book.

Boxes of mounted tear sheets, prints, and duplicate transparencies have evolved into the choice for many working portfolios. Images in these packages can be changed quickly to meet different client requirements. Each of the portfolio's mounted pieces must be removed and held to view, which gives a longer opportunity for consideration. Most photographers have their logos printed on the package and image mounts as a subtle sales effort.

For tear sheets and prints, I suggest using a lamination process. They are available in high-gloss or matte finishes with felt backing. Borders of any color can be mounted under the images to enhance their effectiveness. Lamination will protect your tear sheets better than anything else.

Slide reels are often the choice of editorial and location photographers. This format allows a larger number of images and feature sequences to be shown quickly. Never use original images in portfolio reels, as they can fade, scratch, and can be easily reproduced by unauthorized people. And don't spend ten minutes talking about each image in your show.

Printed pieces are generally produced for independent mailings and to accompany portfolios. This includes postcards, greeting cards, catalog sheets, tear sheet reprints, and similar items. They are best for "leave behinds," which may be filed for future reference. Some photographers laminate a series of these pieces into a smaller accordion-style portfolio. Most photo buyers do not have room for large posters in their offices.

Catalogs are the portfolio of choice for many photographers with extensive stock files and extensive financial resources. High quality printed catalogs are expensive to produce and may become dated very quickly.

High-tech image portfolios have become commonplace with the advent of computers that allow you to create and burn portfolios on CDs and DVDs. Those same computers have programs which can create VHSs, laser programs, and mini-movies, which can be transferred to disc, as well. This technology allows you to create and send out hundreds of high quality portfolios for the cost of three or four presentation folders or boxes of expensive, mounted photo prints and tear sheets.

The best part of working with some of these digital-based portfolios is the ability to use motion picture editing capabilities such as fade-ins, quick cuts, short stories, titles, voice-overs, and music. With most of the better computer systems and simple video or photo editing programs, you can create interesting presentations that both inform and entertain a potential buyer. It's probably best to have someone who has created a few of these programs help you with the first sessions. Remember that with such high-tech portfolios, the format and operation of your portfolio will be looked at just as closely as your images.

Of course, much of this creative technology has been available for some time at film and video postproduction houses in major cities. Many leading pros have created short documentary-type movies of themselves and their work for years. Now they can send those programs out on a disc that can be viewed on most modern computers. Using such postproduction facilities—and their experienced editors—will guarantee that you have a high quality product to show clients. It will also guarantee a high price to create the master program, from which you duplicate copies to send potential clients. This is the way most serious and successful photographers choose to go.

A few words of warning about high-tech portfolios: Don't let fancy technology tricks and music take the place of quality images. While art buyers, designers, and clients like to be entertained and sold, remember that they are looking for image makers and images that will help sell their product. Make sure that your portfolio creates that impression, no matter what the format.

Treat your disc portfolio packaging the same as a print portfolio folder or box. Have your name, contact information, and logo printed on the jewel case, slip cover, or insert. Again, this is a place where your interesting and colorful cover may be the reason someone takes the time to view the disc.

Materials. Portfolio reviewers will be considering both your images and their packaging. Always use the highest quality materials and images possible. Have at least two duplicate portfolios available for simultaneous showings. Having two portfolios also guards against loss and theft.

Review your portfolio regularly and look for ways to improve its impact. Keep in mind that about the time you are tired of a portfolio, it may just be catching on with art directors. Also remember that your portfolio is a sales tool designed for, and aimed at photo buyers, not other photographers. If the opportunity presents itself during a portfolio review, ask for an opinion on your packaging and presentation. These people see hundreds of portfolios each year and know what they like.

■ PRESENTATIONS

Interviews and Attitudes. Getting to see the right people for a portfolio review is often as difficult as getting an assignment from the review. There are two basic approaches. One is to call the company, agency, or publication and simply ask, "Who's the right person to show my photography?" Many organizations have already established procedures for seeing suppliers, which is what you are, and will let you know what to do. Others may provide a name. If you've done a good job in your market research, the mailing list resources will provide the names of people who should see your portfolio.

Your portfolio is meant to inspire sales.

You can also drop the prospective client a letter of introduction and request a personal portfolio review. I suggest including a self-addressed and stamped postcard to make their reply easy.

As I've said, a portfolio presentation is an interview for prospective employment. You, the images, and the

packaging are being considered for future work with the reviewer's company or client. This is the opportunity you've been seeking—don't blow it with a poor attitude or, even worse, poor images.

Their Commentary. The photo buyer looking at your portfolio hires photographers and purchases stock images. Give them a chance to view your images in peace and quiet. In other words, let your carefully prepared portfolio do its job without a running commentary by you. Remember that an experienced art director will be looking at you just as closely as your portfolio. Are you the kind of professional with which their organization wishes to associate?

Art buyers know what they want and will share this information with you.

Your Commentary. Listen carefully before inserting a portfolio, or foot, in your mouth.

Very few images in a good portfolio require any explanation. If you've produced a good package, it will stand on its own. If you are asked about a given image or client, be positive and brief in your response. Let your images do most of the talking. Point out one or two interesting things about three or four images, and say no more. (An interesting point might include the casual dropping of the name of a major organization that hired you to make the shot.) Everyone likes to work with a successful photographer. No one likes to work with a smart-ass who constantly talks about every shot in their book.

Be positive about your work. Also be ready to suggest ideas for incorporating your work with the viewer's projects. Again, this means knowing something about the client's past projects before reaching the meeting.

A Pulitzer Prize–winning photographer once approached a major oil company with an idea to publish a goodwill brochure. The photographer hoped to photograph people living around and associated with the various areas of this company's business, but not their employees. He hoped to show the community benefits derived from their business. The oil-company people loved the idea and started talking print costs, logistics, dates, and other related matters. During this process, the photographer began to point out some of the shortcomings of such a project. You see, this photographer had always been a photojournalist, shooting in hostile environments. This was the first time the normally hostile environment had become cooperative. The photographer talked too much. In fact, he talked the company right out of doing the project. "We'll be in touch," were their parting words.

Remember, there are far fewer good ideas around than good photographers with good portfolios.

Time Is Money. Photo buyers are busy people who also have a short attention span. Be polite with a little small talk, but remember you're there to take care of business. Show your work, introduce a few ideas, ask for the sale, and say good-bye.

Leave a good sample behind with your business card attached. This sample should fit into the art director's prospective file, not be a huge poster that ends up as a fire starter. It can be a promotional flyer, advertising reprint, client's brochure or any good, clean example of your work. Leave something that will make them call you.

Drop-offs. Some photo buyers are just too busy for individual portfolio examinations. This is a fact of corporate life over which you have no control. Some magazines and advertising agencies schedule regular portfolio sessions for their photo users and buyers. While your portfolio may be included with several others, it will also be viewed by all of the organization's potential buyers. Have at least one duplicate portfolio, preferably two or three extras, for drop-offs. Your images should be able to speak for themselves anyway.

I suggest that you avoid dropping off any high quality transparencies that can easily become rip-offs. Don't get me wrong—most clients are very trustworthy. However, portfolios have been stolen from courier services and right off the desks of art directors. If this happens, your images could get into the wrong hands. Play it safe with prints, extra copies of tear sheets, and duplicates, which are more difficult to copy.

If you expect to do a lot of drop-off portfolio presentations, or want to send them out unsolicited to a much wider market, it's probably best to spend the time and money putting your portfolio on a CD or DVD. If a disc is lost, destroyed, or not returned, you're out a few bucks . . . not a several hundred dollar print portfolio package.

Follow-ups. Always send a thank-you note for a portfolio review, even if it's just a drop-off. This is considered common courtesy. Keep it brief and businesslike. Let the reviewer know you're interested in talking about new ideas and markets. After a month or so, send another note with a recent sample of your

work. By this time, you might have another bright idea to share.

Don't be put off if the reviewer doesn't have an immediate job available or seems uninterested in your work. It doesn't mean that they don't like you or your work. No one said this was going to be easy. Be persistent in showing your portfolio, and sooner or later things will start to click.

Evaluate every person and organization reviewing your portfolio. Determine if you are interested in and capable of producing work for their use. If so, put them on your regular mailing list for promotional materials.

Show your portfolio at least once each week, more if you're not too busy shooting or taking care of other business. It will keep you alert and aware of the many changes of people and organizations that buy images.

12. STOCK IMAGES ARE BIG BUSINESS

■ PHOTOGRAPHY THAT SELLS AND SELLS

Successful stock photography consists of making an image once and then selling it many times. You don't need to be a rocket scientist to figure out the potential profit. You, or your agent, are licensing a specific use of an existing photograph. Clients purchase a stock image because doing so is usually faster and less expensive than making their own. The wide selection of high quality stock images available today often means that such photographs may in fact be better than assignment work.

Sooner or later, photography of every subject imaginable—people, places, events, and just plain stuff—is needed by photo buyers somewhere. Needless to say, if either you or your agent have a large file of good stock images available, there is money to be made.

Most of the successful photographers, the ones who really make Big Bucks, sell stock images.

Best-Sellers. It's quite easy to understand why photographers and agencies consider stock images a serious business within the photography industry. After all, it's not uncommon for a top-selling stock image to have a lifetime income of over $100,000.

The catalogs produced by leading stock agencies make interesting reading and research. A word of caution: once a situation or subject has hit the agency catalogs, or the low-cost clip and royalty-free photo discs, it's very available to buyers, so don't treat these resources as shooting guides. Develop your own concepts and ideas so that others will copy you instead.

Best-selling stock photographers are more difficult to find, mostly because their images aren't always used with a credit line. Tom Grill, who along with Henry Scanlon, was a forming principal in the Comstock Agency, is one of the best—yet you may not immediately recognize his name. His high quality images are used by a wide variety of clients and command top fees, well into the hundreds of thousands of dollars each year. Both Tom and Henry participate in photography seminars and conferences about their business and the stock business on a regular basis. My own work has certainly been influenced by their willingness to share information.

■ SHOOTING STOCK

What Sells. Everything subject or theme sells, or is in demand, sooner or later. If you have images of African tsetse flies, someone will buy them for a medical article on sleeping sickness. However, your chances of selling photos of a healthy family hiking or biking in the countryside are considerably better. There is also a high demand for portraits of successful ethnic people in all walks of life.

No matter what your photography specialty, the potential for stock sales from that work exists. The trick is knowing and making images that have commercial value beyond a particular assignment.

Stock images sell and are used for all the same reasons as assignment images: to sell or promote a product or service. In general, stock images are more generic in order to make a wide number of sales, while assignments are more specific. They

are faster and easier to find, and often available at a lower cost than assignment work. That's why clip- and royalty-free photo discs have become popular with less discriminating photo users.

The better stock images portray a concept or feeling that lends itself to many marketing uses. Most stock photography is shot, filed, advertised, and requested on a subject-by-subject basis. If you apply some of the more common concepts to the photography of fixed subjects, the resulting images will have a longer life span and, consequently, a greater value. A sample subject list might include the following:

✓Aircraft	✓Dogs	✓Recreation
✓Animals	✓Equipment	✓Restaurants
✓Boats	✓Families	✓Senior citizens
✓Buildings	✓Flowers	✓Sports
✓Business	✓Food	✓Sunsets
machines	✓Horses	✓Teens
✓Cars	✓Lovers	✓Travel
✓Cats	✓Men	✓Water
✓Children	✓Mountains	✓Women
✓Clothing	✓Musical	
✓Computers	instruments	
✓Couples	✓Parents	
✓Doctors	✓People	

While it's easy to shoot stock photo subjects such as those listed above, concepts are more difficult to portray. In every stock photo shoot, try to apply a feeling, or concept, to your subjects. Marketing concepts might include the following:

✓Antique	✓Exciting	✓Peace
✓Artistic	✓Feeling	✓Pride
✓Asian	✓Fresh	✓Principles
✓Beautiful	✓Geographical	✓Quaint
✓Best	✓Glamorous	✓Sadness
✓Classic	✓Happy	✓Safe
✓Cold	✓Hateful	✓Satisfaction
✓Colorful	✓Healthy	✓Sexy
✓Comfortable	✓High-tech	✓Tasty
✓Cool	✓Honesty	✓Teamwork
✓Craftsmanship	✓Hot	✓Togetherness
✓Danger	✓Independent	✓Trustworthy
✓Dry	✓International	✓Unhappy
✓Economical	✓Inviting	✓Warmth
✓Elegance	✓Love	✓Wholesome
✓European	✓Luxurious	✓Winner

Take a look at the annual award-winning advertisements in *Communication Arts* magazine, the Clio winners, the Magazine Photos of the Year and similar

image-conscious marketing. Most of these involve an effort to convey a distinct feeling to the viewer. This should be the primary goal in all of your stock and assignment photography.

Your Interests. Shooting stock images allows photographers to cover or participate in just about anything imaginable. If you enjoy hiking, swimming, jogging, camping, family sports, or gardening, there's a demand for good recreational images of people in all of these situations, in all types of geographic locations. If you enjoy horses, auto races, fashion, music, dancing, cooking, carpentry, inventing, exploring, native crafts, business, computers, manufacturing, wood carving, collecting, travel, television, stamps, coins, wigs, bugs, or similar things, somewhere someone needs photography on these subjects. And that's your opportunity to shoot and sell stock images.

Many photographers, including myself, specialize in shooting stock images of the subjects we enjoy. My love of travel, foreign cultures, and geography has resulted in the making of an excellent lifestyle and destination stock photo file. There are similar files on wildlife, flowers, famous faces, famous events, rock and roll, cities, churches and temples, antiques, cars, aircraft, and so on.

No matter what your interests, shooting stock images for sale allows you to participate, to be around, and to collect props toward that end. It also allows professionals in specialized fields, say mountain climbers, divers, pilots, doctors, missionaries, and the like to become stock photographers, as well.

Shooting speculation stock photography allows you to work any time, any place, and for any market. You don't need an assignment, because stock is a self-generated assignment. All you need is the desire to make images, a little knowledge on the intended subject, the business format and, of course, the money for materials, equipment, and production capability.

Thanks to the congressional lobbying efforts of ASMP, PPA, and other artist-oriented associations, photographers can now immediately deduct the costs involved in making stock images for sale. Previous tax regulations required the expenses for this type of shooting to be deducted when the images were sold. Talk about an accounting nightmare!

In order to meet tax requirements for speculation stock shooting, that is, having the deductions accepted in an audit, you must be in the business of making and selling photography. This can be as simple as having an agency selling your work on a regular basis, even though you work in another field. If you are an

assignment photographer, no problem. If you are starting out in the business, make sure your intent and goals are aimed at making a profit. That's the basic IRS test, by the way, the intent to do business for profit, not as a hobby or vacation tax write-off.

Producing Stock. Leading stock photographers plan stock shoots around subjects they know have constant markets. This might be something simple like an ethnic meal prepared and shot in your studio. It might be the crafting of musical instruments. It might be life in rural America.

Producing stock photo shoots puts you in the position of both client and photographer. You must conceive the idea, procure the props and people, plan the shoot, schedule the logistics, make and market the photographs, and pay for everything along the way.

I plan recreational shoots in popular tourism locations such as Hawaii, Mexico, Tuscany, or French Polynesia. This involves selecting good shooting locations, hiring local and international models, scheduling accommodations and transportation, planning the shoot list, establishing a budget, checking the market need for images, and, of course, making the images and footing the bill.

It also means shooting a variety of concepts around each situation. In making stock images, I shoot double the normal assignment amount of film in order to produce as wide a selection of marketable images as possible. I also try to create originality in my images so they are attractive to buyers and my stock agent.

You can imagine how high the costs of a major stock photo shoot can be, but producing your own stock should be considered an investment in the future. The images you make today may sell next year and they may still be selling in ten years. Of course, they may never sell at all. You take the same risk all independent businesspeople share in committing hard cash to produce a product for sale.

Make sure you have enough hard cash to cover speculation shoots, conduct normal photo business, and take care of the extras like food and rent. Be sure you have a market in mind for the stock images, too.

Shooting Digital Stock Images. Most of the major stock agencies and many buyers of stock photography prefer working with digital scans of images these days. At this time in the market, this means having film-based images scanned into a digital format for storage and sales distributions via the Internet or a CD. Keep in mind that many photo users still want the original film image so that they can have it scanned themselves.

More and more photographers have taken advantage of the ease with which original digital images can be shot, manipulated, stored, sold, and sent. The quality of digital cameras is good, and is getting better with each new generation of equipment. In fact, it is good enough to start creating stock libraries of images and good enough for some stock agencies to accept for their files.

Unlike traditional film-based photography, you'll need more than a couple of camera bodies and a few lenses to start working. The digital shooter will also need a good laptop computer to download images from camera discs; plenty of memory cards; a larger office computer with image manipulation software and good storage capability; a quality color printer; a scanner; and a high-speed Internet connection or modem. The investment of time, learning, and money is substantial.

Internet Stock Sites. Online digital stock libraries, mostly at Internet sites allowing immediate purchase and downloading of images, are quickly becoming the only way many image buyers work. They like the speed, price, and quality such sites offer. Plus, they like having the images already scanned for immediate use. Creating a stock website requires the help of an experienced web designer. You'll need to consider such things as a search system to find the image a buyer wants; categorizing and storage systems; and immediate payment systems such as credit card or online pay sites (such as PayPal). In addition, someone with a lot of computer and web retail operation experience needs to maintain and promote the site.

Don't let the above paragraph scare you away from starting a simple stock photo sales website. While the initial cost isn't cheap, neither is establishing a photo studio or commercial shooting business. And, it won't be many years before most stock images are searched out and purchased from websites. It's just too easy for buyers. So you should start considering what it takes to create and maintain your own stock site or making a deal with an agency that does all of that for you.

Before taking the leap into online stock photography, I suggest you examine some of the better sites around. The big players, like Getty Images, ImageState, and Corbus are the place to start. Together they control most of the digital and online photography market. However, some of the smaller agencies have very good sites and selections of images as well, and they hold their own in the sales end of the business. Simply asking one of the Internet search engine sites, like www.google.com, to look for "photo library" or

"stock images" will get you hundreds, if not thousands, of sites to examine.

Future Digital Stock. The writing is on the wall about online digital stock photography as a business, so far as leaders like Getty Images are concerned. With something like a million images available through their various online sites, they are easily setting the pace we all will eventually follow. More important, Getty rarely licenses the use of an original film image in film format. All of their sales are in digital format, delivered online or via CD.

While there are still photo users who require the original film, the time it takes for delivery and scanning, not to mention the liability for potential loss and damage, may eliminate the use of film all together in the next few years. Today's photographer must have the ability to deliver images in the format the client needs. Right now, that probably means the ability to scan and deliver your film images quickly. In the next few years, however, it may mean shooting all your images in a digital format.

The Business of Stock. People visiting my office for the first time are often amazed at the trappings needed for a stock photography business. The editing, identification, filing, marketing, and shipping of stock images require a great deal of administration and space. My facilities represent about fifteen years of assignment shooting, about half of which has included creating and marketing stock work. I feel that the administration of stock images, that is, identification and filing, is just as important as the making of those images.

■ IMAGE IDENTIFICATION AND CAPTIONING

The caption information you place on a new stock image will follow that image throughout its lifetime. The more specific and complete the identification is, the easier it will be to administer and market the image. This is one of the most important administrative activities you will perform. An image without identification often becomes lost. An image without release and location information won't sell for Big Bucks.

If you're with a stock agency, they will undoubtedly have an established captioning format. If not, I suggest the following caption style for 35mm and larger transparencies:

The image number should be a brief code that immediately tells you the subject matter and its proper file location. Such information substantially reduces the amount of time required to extract and refile

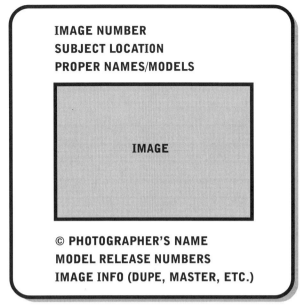

images. It also facilitates the tracking of sales, uses, age, ownership, cost, and other related information for a specific image.

Establishing a numbering system is easy at the beginning but can be difficult to impossible to implement after a few years of haphazard filing, shooting, and selling. No matter the level of difficulty, however, setting up a numbering system is important: Such a system is the best method of proving an image's value in the event of loss and for insurance purposes.

Subject and location are the categories by which clients make requests and therefore, are the categories into which photographers generally file their images. This information should be specific, short, and to the point—yet detailed enough to cross-reference the image in a computer system. For example, a typical slide caption would read:

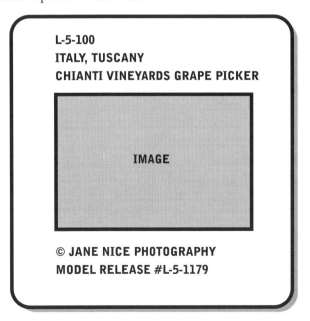

This particular slide can be listed and cross-indexed in your computer system under the following categories: Italy, Tuscany, grapes, vineyards, agriculture, field labor, wine, countryside, and so on.

A caption, along with with your name and a copyright symbol (©), should be put on every slide immediately following the initial edit.

The model release number lets you and the client know that a specific release is on file and available should the need arise. Leave the small side edges of slide mounts blank for future use by stock agencies and other information.

Handwritten Captions Are for Amateurs! I use a Slide Typer captioning system, produced by Trac Industries (see chapter 13), which prints three to six lines of information on the wide side of 35mm mounts. This is a stand-alone system, although there is software available for captioning label systems that works with most computers. Typing small caption labels and stamping your name on images is the least expensive captioning method.

File Systems. All images must have a place in the file system and should always be kept in their respective files, thus making it simple to find images when a buyer comes calling.

Establish a set of file subjects and files as you edit the results of a shoot. Images should be sleeved and installed into this file system immediately. From these files you can easily make selections for clients, publications, and agents.

My own file system is based on the location and primary subject of the image. This is done by assigning a coded number to each image. The first number or letter tells me the location and subject, and this is the same as its file number. It's a quick and easy job for anyone to refile images being returned from clients.

Original Images. Original images look the best and sell the best, no matter what anyone or any stock agency says about duplicates, photo CDs, and online downloads. I send the best possible original images to clients and agencies for their consideration.

I maintain a working file of 35mm and 4x5 duplicate images for unusual uses where originals may be at high risk. Some publishers and clients do not treat images with much respect; if I am aware of this, and still wish to make a sale, I simply submit a duplicate. I also use 4x5 duplicates for all portfolio presentations and 35mm dupes for any projection of images and for courtesy copies to models and certain clients.

Photo CDs. I scan images to photo CDs, which can be duplicated and sent to potential clients as a portfolio (low-resolution scans). These scans can also be done by a professional lab using Kodak Photo CDs. I place lower resolution scans on my portfolio website for quick and easy examination by potential clients. I also maintain a separate online stock photography website, of higher resolution images, for direct licensing to clients. And finally, I protect my very best and most valuable images by scanning them on photo CDs. I store these discs away from the original images, in case of fire or theft, and use duplicate discs to register copyrights.

Everyone has special or favorite hot shots that need their own file and separate consideration for client submissions. I have images with major sales success—or major sales potential—duplicated onto reproduction-quality 4x5 film and photo CDs. Although they're an expensive investment, these duplicates and discs make excellent portfolio pieces and reproduce well in the event of an image loss.

■ RELEASES

You should establish a model release numbering system and file similar to the subject filing system I recommended for organizing images.

Stock images are ten times more valuable with model and property releases.

Ensure that the caption on every model- or property-released image includes a release number. This immediately lets you and the client know that a release has been secured.

My photo delivery memos, invoices, estimates, and all agreements with clients and agencies also include the following phrase:

Model- and property-released photos are indicated on the mount. If there are any questions regarding releases, contact the photographer before using the image.

In other words, I consider it the client's responsibility to check for a proper release unless the mount says one exists. I also provide copies of releases to clients who have a high potential of risk in their image use. This might include a copyrighted property, a partially clothed or unclothed model, exclusive private property, a celebrity, a minor model, and similar subjects. If there is any question about the risk of a certain type of photo involving, perhaps, nudity or a celebrity, obtain a release that specifically spells out what is being photographed and released.

Please don't tell me that asking for a release upon the completion of a session will ruin the relationship or mood you've established with a photo subject. You are a professional photographer in business to sell photos and make money. If you think photo releases aren't important in every aspect of your business, take another look in the legal chapter of this book.

Of course, a photo release also makes your image ten times more valuable.

■ TAXES AND INVENTORY

Taxes. Stock images are not considered inventory by the IRS, due to that excellent lobbying effort mentioned earlier. Once an item has been expensed, which means written-off or deducted, it is not considered inventory. This is CPA and IRS talk, but it means that you need not declare it as an asset or inventory when filing taxes. However, they may take another view if you continue to show losses for a number of years while building a photo file.

Selling the use of a stock image is a service. There is no transfer of tangible property because you get the original back for future sales. The sale of services have their own special tax category in most states. Some states consider any sale within their borders to be taxable. Some states also impose taxes on sales made outside their borders, even though the job, sale, and check may be outside their state. Remember that most states' hunger for tax money is greater than your hunger for success.

Check with a knowledgeable CPA on tax regulations as they relate to the production and sale of stock images. The rules and regulations governing this business are constantly being considered and changed by well-meaning bureaucrats.

Insurance. The better your stock image filing and identification system—which should include individual values—the better your relationship with an insurance agent, and the greater the worth of those images.

Establishing stock image lifetime sales values is difficult for even the most seasoned professional. While it's easy to prove what a given image has sold for up to the current date, no one can predict what its future sales might realize. Some images sell and sell for years, others sit and collect dust. This makes it difficult to obtain insurance and settle claims for lost images. Suggested insurance valuation and coverage of stock images is discussed in chapter 4.

Estate Planning. The IRS has very little trouble in establishing the value for a library of stock images, which they may do in the event of your death. Their method is to average the past sales of your images and apply this value across the board to all of the images in your file. Obviously, this is a time when your heirs will want file images to be valued on a different scale. Poor and non-selling images must be taken into account by an appraiser.

I suggest making arrangements with a stock photo agency or well-established stock photographer to evaluate the images in your file every ten years or so for estate planning purposes. This should be done, obviously, while you're still alive and can assist. Such an evaluation will establish a continuous written record— put together by experts—for tax and insurance purposes. Expect to pay a fee for the stock image evaluation, based on the file size plus expenses. It's tax-deductible.

■ STOCK RATES AND RIGHTS

There is no across-the-board price to use a stock image. The pricing formula is a bit complicated for first-time sellers and buyers. Uses are categorized by the reproduction size, placement, media, number of imprints, geographical size of audience, and whether it's for editorial, advertising, or commercial use. Advertising and commercial uses must have the appropriate model or property releases and command higher rates. Most editorial uses don't require releases or have other commercial value, which makes them lower in price.

For instance, a client may wish to buy your photo to illustrate the cover of a brochure that will be printed one hundred thousand times, and will be distributed within a regional area. Or a publisher may desire to use your photo half page in a regional magazine article with a circulation of fifty thousand readers. An advertising agency may wish to use your image in a full-page ad that will run in ten national magazines with a total circulation of five million. Each of these uses has a different price, which you must be able to quote prospective clients. You must also be able to rationalize with, or educate, some clients as to the reasoning for such pricing. Some photographers prefer to have an agent and/or stock agency handle their price negotiations.

Stock Use Rates. So what do you charge for the use of a given photo? Most photographers say that they follow ASMP rates, although this isn't accurate. In fact, the ASMP and other professional associations do not *set* rates for any products, as such practices are against federal law. (Organizations and individuals are prevented, by federal antitrust laws, from getting together and establishing uniform rates they charge for

their services and products.) Photographers are referring to the results of a stock rates survey, conducted many years ago, of the ASMP membership. The survey's average rates appeared in an old ASMP *Stock Photo Handbook*. Their new book does not list any rates.

There are several stock and assignment photo pricing guides available at professional camera stores. I suggest you evaluate the rates in these and other publications, and then establish general rates of your own. Draw up a dozen or so categories and prices for regional, national, and international uses. Do this in a computer so that changes can be easily made.

No matter what the industry standard rate is for a certain photo use, buyers often have their own established rates—which you can take or leave. Stock agencies also may charge as much or as little as they please. Many low-ball prices in order to make lots of sales. Remember, they are in business to make themselves money first. You just get a share of the price they sell for and have nothing to say about the price at which they sell.

I use the stock photography software pricing and selling guide called fotoQuote, developed by Cradoc Bradshaw. It's a simple geographic and specific-use oriented guide to pricing most stock images. The software sells for less than your minimum stock image should be priced. Information on this product is located in chapter 13.

Negotiating Rates. Many photo buyers have their own established standard rates or use one of the many printed guides that are available. No matter, these people will still test your business sense and ask for a price quote, just to see if they can save a few bucks. Some clients have unusual uses, may purchase a large number of image uses at a discount, or might want unlimited rights. These cases demand negotiation and attention to the details in their request and uses.

Clients will check your rates for stock photography uses for two reasons. First, when they're window shopping. This is the time to be general or generic. The second check comes when they've selected an image and want to negotiate a purchase price. This is the time to have a specific price quote ready.

The major clients and multiple image uses often require the most negotiation. When dealing with these people, ask if they have a budget or price in mind. Their answer may be sufficient to end the negotiations with your acceptance.

It's easier to come down in price than it is to go up.

Say an advertising agency plans to run several full-page advertisements, using your image prominently, a dozen times in a national magazine. The rate is X number of dollars per use, based on the circulation. The clients may want a better deal because of the extent of their purchase. This is just good business on their part. Ask the cost of the total media buy, which will be X number of dollars per page. The amount may be so substantial that your rate for the photo isn't enough to get a single-digit percentage of the media placement total cost. This is a good point in your favor. Ask them what they have in mind. Ask yourself if the image is a hot one and rates a special value.

Transfer of Rights. The client purchases specific use rights, which is a license to use your copyright in a certain manner upon their payment of the invoice. The *exact usage* should be written on the invoice, so that there is no question about what is being purchased. The following phrase should be included in your estimates, agreements, delivery memos, and invoices:

Specific use rights to these images transfer to client upon payment in full of the photographer's invoice. Any use prior to such payment may be considered an infringement of copyright. Any use, such as electronic publication or storage, second editions and manipulation, not specifically provided for on the photographer's invoice requires additional compensation before such use.

■ SELLING STOCK PHOTOS
There are two ways to sell stock images: the easy way, through an agency, or the difficult way, by yourself.

Direct Sales. Selling your own stock photos really isn't all that difficult. In fact, there are many photographers who are very successful at selling stock. I'm one of those photographers. However, it is a separate business function, which means you must sell and administer in addition to producing the images. Many photographers prefer to produce lots of images and leave the professional salespeople to handle the selling.

There are a number of ways to sell your own stock, most of which are similar to selling assignment work. The common methods are by direct mail, advertisements in trade publications, in-house sales representatives, and personal client calls. No single method will guarantee success.

The annual photo books, sometimes called art buyers' books, have always been good places for photo

buyers to see lots of images. They are also excellent places to promote your own images. Leading books such as the *Black Book* and the *Workbook* sell pages to both photographers and stock agencies. In addition to paying for space, you also have to cover the costs of design, separations, and the like. Most of these books have payment plans and design help. As an incentive, the books also give advertisers reprints of their individual pages, which should be included with direct-mail packages and other marketing materials.

The art director magazines are also good places to market your stock images. The best is *Communication Arts*. On the positive side, these magazines include interesting features and advertising from all sorts of suppliers, and you won't be bunched in with hundreds of other photographers. They are also read frequently by photo buyers. The downside is that the costs run higher than a page in the annual photo books and the life span is only a month or two.

All of the publications that solicit sales from photographers have mailing lists and websites to help you learn about their products and services. Take a few minutes every now and then to look over their material to see if they are right for your own marketing plans.

Stock Lists. Your comprehensive stock list should be included with any mailings or client leave-behinds, including reprints from the photo books and magazines. Keep your list on a computer so it can be updated on a regular basis. Don't list a subject, location, or topic unless you have a good file of images to send prospective clients.

Art buyers receive hundreds of postcard, flyer, catalog, and poster promotions each week. They will spend about ten seconds examining each item. The best ones will be held aside for further examination and possibly the working file. The best promos often make their display wall. However, they will almost always file a stock list for future reference. Make sure yours has good contact information on it.

■ STOCK PHOTO AGENCIES

Typically, a stock agency handles the marketing, sales, and business administration of a library of images. It makes an investment and then takes the risk that the images they have selected and inventoried will sell. For this service and investment, the agency will generally receive 50 percent or more of image sales. This is similar to the way any agent represents an author, musician, or other creative talent, although commissions are much lower for those agents.

A stock agency is in business to sell the images of many photographers.

In working with an agency, it's your job to produce salable stock images, with proper captions and releases, in a timely manner for the agency. You take the risk that this investment of time and money will sell well enough to cover production costs and make a profit that could not be equaled by making sales yourself.

Working with a stock photo agency is a partnership from which both sides expect to profit.

The Agency Role. Agencies are responsible for marketing and administration, so the better an agency's photographers and images, the better the marketing potential. The better your agency is at selling, the better the sales. The agency is responsible for accounting, billing, duplication, research, and other administrative efforts involving your photographic images. The best thing about stock agency photography is that, once you have images on file, they sell while you do something else, like shoot another assignment or take a nap.

You shoot and the agency sells. Let them do their job without any interference.

Some stock agencies produce or purchase work-for-hire stock photography. This means they hire a photographer to shoot certain subjects or locations, paying the expenses and a fee or small royalty on sales. The copyright to these images then belongs to the agency. While I'm not crazy about the practice, it has become prevalent as a means of earning short-term income for hungry photographers. In the long term, however, these photographers will make a great deal less (and the agency will make a great deal more).

Selecting an Agency. Selecting an agency depends on a number of factors. You want a successful, aggressive agency; they want a successful, talented photographer. Remember that stock photo agencies are a serious business aimed at making money. Their time is valuable, which means you must have more than a passing interest in being represented.

Finding the agency that is right for you takes the same kind of research as finding clients for your photography. First, talk with photographers to see who they work with or recommend. Second, ask art directors which agencies they call for images. See if the art director will let you look through a few agency cata-

logs or image CDs that proliferate in the offices of photo buyers. Take a close look at the stock agency advertisements in leading graphic publications and talk with photographers represented by the agency.

There are two basic types of agencies. Specialty agencies represent only a single genre of images, such as wildlife, news events, or historic images. The general agencies cover just about every general subject. The ideal agency is one that has a need for the kind of photography you produce. Your research should provide reputable and respectable agencies.

Stock agencies are interested in the quality of your work, how much you have available, and how many new images they can expect every month.

Selling Yourself to Potential Agencies. Edit your best portfolio work into a single sheet of twenty 35mm images. Duplicate and caption these images. Send the sheet, with a letter of introduction, to a prospective agency. I suggest limiting this effort to a single agency at a time. Many agencies are owned by larger corporations that talk to each other. Remember, they are the market and it's a buyers' market. Set your sights on the best agency possible and be persistent in trying to attract their attention.

The following is sample letter to an agency:

Dear Agency:

I am a professional photographer seeking the services of a good stock agency. You come highly recommended by James Brown, an art director with XYZ Company.

I have enclosed a small sample of my photography for your consideration. These images are duplicates. Should you desire, I am prepared to present a larger sample of original images.

If my work fits your established standards, perhaps we could meet to discuss the possibility of an agreement. If we reach such an agreement, I am ready to provide you with five thousand original images for immediate consideration, plus another five hundred new images each quarter.

Your time and consideration of my work are greatly appreciated.

Sincerely,
Photographer So-and-So

Once you've attracted the attention of an agency, it's time to discuss and negotiate the business side of things. There are several areas that should be discussed with your potential agent. Remember that you are dealing with a business interested in maintaining a professional relationship with you and making money. They are not interested in stroking your ego. They also expect you to know something about their side of things and to ask intelligent questions.

Every stock agency will want you to sign a contract or letter of agreement, which spells out exactly what's expected between agency and photographer. Ask for a copy of the contract, to examine in advance, before meeting to discuss business. Make sure you understand the requirements, term of representation, fees, and related items.

Make sure you can live up to all the agency contract terms before signing.

Agency contracts may or may not be negotiable. No matter which, your lawyer should give contracts the once-over to advise you of any potential areas of uncertainty. Armed with this information, personally meet with the agency to discuss your relationship. Most are very open to a photographer's personal approach, but often become a brick wall if forced to deal with a lawyer or to make any changes to what they call a "standard contract."

When an agency wants you to sign a contract and join the ranks of their photographers, they are at their very best. Unless you become one of their highest-grossing photographers, you will become another numbered account from which they must accept images and to which they must make payments for sales. In other words, make your needs known up front and in writing, because once the ink has dried you have to go to work and they go back to work. There aren't many second chances to reconsider any of the terms. Don't be put off by this fact of business; it's just business, and you are dealing with a corporation that intends to make a profit.

The Fine Print. Some agencies want exclusive representation. This means they're the only agency representing your work. It also sometimes means you can't make direct stock sales to clients. All agencies want exclusive images. A good agency in Los Angeles will market nationally and internationally. Their catalogs, submissions, and advertising should not have the same images, from the same photographer, as an agency in New York. You can appreciate the confusion an art

buyer faces in seeing similar work, by the same photographer, from different sources.

There are a few smaller regional agencies that do allow photographers to be represented by other regional agencies. Keep in mind that today's small agency will grow and sell nationally, and it will probably be purchased by a larger agency as a result. This could mean that two agencies in the same city may have the same photographer's images.

This may seem obvious, but make sure you always retain the copyright to the images you provide an agency. This should include duplicates they may make, manipulated and/or combined new images created from your images or CD portfolios, and other changes they make in your images. Do not allow them to share or own the copyrights to your images, no matter what the format or what their standard practice. Your images are the only thing an agency wants from you. If they own your images, they don't need you. Read the fine print in your contract about copyrights.

Contract Length. The Term of Representation is generally three years for the first contract. This gives you and the agency enough time to see if a mutual profit can be made. After that, contracts generally run five years. Many agency contracts have an automatic renewal, if neither you nor the agency objects in writing. Be sure your contract has a start and finish date.

Some contracts state that the agency has a certain number of years to market accepted images, which begin with the acceptance of an image. This means each image has its own length of time with the agency, regardless of the contract expiration date. There can also be an automatic renewal of the contract beginning each time an image is selected.

What happens if either you or the agency is unhappy? Can the agency quit accepting your images? Can you quit submitting? What if one party elects not to renew the agreement? In such cases, there should be a procedure and fixed schedule for the return of your images. Most agencies have the right to market any images used in their catalogs or promotion beyond contract termination. This is not an unreasonable request so long as a specific time period is agreed upon in advance. Make sure this includes any duplicates the agency may have produced—especially when you have paid for their production.

Some contracts do not require agencies to ever return images. And, believe it or not, some agency agreements allow them to market any accepted images in perpetuity. So far as I'm concerned, no business agreement should last forever.

Payment and Accounting. How does the agency handle accounting of image sales? How often do they pay photographers, and what proof of sales is provided? Do photographers have audit or inspection rights to their own accounts and submissions? What fees are they expected to pay or share with the agency?

Agencies generally consider photographers to be necessary suppliers rather than creative talents. Many impose fees for a variety of services, some of which may be aimed at making money from photographers before an image is sold. There may be a fee to accept and file an image. The agency pays a staffer $10 an hour to accept, edit, record, and file one hundred of your images. They charge you $2 per image to cover this cost. Figure it out. Imagine the agency fee for accepting ten thousand images! Agencies may also charge their clients a research fee, which the agency keeps, to find and refile your images.

As the markets get larger for stock images, agencies make agreements with foreign agencies to represent their photographers, or even open up shop in such locations themselves. They are able to represent the same image in many locations by selling rights to reproduction-quality duplicate images. Logically, agencies expect the cost for duplication to be shared by photographers. You might want to include a line in the contract stating the agency can only charge the cost of making duplicates, or providing other similar services, perhaps to be shared by you and the location agency. In other words, the agency can't make a business of and profit from duplicating your images. Again, make sure that you own all duplicates of your images.

Agency Promotion. Most agencies market with extensive catalogs, advertising, CD catalogs, and websites representing their file of images—not their photographers. Over the years, this has become the place for photo buyers and creative people to examine and select stock images. Rarely will you see an agency, magazine, designer, or other marketing-oriented business that doesn't employ most of these resources.

Photographers are not required to participate in agency marketing programs. If they do, it may require purchasing the image reproduction space and related production materials. Some agencies have developed these programs into a major profit center, making money from the photographer's participation rather than the sale of images. It won't take much to figure your photo page cost and compare it with your agencies' charges. If costs are the same, the profit goals are the same, too.

 Make sure your agency is in business to profit from the sale of images, not from your submissions and catalog page sales to you.

Don't misunderstand my questioning of agency fees. Stock photo agencies are in business to make money. I know many agency principals and respect their profit and business motivations, especially when it includes photographers. There are, however, agencies that charge you an image filing fee, a duplication fee, a catalog fee, a pull fee (to leave the agency), and a client research fee. Some charge an additional 25 percent of your sales for images in catalogs, which is a huge profit for little investment on their part. Some of these agencies intend to profit from the handling of images rather than the selling of images. Don't let that happen to you.

As mentioned earlier, some agencies are only in a numbers game—lots of photographers, lots of quick sales, and lots of profit, mostly for themselves. The choice in agreeing to unreasonable charges and fees is yours. Take a close look at the agency you hope to be with, and talk with some of their average photographers before signing anything.

Your Role with a Stock Agency. You can be either an asset or a pain in the asset to a stock photo agency. One makes money for both parties, the other costs both parties money. The single ingredient to making money with your agency is communication. This doesn't mean calling every week to see if they have sold your latest submission. It also doesn't mean calling to see where your check is for the past quarter. It means letting the agency know what you are doing work-wise and paying attention to the information they send you regarding agency image needs.

You need to know what the agency is selling; what's hot in new photo uses; and how you can improve submissions, quality, ideas, caption information, presubmission editing and, yes, sales ideas for the agency.

Better stock agencies send newsletters and lists of photo needs to their photographers on a regular basis. These reports often relate the agency's best sales, new photo-buying trends, marketing opportunities, photographer and agency news, and other information aimed at the common goal of selling images. The better photographers read the reports and adjust their shooting and submissions accordingly. This doesn't mean you have to change styles or quit being a creative shooter because the market is slow. It means that photo buyers are requesting certain images, which you can produce and submit.

Submissions. Your agency may require a certain number of submissions and acceptances each year. Their big stick might be a reduction in your share of income from sales if this minimum isn't met. This isn't a way to make more money from you, it's a way to get submissions. Photographers who constantly produce and submit new work to an agency are desirable and profitable to that agency and themselves.

The more quality images you submit to this agency, the more money you will make. These are the welcoming words you will receive from a stock photo agency. The more images an agency has, the greater their potential for sales. The greater your agency sales, the greater your share. Simple process.

How many images should you submit each month? I suggest you submit the best images made during the past month, be they ten or ten thousand. Even though a large number of images on file with an agency can lead to greater sales, the quality of your work is the basis of all sales and agency selections. Your job is to consistently make and submit high quality images.

Too many photographers sign on with stock agencies just to find a home for their excess or outtake images. What the photographer can't sell, they hope the agency will. This is not the way toward greater riches. And you can bet your next commission check that the other photographers will be submitting their best first-takes to the agency.

Agency Clients. The world's leading users of photography, the clients who spend the really big bucks on images, know all about stock photo agencies and their various products. As often as not, the agencies are among the first places that are called when there's an immediate need for good photography. By making two or three calls, a client can have hundreds, if not thousands, of top-quality images on their desk within a matter of hours—no assignments, no production costs, and no egos to stroke.

In the world of assignment photography, reputation and experience are often the prerequisites for getting choice jobs. Stock photography, on the other hand, is purchased because it's the right image, not because it's the right photographer. Your images have the same opportunity to sell as the best hotshot's in the same agency. The client rarely reads the name on the mount.

Selling and Your Agency. The client may not always read your name on a stock agency photo mount, but when they do it can mean a choice assignment may be offered. If so, this is a major benefit of working with the right agency.

Sometimes a client of your stock agency will call you directly, seeking a better deal. A major Los Angeles advertising agency that I did several assignments for liked some of my images in the file of my stock agency. They didn't like the usage rate quoted by my agency and contacted me directly for a better deal because of those assignments. This is a tough but not uncommon position. While it was difficult to turn down their offer, which would have been more than my 50 percent of the agency sale, I said that my relationship with the agency was more important than a few quick bucks. The art director agreed and went back to the agency for the purchase.

It can be tempting to sell around your stock photo agency, especially if you occasionally sell stock directly. It is easy and tempting to make direct calls to clients who have purchased your images through an agency. While this may make a few sales, some clients have no loyalties and only want to save a buck. It may also damage the relationship with your agency. It may void your contract. Worse, it may bring on a legal action. No matter which, it isn't the right thing to do with a business partner, and that's exactly what a stock agency is—your partner.

In signing an agreement with a stock agency, you promise to produce and provide images, which they promise to market. This is a great combination that can lead to even greater profits. I suggest you spend as much time as possible making images for the agency to sell, rather than seeking ways to make sales around their efforts.

The Bad News. You may have gotten the impression that it's easy to sign up with a stock photo agency. Unless you're a very good and prolific shooter, however, it isn't easy.

Ten years ago there were stock agencies all over the place, but today there are only half a dozen major players in the business, with two or three mega agencies at the top of the pile. These mega agencies represent four or five thousand shooters, and they literally have millions of images in their files. These larger agencies are often owned by even larger corporations who are interested in the bottom line. If you are able to sign on with one of these corporations, you will become a number and will be expected to turn a profit. If you don't, your contract will expire and you will be cut free to pursue other avenues.

The mega agencies don't need more photographers or images, unless they are very good, persistent in their approaches to the agency, or are well-established competition to their own sales and promotions. You must sell the agencies just like any other client, following all the rules presented in earlier chapters.

The Good News. As with any business, some photo buyers like special attention. I call it service. They like talking to the same sales representative every time, getting answers to questions and model releases quickly, having the exact images they requested sent, and having their needs met with a smile. The mega agencies are big in numbers, but not always big in personal service. And some people simply don't like dealing with huge business concerns, no matter what price and selection advantages they may offer. Some photographers feel this way, too.

Smaller regional stock photo agencies are forming again, which is where you might begin the search for placing your work. This is where you will have the best chance in signing on and where you will receive the most appreciation as a creative talent.

When a stock agency and photographer click well so do sales and profits—no matter what the agency.

RESOURCES

Learn from the mistakes of others. You won't live long enough to make them all yourself.

These words greet trainees at the Navy Special Warfare Schools, which train Special Forces SEAL Teams. These are the guys who do underwater demolition, parachute behind enemy lines, blow up missile sites, and make life very difficult for our enemies. Both the Navy and I know that Eleanor Roosevelt said those words first. So how does this macho military business relate to photography? Just like the Navy's SEALs, you won't live long enough to make all the mistakes that our profession will throw at you. But you can find out all about the potential problems and opportunities in business and photography by visiting the library, a bookstore, or the World Wide Web. Just seek out and study the work and words of people you admire and respect. Learn from what they have already accomplished and taken the time to put down on paper. Following the directions in these resources generally helps things work out well. Doing things by feel is almost always more expensive in time and money.

There is a good how-to book available on just about everything. There are hundreds of excellent books available on photography and the business of photography. A well-read photographer knows what's going on and how to be ahead of the competition when things start moving fast. You will find all the information necessary to develop a very successful business just by reading. (But you already know this, or you wouldn't be reading my book in the first place!)

Recommended Resources. I've listed several resources that have helped me make successful business and creative decisions. Even a brief study of these suggested references will give you an idea of the information that's available. These resources should only be the starting point in your continuing education.

I've tried to provide current and accurate places to obtain my suggested resources. However, with time and today's mobile businesses, some of these sources may have changed. My first stop for any publication is generally amazon.com or the website of the publisher of this book, Amherst Media (www.AmherstMedia.com). My next stop is www.dogpile.com, which is a combined search engine of the Internet. If you can't find the exact item I've suggested at one of these locations, there will be a dozen other good ones to take their place.

■ PHOTOGRAPHY BOOKS

Professional Marketing & Selling Techniques for Wedding Photographers, Jeff Hawkins and Kathleen Hawkins (Amherst Media, 175 Rano St., Suite 200, Buffalo, NY 14207, 800-622-3278, www.AmherstMedia.com)
This book offers an excellent nuts and bolts approach to the retail photography business—regardless of your specialty. It gives some very good tips on setting business goals, market analysis and straightforward sales techniques.

How to Operate a Successful Photo Portrait Studio, John Giolas (Amherst Media, 175 Rano St., Suite 200, Buffalo, NY 14207, 800-622-3278, www.AmherstMedia.com)
This book offers a good overview of how a photography studio should operate. From equipment and lighting techniques, to promotional and marketing ideas, this is an excellent guide for beginners and seasoned professionals. In addition to portraits, the book covers such specialties as weddings, corporate portraiture, proms, and special events.

Legal Handbook for Photographers, Bert P. Krages, Esq. (Amherst Media, 175 Rano St., Suite 200, Buffalo, NY 14207, 800-622-3278, www.AmherstMedia.com)
As you read earlier in this book, there are many legal considerations in the world of freelance photography. The bet-

ter informed you are on such matters, the fewer problems they will cause. Written by an experienced lawyer, this handbook is an excellent guide through the maze of rights, liabilities, and similar legal topics as they relate to photography.

Professional Business Practices in Photography (American Society of Media Photographers, 150 Second St., Philadelphia, PA 19106, 215-451-2767, www.asmp.com)
This is a good basic guide to the business requirements of photography. An informative and practical manual on contracts, stock, forms, copyright disputes, and other subjects related to the business of photography. A free copy is a benefit of membership in ASMP.

The Photographer's Guide to Marketing and Self-Promotion, 3rd Edition, Maria Piscopo (Allworth Press, 10 East 23rd Street, New York, NY 10010, www.allworth.com or www.mpiscopo.com)
In its third successful edition, this is an excellent resource for beginning and professional photographers alike. Maria has probably examined the businesses of more photographers than any other single person. As a result, she knows what she's talking about. Her ideas and suggestions should be considered the standard by which you work.

The Photojournalist's Guide to Making Money
Marketing Strategies for Writers, Michael Sedge (Allworth Press, 10 East 23rd Street, New York, NY 10010, www.allworth.com)
If you're interested in selling to global markets, these books provide lots of useful information for beginners and professionals alike. Living and working from the west coast of Italy, Mike Sedge knows what he's talking about when it comes to international marketing. He provides specific information that will help you get started with foreign mailing lists, dealing with clients, international business organizations, and overseas marketing agencies.

Negotiating Stock Photo Prices, Jim Pickerell (110 Frederick Ave. Suite A, Rockville, MD 20850, 301-251-0720, www.pickphoto.com)
A prolific stock photography shooter shares some of his extensive information and experience. Good solid information on pricing and negotiation. His website is loaded with good information and links to other excellent resources. Now in its fifth edition, this book is available directly from the author via his website or telephone.

The Perfect Portfolio, Henrietta Brackman (Amphoto, Watson-Guptill Publications, 700 Broadway, New York, NY 10003, 800-ART-TIPS)

The best guide to developing an image, market, and career portfolio. Many of Brackman's secrets of selection, editing, and presentation are shared, all from over twenty years of working with such greats as Pete Turner, W. Eugene Smith, and Larry Dale Gordon.

Stock Photography: The Complete Guide, Ulrike Welsh (Amherst Media, 175 Rano St., Suite 200, Buffalo, NY 14207, 716-874-4450)
One of the most complete, step-by-step guides to stock photography available. How to shoot, price, market, sell, and store images. Computers, copyrights, and digital imagery round out this excellent book.

▣ GENERAL BUSINESS/MARKETING BOOKS

Innovation and Entrepreneurship, Peter Drucker (Harper-Collins Publishers, 10 East 53rd Street, New York, NY 10022)
According to the *Wall Street Journal*, Peter Drucker is the dean of business and management philosophers. While this is a slow reading book for picture people, it provides a solid foundation for the businessperson interested in succeeding.

The Art of Negotiation, Gerald Nierenberg (Barnes & Noble Books, 122 Fifth Av., New York, NY 10011)
Master the art of making a good deal, which is the heart of a successful business. The next time you sign away all rights, and for a very small fee, it's probably because the other guy has read this book.

How to Get Control of Your Time and Life, Alan Larken (Signet New American Library, Wyden Inc., 750 Third Avenue, New York, NY 10017)
This is one of the corporate world's most popular books. It's designed to help you gain control of time, planning, priority-setting, and organization. In a business as erratic as photography, having command of these things does mean having control of your life. Our time is what we sell.

In Search of Excellence: Lessons from America's Best-Run Companies, Thomas J. Peters and Robert H. Waterman, Jr. (HarperCollins Publishers, 10 East 53rd Street, New York, NY 10103)
The information in this book is the result of an extensive survey of our corporate clients. Among other things, the authors report that successful people are brilliant on business basics and don't let tools substitute for thinking and creativity.

On Writing Well, William K. Zinsser (HarperCollins Publishers, 10 East 53rd Street, New York, NY 10103)
The photographer who can get thoughts down on paper—whether it's correspondence, proposals, captions, or goals—will

be successful. This is a well-written guide on writing well. It's also a continual best-seller with professional writers.

How to Sell Anything to Anybody and How to Sell Yourself, Joe Girard with Stanley H. Brown (Warner Books 800-759-0190, www.twbookmark.com)
Joe Girard is the world's best salesman. Check out his listing in the *Guiness Book of World Records*. Through his books, he can teach everyone something about sales, ideas, promotions, and making bucks in any business. After all, selling is how we put food on the table.

Advertising Your Way to Success, Cort Sutton (Prentice Hall, c/o Pearson Education, 1 Lake St., Upper Saddle River, NJ 07458, 201-236-2330, www.prenhall.com)
The easy and understandable approach to advertising for the independent and small business owner. It will help you treat photography as a product. Excellent examples of promotional ideas and advertisements.

Swim with the Sharks without Being Eaten Alive, Harvey MacKay (Random House 1745 Broadway, 15-3, New York, NY 10019, www.randomhouse.com)
A very good pep talk book, full of helpful suggestions about selling. Aimed at beating the competition to the job and the bank. Our clients have been reading this one, so it follows that we should be reading it, too.

Standard Directory of Advertisers (The Red Book of Advertisers, 121 Chanlon Rd., New Providence, NJ 07974, 800-521-8110)
A good listing of regional and national advertisers. Detailed information: names, addresses, phones, fax, gross sales, advertising budgets, and advertising agency contacts. The first step toward a good mailing list.

Standard Directory of Advertising Agencies (The Red Book of Advertisers, 121 Chanlon Rd., New Providence, NJ 07974, 800-521-8110)
An extensive listing of advertising and public relations agencies. Once you find the clients in the advertiser's red book, this publication will help you find the people to contact. Expensive, but the best resource in the business.

Literary Market Place (Information Today, Inc., 143 Old Marlton Pike, Medford, NJ 08055, 800-300-9868 www.literarymarketplace.com)
This is the most extensive listing of book publishers available. It contains names, addresses, phone numbers, and publication information.

How to Prepare and Present a Business Plan, Joseph Mancuso (Prentice Hall, c/o Pearson Education, 1 Lake St., Upper Saddle River, NJ 07458, 201-236-2330 www.prenhall.com)
A good business plan is the heart of good business. This guide lays the ground rules for business plans that will help you with potential bankers and investors. It includes forms, checklists, and sample financial statements.

The Lazy Man's Way to Riches, Joe Karbo (Financial Publishers, 17105 South Pacific, Sunset Beach, CA 90742)
One of the all-time mail-order kings, Joe Karbo, brings home the positive results of setting goals and then going after them. This is the guy with those get-rich-quick, full-page ads that run in newspapers all over the country. You might be surprised at what can be learned in this interesting book that's sure to help your own sales efforts.

The Lazy Man's Guide to Riches has sold over four million copies since its release early in the 1970s. It's been updated and is now available in several languages, along with a dozen other equally interesting and inspirational publications by Karbo.

Go Rin No Sho (A Book of Five Rings), Miyamoto Musashi Trans. Victor Harris (Overlook Press, One Overlook Dr., Woodstock, NY 12498, www.overlookpress.com)
This book is the basic guide for Japanese businessmen, the guys who are kicking our butts all around the business world and running sales campaigns like military operations. It was written by a samurai warrior in 1645. It's aimed at martial arts but applies to business.

■ MAGAZINES

PDN (Photo District News) (770 Broadway, 7th Fl., New York, NY 10003, 646-654-5780, www.pdnonline.com)
Subscribe to this publication immediately. It's the best place to keep up with the business of commercial photography. Don't miss their frequent photography conferences, which feature manufacturers, top pros, and the latest in photography.

Nikon World (877-44-NIKON, www.nikonworld.com)
Devoted to the art of photography and, of course, promotion of the fine Nikon line of equipment. Features top portfolios, equipment reviews, and information.

Communication Arts (110 Constitution Dr., Menlo Park, CA 94024, 650-326-6040, www.commarts.com)
The best in visual communications. Their annual photography and commercial award editions are good resources of current work.

EDUCATION

PhotoPlus Expos (www.photoplusexpo.com, Sponsored by: Photo District News, 770 Broadway, 7th Fl., New York, NY 10003, (646) 654-5780, www.pdnonline.com)
The best major photo information and product conferences. A very reasonable way to see the latest in equipment, materials, and photography ideas. Conferences are offered each year in New York, Chicago, and California. Seminars and workshops are also conducted by leading professionals in the photography business. Call and ask to be included on their mailing list for catalogs and Expo dates.

Maine Photographic Workshops (David Lyman, Director 2 Central St., Rockport, ME 04856, 877-577-7700 www.theworkshops.com)
This is an excellent place to see leading photographers and their work up close. The classes and workshops are also great places to learn about the real world of photography. An extensive seminar and course catalog is available. The location itself makes a beautiful photograph.

Brooks Institute (School of Photo Art and Science, 801 Alston Road, Santa Barbara, CA 93108, 805-966-3888 www.brooks.edu)
A great professional school and a beautiful location to shoot. Brooks offers a quality education and degree in the technique and art of photography.

Creative Services Counseling (Maria Piscopo, 2973 Harbor Blvd. #229, Costa Mesa, CA 92626, 888-713-0705, www.mpiscopo.com)
Established professionals swear by, and I'm sure on occasion at, this knowledgeable career counselor. Piscopo conducts seminars throughout the country, where she also offers private counseling. She has the ability to compliment, criticize and stimulate photographers. You can get a good idea of her capabilities by reading the *Photographer's Guide to Marketing and Self-Promotion*.

The Black Book (740 Broadway, 2nd Fl., New York, NY 10003, 800-841-1246, www.blackbook.com)
The leading advertising and assignment resource for photographers. In addition to publishing a quality book, they also offer online portfolios and client resources. A very good place to display your work. A very good place to see the work of top pros.

The Workbook (940 N. Highland Avenue, Los Angeles, CA 90038, 800-547-2688, www.workbook.com)
A huge resource for selling your stock and assignment photography. In addition to publishing a large yearly catalog of photographer's individual advertising pages, they also offer online portfolios, directories, and client resources. This is also an excellent place to display your work and to see the work of top professionals.

Pickerell Services (Stock Connection, 110 Frederick Av., Suite A, Rockville, MD 20850, 301-251-072, www.pickphoto.com)
An extensive online photography website. Loaded with portfolio galleries, educational information, product resources, and links to other interesting photo sites. Jim Pickerell has been in the stock business since it began and designed this site for others interested in learning from his many years of experience.

PROFESSIONAL ASSOCIATIONS

Membership in professional associations is an excellent way of keeping current on business developments, new products, promotions and what your competition is doing. These associations represent us in legal matters, survey markets, offer many group buying opportunities, and are a good resource for help with prospering in our business. Best of all, in meeting the membership and ethical requirements you gain excellent credibility. Write for membership requirements.

ASMP (American Society of Media Photographers, 150 N. Second St., Philadelphia, PA 19106, 215-451-2767 www.asmp.org)

NPPA (National Press Photographers Association, 3200 Croasdaile Dr., Suite 306, Durham, NC 27705, 919-383-7246, www.nppa.org)

NPS (Nikon Professional Services, 1300 Walt Whitman Rd., Melville, NY 11747-3064, www.nikonpro.com)

PPA (Professional Photographers of America, 229 Peachtree St., NE Suite 2200, Atlanta, GA 30303, 800-786-6277, www.ppa.com)

SATW (Society of American Travel Writers, 1500 Sunday Dr., Suite 102, Raleigh, NC 27607, 919-861-5586, satw@satw.org)

FEDERAL AGENCIES

The Internal Revenue Service (IRS, 1111 Constitution Av. NW, Washington, DC 20224, 800-876-1715 www.governmentguide.com)
The IRS is one of the most extensive resources of tax information available, which should come as no great surprise. The funny thing is, however, many small business owners do not take advantage of this free service. There's no doubt that the business of freelance photography can often pose interesting tax questions. If you are unable to answer one of these unusual

questions, drop the IRS a brief note. Asking for information will not trigger an audit. Not asking and making a mistake in your taxes, however, just might pull that audit trigger.

IRS Forms Distribution Center (Box 25866, Richmond, VA 23289, 707-368-9694, www.irs.gov/formspubs)
The following IRS publications may be valuable:

Your Rights as a Taxpayer
The ABCs of Income Tax
Your Federal Income Tax
Tax Guide for Small Businesses
Travel, Entertainment and Gift Expenses
Exemptions, Standard Deductions and Filing Info
Tax Withholding and Estimated Tax
Educational Expenses
Miscellaneous Deductions
Guide to Free Tax Services
Business Use of a Car

The Small Business Administration
Office of Business Development (1441 L Street NW, Washington, DC 20416, www.sba.gov)
Request a list of this organization's numerous publications.

U.S. Library of Congress
Copyright Office (101 Independence Avenue SE, Washington, DC 20559-6000, www.cweb.loc.gov/copyright)

■ MISCELLANEOUS

PhotoSource International (Ron Engh, Pine Lake Farm, 1910 35th Rd., Osceola, WI, 54020-5602, 715-248-3800; fax 715-248-7394, E-mail info@photosource.com, www.photosource.com)
Home of *PhotoDaily, Photo Stock Notes, PhotoBulletin, Photo-Market,* and *PhotoLetter.* Ron is a leader in photography direct marketing. Call or write for samples of his publications and materials. He's also the prolific author of several excellent books on selling photography. His website is an excellent resource for learning about and keeping up with the always changing business side of photography. His weekly online newsletter, *PhotoAIM,* featuring the opinions and experience of leading photography professionals, is always interesting, informative, and provocative.

Trac Industries (26 Old Limekiln Road, Doylestown, PA 18901, 215-345-9311)
Makers of the Slide Typer captioning computer system, which changed the way I administrate and file stock photography. They have several other products available. Call for a catalog.

fotoQuote (Cradoc Bagshaw, Box 1310, Pt. Roberts, WA 98281, 800-679-0202, www.fotoquote.com)
This is excellent software for quoting jobs and stock photo prices. Easy to use right out of the box, prices in international currencies, licensing agreements, a huge magazine data base for job and price quoting, and a simple graphic map for quoting in or to specific locations.

Agency Access (1556 Ocean Ave. #12 Bohemia, NY 11716, 212-279-9666, 800-704-9817, sales@agencyaccess.com, www.agencyaccess.com)
I use Agency Access for my direct mail lists. They have a simple site that allows you to create customized listings for a wide variety of photography buyers and users. In my case, I can select the specific publications or organizations and the type of buyer or user inside that organization. They also provide phone and e-mail contact information. An excellent list of some two hundred names can be created for under $100.00.

BASIC FORMS

FORMS APPEARING IN THIS SECTION MAY BE COPIED OR DUPLICATED FOR YOUR OWN BUSINESS USE.

■ YOUR LOGO

A logo is the identifying mark—generally your business name in a graphic design—that should be used on all printed materials. It should immediately provide clients with your name, address, phone and fax numbers, e-mail and website addresses, and other related information.

A logo should also say something about the photography, service, or product you produce and deliver. It can be as simple or complicated a beautiful graphic design as your creative desires and pocketbook will allow.

With today's computer graphic systems, many businesses choose to have their logo scanned and placed in a document. This allows many forms, invoices, and letterheads to be produced in the computer on an as needed basis. I suggest talking with a graphic designer or good quality print shop to get your own logo put together.

SAMPLE LOGO

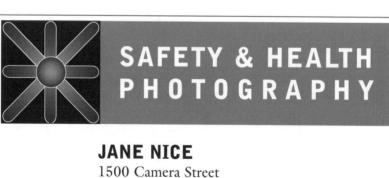

SAMPLE BUSINESS CARD

Date

Mr. James James
Vice President
James Advertising
1000 Madison Ave.
New York, NY 10000

Your logo and
address

SALES CALL/PORTFOLIO LETTER
(To be printed on your letterhead.)

Dear Mr. James:

One photograph may be worth a thousand words, but if it's the right image, it can be worth a hundred times that to the clients of James Advertising.

I can make exciting photographic images that will help your clients sell their products in the widest possible range of markets. If you like the enclosed sample, you'll like what we can create together.

Allow me fifteen minutes of your time, and I'll share my images and ideas.

Sincerely,

John Q. Photographer

Date

Mr. James James
Vice President
James Advertising
1000 Madison Ave.
New York, NY 10000

Your logo and
address

Dear Mr. James:

It was a pleasure meeting you yesterday. Thanks for taking the time to view my photography and for considering it for future projects with James Advertising.

I was most interested in the extent to which your company plans to utilize visual images for future campaigns. I'm sure the addition of Creative Director Mary Pleasant to your staff is in part responsible for this exciting direction. Her many media awards from *So and So* magazine were well deserved.

During our meeting you mentioned a potential location photography project with the Same Old Widget Company of Mill Town, USA. I am most interested in presenting an estimate to produce this location photography.

Thank you for considering my photography and visual marketing ideas. Should you desire to see additional images or references, please call. I look forward to the possibility of working with the professionals at James Advertising.

Sincerely,

John Q. Photographer

SALES CALL/PORTFOLIO FOLLOW-UP LETTER
(To be printed on your letterhead.)

ESTIMATE

Your logo and address

Shooting Date:		Today's Date:
Agency: PO#: Art director: Phone: E-mail:		Client: PO#: Representative: Phone: E-mail:
Billing address:		
Job description:		Shoot location:
Usage:		Rights:
Film type:		Equipment format:

EXPENSE	DESCRIPTION	ESTIMATED	ACTUAL
Photo Fees			
Film			
Polaroid			
Processing			
Telephone			
Assistants			
Props			
Transportation			
Insurance			
Special Equipment			
Accommodations/Per Diem			
Miscellaneous			
TOTAL:			

THE NOT SO FINE PRINT
TERMS OF ESTIMATE

1. THIS IS AN ESTIMATE, not a bid, to provide services and other items necessary to produce photography for the client and the proposed use stated on the front of this form. It's good for the next thirty (30) days and then subject to a reconsideration.

2. The estimates for fees and expenses are based on your original layouts, job descriptions, and reproduction rights. We expect payment for all estimated expenses in advance of the job. They are subject to actual costs, which will be reported in the final invoice.

3. We understand budgets, approvals, and changes in creative needs. Please inform us should there be any changes, additions, or variations in your requirements, as they may affect the project costs. The client for whom this work in ultimately made is also ultimately responsible for payment of fees and expenses incurred by the photographer in this project.

4. If you wish to accept our estimate and tie us into a firm quote for the service/fee portion of this estimate, do so by entering into a simple letter of agreement. Such an agreement is the place to cover cancellations, postponements, reshoots, and other related items that may affect the project.

5. Your rights are stated on both the estimate and the invoice and are granted upon payment. Nonpayment is an infringement of our copyright. We own the copyright to these images unless otherwise stated in writing. You are expected to provide copyright protection for us, at no charge, for each use.

6. You accept full liability for all uses and indemnify us against all claims for any improper, illegal, or outrageous uses. We maintain the right to use these photos in our own promotions and to resell any generic images.

7. WE WANT TO DO BUSINESS WITH YOU. If there are any questions, please call or fax us immediately. Should any legal disagreement arise from this project, let's attempt to settle it together. Should that fail, we reserve the right to arbitration or other legal action.

(This form should be printed on the reverse side of your estimate form.)

CONFIRMATION LETTER

(This form is to be printed on your letterhead.)

Your logo and address

Date

Mr. James James
Vice President
James Advertising
1000 Madison Ave.
New York, NY 10000

Dear Mr. James:

I am pleased to have been selected to produce photography of "The New Widget," for a one-year advertising campaign you are conducting in behalf of the Same Old Widget Company of Mill Town USA.

According to your creative director, Mary Pleasant, shooting will begin at 9a.m. on the first of July, at the Same Old Widget plant in Mill Town. I have received Ms. Pleasant's layouts for the principal shots and expect her to supervise at the site. The photo team, myself, and production assistant, have scheduled three days' working time at the Mill Town plant.

We understand that a purchase order and check in the amount of $0000, for one-half the photo fees and all estimated materials, travel, and related expenses, will be forthcoming. A complete invoice will be presented along with our final selection of images. In the event of a cancellation or postponement on your part less than three days prior to the photo team departure, the photo fees paid to date will be forfeited.

The Same Old Widget Company will receive one year's unlimited use rights in any media for the selected images, upon payment of our invoice. Additional use rights are available.

James Advertising and their client, the Same Old Widget Company, will receive written one-year unlimited use rights to the selected images, upon payment of the final invoice. Additional rights are available and negotiable.

Thank you for using my photography for this project. I am looking forward to working with the professionals at James Advertising.

Sincerely,

John Q. Photographer

LETTER OF AGREEMENT

This LETTER OF AGREEMENT sets forth the terms and conditions under which John Q. Photographer will provide services necessary to produce photographic images for James Advertising of their client the Same Old Widget Company.

1. John Q. Photographer and one production assistant will provide three days of location photography of the New Widget, at the Same Old Widget Company in Mill Town, USA starting July 1st at 9a.m.

2. John Q. Photographer will provide all of the normal and necessary photo and lighting equipment to complete this project. In addition, he will procure the necessary films, processing, and proofs.

3. James Advertising has provided a production memo, a copy of which is attached, stating the type and size of film, desired composition parameters, and product placement. Mary Pleasant, Creative Director for James Advertising, will be present at the actual photo sessions to supervise and approve progress.

4. James Advertising will provide a check in the amount of $0000, which is advance payment for one-half the photo fees and all estimated material, transportation, and location costs. In the event of a cancellation or postponement on your part, less than three days prior to the photo team departure, the photo fees paid to date will be forfeited. A copy of the photographer's estimate for these items is attached.

5. John Q. Photographer will provide a final and complete invoice for the balance of photo fees and any outstanding expenses, along with a complete accounting of and receipts for location expenses. Rights to image use will commence upon final payment of this photographer's invoice.

6. James Advertising and their client, the Same Old Widget Company, but no third parties, will receive one year's unlimited use for the selected images. Additional uses or extensions are subject to negotiation and written approval by the photographer.

7. John Q. Photographer retains the right to use the images, in their final campaign form, for his own business promotion and to resell any generic images.

8. In the event of any disagreement or failure to complete this agreement, John Q. Photographer retains the right to arbitration.

John Q. Photographer

James James
James Advertising

Date

Date

PHOTO DELIVERY RECEIPT

Your logo and address

Date: _____

Enclosed please find: _____

Received by: _____

QUANTITY	FORMAT	SUBJECTS

Please acknowledge receipt, item count, and terms by signing and returning top copy.
Holding or using images signifies your acceptance.

SUBJECT TO TERMS ON REVERSE SIDE

THE NOT SO FINE PRINT
TERMS OF PHOTO DELIVERY

1. The enclosed photos are for your examination and consideration for future use. We expect this will take a reasonable length of time, up to thirty (30) days. Let us know if you need longer for consideration, otherwise we charge a weekly holding fee.

2. These images represent our best photos for your proposed use. Please treat the photos as though handling valuable papers, cash or similar items. They are worth a great deal over a lifetime of sales. DO NOT PROJECT original slides, as they will fade, become scratched and damaged. Please use signed return receipts and insurance when shipping.

3. Our rates are based on each use, media placement, print quantity, market, and similar items. Let us know your planned uses, and we'll outline the costs. WE UNDERSTAND BUDGETS AND VALUE LONG-TERM BUSINESS.

4. We own the copyrights to these images, which remain with us unless negotiated and stated otherwise on our invoice. Your use rights are granted upon payment of our invoice. Nonpayment is an infringement of our copyright. You are expected to provide copyright protection for us, at no charge, for each use. You accept full liability for all uses and indemnify us against all claims for any improper, illegal or outrageous uses. We maintain the right to use these photos in our own promotions and to resell generic and similar images.

5. Model and property released images say so on the mounts.

6. We're in business to sell pictures, not to collect for damage or loss. However, if images are lost or damaged, you are liable to us for their full value.

7. WE WANT TO DO BUSINESS WITH YOU. If there are questions, please call or fax immediately. No matter how serious a problem, we'd like to discuss and settle it directly with you. Of course, if this doesn't work out, we retain the option of arbitration or other legal action.

YOUR CONSIDERATION OF MY WORK IS APPRECIATED!

(This form should be printed on the reverse side of the photo delivery receipt.)

INVOICE

GRANT OF RIGHTS

Federal ID #: 91-000000
Social Security #:000-00-0000

Your logo and address

Date:

DESCRIPTION	AMOUNT DUE
Unless otherwise indicated, payment of this invoice grants one-time nonexclusive rights to the listed photography.	
TERMS: Net 30 days. Monthly Rebilling Charge added to past due accounts. **TOTAL:**	

INVOICE
GRANT OF RIGHTS

1. THANK YOU FOR DOING BUSINESS WITH US. This invoice is only for the services, fees, and uses stated on the front. You are purchasing the one-time nonexclusive rights to the photography listed. We own the copyrights to these images unless negotiated and stated otherwise on this invoice. Any electronic publishing, storage, or manipulation requires additional compensation and written authorization by the photographer.

2. Terms are payment in 30 days, after which monthly rebilling charges will be added. Your use rights are granted upon payment in full of this invoice. Nonpayment is an infringement of our copyright. The client for whom this work is made is responsible for payment of fees and expenses incurred by the photographer in this project.

3. Our rates are based on each use, media placement, print quantity, market, and similar items. Please let us know if you have additional uses and we'll negotiate costs. WE UNDERSTAND BUDGETS AND VALUE LONG-TERM BUSINESS.

4. We maintain the right to use these photos in our own promotions and to resell generic and similar images.

5. Model and property released images say so on the mounts.

6. We're in business to sell pictures, not to collect for damage or loss. However, if images are lost or damaged, you are liable to us for their full value.

7. WE WANT TO DO BUSINESS WITH YOU. If there are questions, please call, e-mail, or fax immediately. No matter how serious a problem, we'd like to discuss and settle it directly with you. Of course, if this doesn't work out, we retain the option of arbitration or other legal action.

8. YOUR BUSINESS IS APPRECIATED.

(This form should be printed on the reverse side of your invoice.)

INVOICE PAST DUE LETTER

(To be printed on your letterhead.)

Date

Mr. James James
Vice President
James Advertising
1000 Madison Ave.
New York, NY 10000

Your logo and
address

Dear Mr. James:

Thank you for the press proof copies of the Same Old Widget Company's new national advertising campaign, which utilizes my photography. I am very pleased with the overall look of this campaign.

In looking through our receivables for July, I noted that our invoice for this photography project is still outstanding. I'm sure this is an oversight by your busy accounting department. Your attention in this matter will be greatly appreciated.

Sincerely,

John Q. Photographer

Date

Mr. James James
Vice President
James Advertising
1000 Madison Ave.
New York, NY 10000

Your logo and
address

Dear Mr. James:

My bookkeeper has informed me that James Advertising is 120 days outstanding in payment of our invoice for the Same Old Widget Company's photography project. A copy of the invoice, which now includes several monthly rebilling charges, is enclosed. I have called to discuss this matter with your accounting department, to no avail.

Our invoice requires payment in thirty (30) days and states that your client's use rights are granted only upon payment. Nonpayment is an infringement of our copyright. The client for whom this work was made is also ultimately responsible for payment. Unless payment is received within ten (10) days, we will have no alternative but to take action to protect our copyright and to seek payment from the Same Old Widget Company.

Your immediate attention to this matter would be appreciated.

Sincerely,

John Q. Photographer

COLLECTION LETTER

(To be printed on your letterhead.)

ASSIGNMENT CHECKLIST

FORMS & PAPERS

- ❏ Job layouts or descriptions
- ❏ Photo releases
- ❏ Purchase order
- ❏ Agency names/phone numbers/payment addresses
- ❏ Client names/phone numbers/addresses
- ❏ Materials estimate advance
- ❏ Portable portfolio

MATERIALS & EQUIPMENT

- ❏ Film
- ❏ Polaroid
- ❏ Camera system
 - ❏ Bodies
 - ❏ Digital bodies
 - ❏ Lenses
 - ❏ Film backs
 - ❏ Polaroid backs
 - ❏ Polaroid camera
 - ❏ Digital disks
 - ❏ Light meter
 - ❏ Color meter
 - ❏ Filters
 - ❏ Correction
 - ❏ Enhancment
 - ❏ Tripods
 - ❏ Cases
- ❏ Plastic freezer bags
- ❏ Gaffer tape
- ❏ Marking pens
- ❏ Garbage bags
- ❏ Tool kit
- ❏ First Aid kit
- ❏ Computer system (laptop for location shoots)
- ❏ Strobe system
 - ❏ Power pack
 - ❏ Heads
 - ❏ Stands
 - ❏ Clamps
 - ❏ Sync cords
 - ❏ Remote trip
 - ❏ Slaves
 - ❏ Reflectors
 - ❏ Grids
 - ❏ Filters
 - ❏ Gels
 - ❏ Strobe meter
 - ❏ Power cord
 - ❏ Extension cords
- ❏ Walkie-talkies
- ❏ Batteries
- ❏ Flash light
- ❏ Bug repellant
- ❏ Swiss Army knife
- ❏ Scissors
- ❏ Notebook

TRAVEL CHECKLIST

DOCUMENTS

❑ Passport (with extra photos and copies)
❑ Airline tickets (and copies)
❑ ATA Carnet (foreign customs guarantee)
❑ Customs regulations (copies)
❑ Equipment registrations forms (US Customs)
❑ Letter of credit
❑ Credentials (letter of introduction and press card)

❑ Emergency medical information
❑ Medical prescriptions
❑ Insurance papers
❑ Equipment (copies)
❑ Personal (copies)

NAMES, ADDRESSES, PHONE/FAX NUMBERS

❑ Tourist organization and Visitors & Convention bureau
❑ At home contacts
 ❑ Client
 ❑ Agency
 ❑ Family
 ❑ Business associates
 ❑ Airline(s)
 ❑ Hotels
 ❑ Family doctor
 ❑ Business lawyer

❑ On location contacts
 ❑ Client and agency contracts
 ❑ Model agencies
 ❑ ASMP and PPA
 ❑ U.S. Information agency
 ❑ U.S. Embassy

PERSONAL ACCESSORIES

❑ Seasonal clothing
❑ Walking/work shoes
❑ Sweatshirt
❑ Dressy outfit
❑ Dress shoes
❑ Belts, ties, socks, etc.
❑ U.S. cash
❑ Travelers checks
❑ Credit cards and copies of account numbers
❑ For travel outside the U.S.:
 ❑ Location's currency and exchange tables
 ❑ Foreign phrase book

❑ Pocketbook
❑ Portable portfolio
❑ Maps
❑ Travel, restaurant, and business guides
❑ Toiletries
❑ Sewing kit
❑ Water purification tablets
❑ First Aid kit
❑ Bug repellent
❑ Shopping list
❑ Canvas bag (for return packing)

PHOTO RELEASE

I give (Your Name) permission to photograph myself and/or property, and to use or sell the materials as he wishes.

Signed: _____

Name (Print): _____

Address: _____

City: _____ State: _____ Zip Code: _____

Date: _____

MINOR PHOTO RELEASE

I give (Your Name) permission to photograph the below-named minor, and to use or sell the materials as he wishes.

Signed: _____
(Parent/Guardian)

Minor's Name: _____ Age: _____

Address: _____

City: _____ State: _____ Zip Code: _____

Date: _____

PROPERTY PHOTO RELEASE

I give (Your Name) permission to photograph the below named property, to which I have ownership and/or legal control, and to use or sell the photos as he wishes.

Despription of property: _____

Signed: _____

Name (print): _____

Address: _____

City: _____ State: _____ Zip Code: _____

Date: _____

CASTING SHEET

Your logo and address

Name: _____

Mailing Address: _____

Phone: _____

Social Security #: _____

Birth Date: _____

Height: _____

Weight: _____

Eyes: _____

Hair color: _____ Length: _____

—PHOTO—

Sizes

Suit: _____ Dress: _____ Shoes: _____

Shirt: _____ Pants: _____ Hat: _____

Bust: _____ Waist: _____ Hips: _____

Agency: _____

Phone: _____

Representative: _____

SAG AFTRA
SEG AFM
AGVA WORK PERMIT

LOCATION EXPENSES

Your logo and address

Location: _____

Subject: _____

Client: _____

Job#: _____

Date: _____

Total Expenses: _____

Cover page (itemized on next page)

LOCATION EXPENSES

Your logo and address

DATE	ITEM/LOCATION	AMOUNT

Inside page (Cover page on previous page)

STATEMENT OF CASH PAYMENT

Your logo and address

| Date: |
| Vendor: |
| Address: |
| City: |
| Country: |

DESCRIPTION OF ITEM/SERVICE	AMOUNT
TOTAL PAYMENT:	

Comments:

■ MAKING CASH PAYMENTS

A "Statement of Cash Payment" should be used when buying services or products for which no receipt is provided and cash is the only accepted method of payment. Examples might include hiring an on-the-spot model or a fisherman's boat; paying someone to carry heavy equipment; or, most commonly, for payments made to taxi drivers when traveling abroad. By using this form, you are creating a written record of what was purchased, the amount paid, the date, and other particulars. The IRS will accept such paper work for business expense deductions so long as your purchase is normal and necessary for the job at hand.

STATEMENT OF CASH RECEIPT

Your logo and address

Date:
Received from:
Address:
City:
Country:

DESCRIPTION OF ITEM/SERVICE	AMOUNT

TOTAL PAYMENT:

Comments:

■ RECEIVING CASH PAYMENTS

A "Statement of Cash Receipt" should be used when a company or person pays you in cash. On occasion, a client might wish to get a better price by paying cash at the time you photograph their product. This happens in foreign countries now and then. Another example might be a person who sees you make a scenic photo and wants to purchase a print. When they pay you cash, you can provide a receipt (and a copy for your files) and will have an address on file to which you can ship the print. The IRS requires that you use a method such as this to keep track of all cash income.

JOB COMPLETION FOLLOW-UP

(To be printed on your letterhead.)

Date

Mr. James James
Vice President
James Advertising
1000 Madison Ave.
New York, NY 10000

Your logo and address

Dear Mr. James:

It has been a pleasure working with the professionals at James Advertising on the photography project for the Same Old Widget Company of Mill Town, USA. I was especially impressed with the capabilities of Creative Director Mary Pleasant.

Thank you for considering and using my photography for this project. We are interested in participating in any future photography programs that may arise with James Advertising. Please feel free to call anytime to discuss ideas.

Sincerely,

John Q. Photographer

INDEX

Other Books from
Amherst Media

PHOTOGRAPHER'S GUIDE TO
The Digital Portrait
START TO FINISH WITH ADOBE® PHOTOSHOP®
Al Audleman

Follow through step-by-step procedures to learn the process of digitally retouching a professional portrait. $29.95 list, 8½x11, 128p, 120 color images, index, order no. 1771.

The Portrait Book
A GUIDE FOR PHOTOGRAPHERS
Steven H. Begleiter

A comprehensive textbook for those getting started in professional portrait photography. Covers every aspect from designing an image to executing the shoot. $29.95 list, 8½x11, 128p, 130 color images, index, order no. 1767.

The Master Guide for Wildlife Photographers
Bill Silliker, Jr.

Discover how photographers can employ the techniques used by hunters to call, track, and approach animal subjects. Includes safety tips for wildlife photo shoots. $29.95 list, 8½x11, 128p, 100 color photos, index, order no. 1768.

Digital Photography for Children's and Family Portraiture
Kathleen Hawkins

Discover how digital photography can boost your sales, enhance your creativity, and improve your studio's workflow. $29.95 list, 8½x11, 128p, 130 color images, index, order no. 1770.

Professional Strategies and Techniques for Digital Photographers
Bob Coates

Learn how professionals—from portrait artists to commercial specialists—enhance their images with digital techniques. $29.95 list, 8½x11, 128p, 130 color photos, index, order no. 1772.

The Digital Darkroom Guide with Adobe® Photoshop®
Maurice Hamilton

Bring the skills and control of the photographic darkroom to your desktop with this complete manual. $29.95 list, 8½x11, 128p, 140 color images, index, order no. 1775.

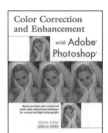

Color Correction and Enhancement with Adobe® Photoshop®
Michelle Perkins

Master precision color correction and artistic color enhancement techniques for scanned and digital photos. $29.95 list, 8½x11, 128p, 300 color images, index, order no. 1776.

Fantasy Portrait Photography
Kimarie Richardson

Learn how to create stunning portraits with fantasy themes—from fairies and angels, to 1940s glamour shots. Includes portrait ideas for infants through adults. $29.95 list, 8½x11, 128p, 60 color photos index, order no. 1777.

Beginner's Guide to Adobe® Photoshop®, 2nd Ed.
Michelle Perkins

Learn to effectively make your images look their best, create original artwork, or add unique effects to any image. Topics are presented in short, easy-to-digest sections that will boost confidence and ensure outstanding images. $29.95 list, 8½x11, 128p, 300 color images, order no. 1732.